Harald Küppers Color

Harald Küppers

Origin
Systems
Uses

Translated by F. Bradley, FRPS, AIIP

Van Nostrand Reinhold Ltd, London

Van Nostrand Reinhold Company Regional Offices:
New York Cincinnati Chicago Millbrae Dallas

Van Nostrand Reinhold Company International Offices:
London Toronto Melbourne

This book was originally published in German under the title:
Farbe: Ursprung, Systematik, Anwendung
by Verlag Georg D. W. Callwey, Munich, Germany

Library of Congress Catalog Card Number: 72 13977
ISBN 0 442 29985 0

Color printed in Germany
Text filmset and printed in Great Britain by Jolly & Barber Ltd, Rugby
Bound in Great Britain

Translated from the German by F. Bradley, FRPS, AIIP

Published by Van Nostrand Reinhold Company Inc.,
450 West 33rd Street, New York, N.Y. 10001
and
Van Nostrand Reinhold Company Ltd.,
Egginton House, 25–28 Buckingham Gate, London S.W.1E 6LQ

Published simultaneously in Canada by
Van Nostrand Reinhold Company Ltd.

16 15 14 13 12 11 10 9 8 7 6 5 4 3 2 1

Contents

List of illustrations

General section

Our many-colored environment

We see the world in which we live in many colors. Visual objects differ not only in their shape and size, but also in their colors. The characteristic of color is of considerable significance in nature. Colors are signals, colors are evidence of a certain condition. The luminous color of a rose visible from afar is designed to attract the insects, Come here, there is plenty of pollen and honey for you. As the insects find their food, so the carpels are fertilized; Nature has killed two birds with one stone. The red cherry and the purple plum, too, signal, 'We are ripe!' And the bird that eats the cherry affords the cherry stone a chance to be carried to a spot that allows it to germinate and grow. The system of nature thus appears to use color as a means to a certain end.

When we see a red-hot piece of iron, our instinctive reaction is, 'Be careful'. Fire is red, but so is blood. The instant emotional judgment is 'danger'. Because these emotional values are anchored in the human subconscious, the color 'red' has been chosen to indicate 'stop' in road traffic. The colors a painter chooses for his paintings are no more random than is the choice of colors for traffic signals. Nor will a girl choosing her dress leave the color combination to chance. In certain conditions colors are thus chosen with deliberation, or else they correspond to a mood, or to a purpose subconsciously intended. The choice of hues and their correlation reveals much about the person choosing them and what he has in mind.

These few examples may suffice to outline the great importance of the variety of colors to man, every man, indeed to nature as a whole. The appearance and perception of colors therefore make a strong impact on us in our daily lives. Sometimes continually. But only few of us try to rationalize this phenomenon. Thus perceptions of color often directly affect the emotions, bypassing our consciousness. Surprisingly, this often happens to such experts as painters, graphic artists, interior decorators, and textile designers who deal with colors professionally.

Why is it that people have always shown much more interest in form than in color?

Basic principles of geometry are taught in school as a matter of course. The student learns to distinguish between the dimensions. He studies ideal geometrical shapes, such as the circle, rectangle and triangle, including all their laws and equations. Geometrical bodies, symmetrical and asymmetrical, are investigated, their sections and perspectives drawn and their volumes and areas calculated. Compared with this, the schools teach little about colors and their relations. Why should this be? How can we explain why the theory of color has been, and still is, so neglected? Should we not accept 'learning to see', the conscious appreciation of color harmonies, the composition of personally chosen sets of color, as a significant facet of human awareness? Should not education in this field be as important as in the field of music?

You can avoid music. If you feel no inclination towards it you can refuse contact with it. But nobody can avoid color, for whenever a person sees, he sees color (the neutral or achromatic colors, i.e., black, gray, and white, must be regarded as extreme limiting values of color perception).

Since the various colors of the objects constitute a considerable part of the information in the visual process, this should be duly recognized. This means that correct seeing must be taught and learned, and just as it is possible to develop general taste[1] it should likewise be possible to develop taste in colors.

Composers, i.e., persons who can think of original melodies, do not grow on trees. Most of us are content to listen to, rather than to create, music. In the field of color, however, conditions could be basically different. Here, everybody ought to become his own 'composer'. In this field, everybody has a chance to express himself individually since, after all, the purchase of every object almost always involves a decision on a certain color. It begins with the choice of clothes, crockery, furniture, wallpaper, and carpets. It applies to the choice of a new car. Even the layout of a garden is, or at least could be, an arrangement of colors. We could indeed, if we wished, go so far as to say that the decision to enter matrimony is also influenced by color. After all, whether a young man falls in love with a blonde or a dark-haired girl or prefers green, gray, or brown eyes, is also a choice determined by color. Perhaps we shall succeed one day in proving that those marriages are particularly happy in which the colors of the eyes and hair and even the complexions of the two partners harmonize in a certain way. That the same taste in colors of

7

two partners can be a valid yardstick for their mutual understanding is a fact marriage bureaus do not ignore in their counseling.

Colors thus have a continuous effect on us even if we pay no attention to them: in the shopping centers of a city in which we stroll, in the hotel where we have registered, in our own home, during a walk. Figs. 1 and 2 are examples of the most varied color harmonies that we can meet almost within a stone's throw of each other. Both pictures were taken in the Engadin during the same week in the fall: the gaily colored atmosphere of the descent from Muottas Muragl near Samedan of Fig. 1, and Fig. 2 with its subdued and somber color harmony of the Diavolezza region only a few miles away.

Color, as we have said, is all-pervading. But we must learn to look at it, to see everything our environment holds in store for us in the variety and surprise of color. Having learned to see will for many mean enhanced awareness and perhaps even a fuller life.

'Color' as a problem

Every object can be looked at from various angles of view. As we walk round a house the perspective will continually change. There is a dramatic difference between looking at a house from an airplane and from a deck chair.

One can approach some problems in a similar manner. The one presented by color can be seen in the most varied perspectives as well. Fig. 3 shows the scheme of a 'circle of problems' around the conception of color. This circle presents a quite organic structure of fairly continuous progression. In this respect it resembles the color circle, in which, too, each color merges into the next without any discontinuity.

It is quite immaterial where we begin with our consideration of this scheme. Nuclear physics might be a good starting point, since it is the source of our understanding of all material phenomena. It reveals the basic structures and shows that in this field there is no difference between matter and energy. Here, too, the existence of the various light quanta or photons and their motion is explained. According to this theory, light consists of a large number of 'energy parcels' of various sizes that are either captured and retained by some atoms, or sent away again on their separate journeys. It reminds us of a children's game. Energy — which of course includes every single light quantum — is a quantity that from a physical point of view cannot be lost, only converted.

An atomic bomb explosion is a pertinent illustration that matter and energy have the same origin. Destruction of the regular atomic structure, i.e., the tearing apart of the individual atomic entities, converts the original matter into energy, liberates the energy that had previously been locked in the solid structure of matter.

It therefore appears reasonable for a comprehensive theory of color to have its origin at this point.

Classical physics, the immediate neighbor of nuclear physics, provides information on the generation of color stimuli by various electromagnetic vibrations (a color stimulus is the measurable radiation capable of triggering, via a physiological process, color perception in a person). Classical physics teaches that all the visible colors are hidden in white light. Optical experiments to spread the light into spectra and the spectrum analysis of matter belong here.

Logically the theory of color is the next problem. It indicates the results to be expected with mathematical accuracy when colored pigments or colored lights are mixed in certain proportions. It reveals the relations existing between the various colors and the rules governing them.

From the rules evolved from the mixture of colored pigments and colored lights, color theories and systems can be developed. Their purpose is to show the great variety of color phenomena in a logical and lucid context and to represent them in clear diagrams. Some systems enable us to define a large number of hues unequivocally and thereby to gain a clear understanding of the subject. Others create the basis for the quantitative calculation of planned results of mixtures. Lastly, there are systems that serve merely as a mental scheme or demonstration model.

The technical mastery of color calls for those systems that permit, at sufficient mathematical accuracy, the predetermination of the practical results when primary colors are mixed. Without them electronically-controlled instruments for the production of color separation negatives in reproduction technology and for the evolution of formulae in dye factories and textile dye works would be unthinkable, without them there would be neither color photography nor color television.

Reproduction technology today is the decisive preparatory stage for the most varied printing techniques. Multicolored originals, whether paintings, drawings, or color photographs on paper or in the form of transparencies, are separated into their three constituent primary colors. The reproduction process analyzes, as it were, the components of the mixture representing every single hue of an original. In the printing blocks the tone values of a given area must most accurately correspond to these proportions of the constituent printing inks. The various blocks are printed together, i.e., the various constituent printing inks are successively laid on the same

area of paper, and thus produce the desired colors through color mixture.

This method, together with the reproduction and subsequent printing processes employed, makes the industrial production of any required quantity of color prints possible. We need think only of the color supplements of our newspapers, printed by photogravure, catalogs of mail-order houses, or posters, often produced with the offset method, or of art reproductions, picture calendars and prospectuses, printed by letterpress. In addition to these three main techniques a number of other printing methods are used. All, however, share one feature: certain color pigments (paste paints) are applied to some material (printing base); the overprinting of certain proportions of pigments can produce new color tones as the result of mixture.

The term 'paste paint' has already given us the clue to the next subject. Colors, by which we mean dyes, pigments, and paste paints, are today manufactured mainly chemically. This was not so in the past, when naturally occurring coloring substances were used. These were obtained usually from animal or vegetable products, i.e., their origin was organic. Nowadays the chemical industry provides the pigments that make the printing inks, varnish and oil paints appear colored.

Needless to say chemistry and photochemistry are closely related. Only the mastery of the extremely complex reactions of photochemistry has made color photography possible. How simple it is today: you walk into a store, buy a reversal film and insert it in your camera. An automatic exposure meter tells you the correct exposure time. All you have to do is press the shutter release button. Mail the exposed film to a reversal station; a few days later, relaxed in your armchair in your living room, you can project the finished slides.

And all the time you do not give a thought to the complex chemical processes that prepared the ground and those that are actually involved here.

The manufacture both of color reversal and of negative films is based generally on the same photochemical principle. Apart from the intermediate layers serving as filters, color films consist of three layers for the three primary colors used. These layers are sensitive to different regions of the spectrum. The process now resembles the production of mixed colors in printing technology. For every hue a certain tone value is produced in the associated layer.

The color layers are subjected to chromogenic development, i.e., their colors are transparent. The different color values in the three superimposed color layers yield the corresponding hues in the relevant areas of the color film through color mixture.

Organic chemistry constitutes the transition to biology —

the science about the life of the organisms. We have already noted in the previous chapter that the color, not only of a certain substance, but also of an organism, cannot be an accident. Not without reason do the leaves of a tree turn red, yellow, and brown in the fall, or the grass yellow in the heat of the summer. Colors and biological functions are directly interrelated. Intense radiation from the sun changes not only the color of the human skin, which, depending on the constitution of its owner, may turn brown, but also red (sunburn).

Light and sun add color to fruits and leaves. To all life on earth light is indispensable as a source of energy, required by plants, animals, and man. Only light enables the plants to perform the process of photosynthesis, i.e., to produce fructose and cellulose from water and carbon dioxide (CO_2). The energy of light is thus the fuel that powers the machinery of the plant organism and thereby keeps it alive.

There is only a short step from biology to medicine. Medicine is the art of healing, the science of man in sickness and health. Color is an aid to research and diagnosis. Bacteria and viruses can be made visible by staining the specimen in which they are suspected. But color can also be an important factor in therapy. The encounter with color can captivate a person, help him to concentrate, or divert him. Color can increase your joy of life, enhance your optimism, cheer you up. Why else should a gorgeous bunch of gay flowers give you such tremendous pleasure? From a material point of view it has almost no value, indeed it will have wilted after a few days. Its appeal is to the emotions, and it thus creates pleasure. In certain conditions, however, colors can cause depression, a drop in performance, and faulty judgment.

We have now arrived at the subject of color perception. Here the question arises, 'How is color perception established in human consciousness?' This question belongs to the field of physiology, the science of the function of the cells, tissues, and organs. The objective color stimulus, i.e., the physical fact, leads to the subjective color perception via the organ of the human eye. This color perception is the cause of the color experience of the individual. The majority of us see colors 'normally'; others cannot recognize certain colors, i.e., they are color-blind. With the aid of suitable color-test patterns such defects of color vision can be diagnosed reliably and with little effort. Careers advisers can thus find out whether a high school graduate is precluded from taking up certain occupations, for instance in the printing and textile industries. 'Color efficiency' can be tested very accurately with the instruments used by ophthalmologists; such tests are assuming ever greater importance with increasing traffic and the growing numbers of applicants for driving licenses.

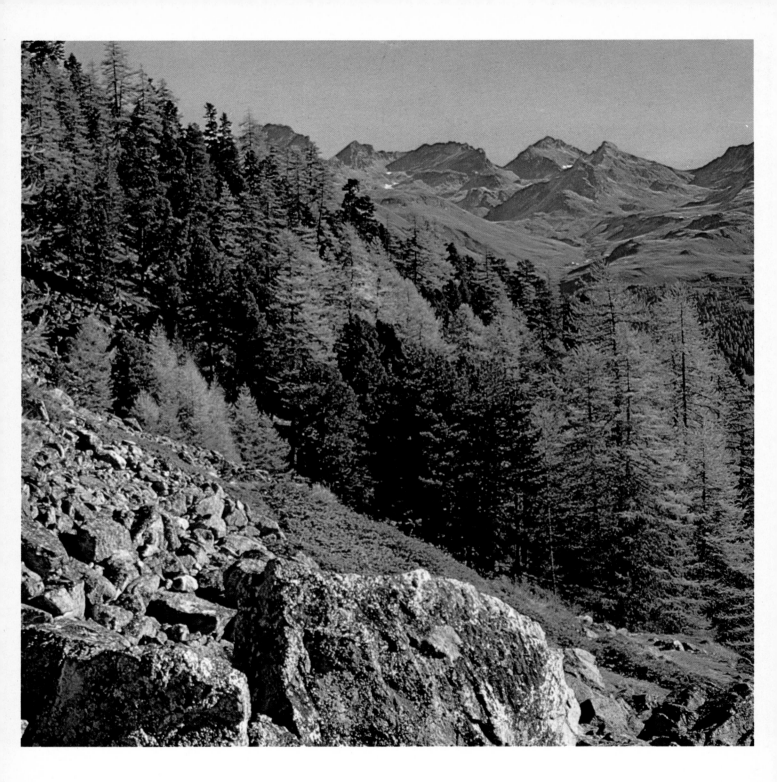

Fig. 1 Colorful fall landscape in the Engadin. View of the
Bernina range from Muottas Muragl.

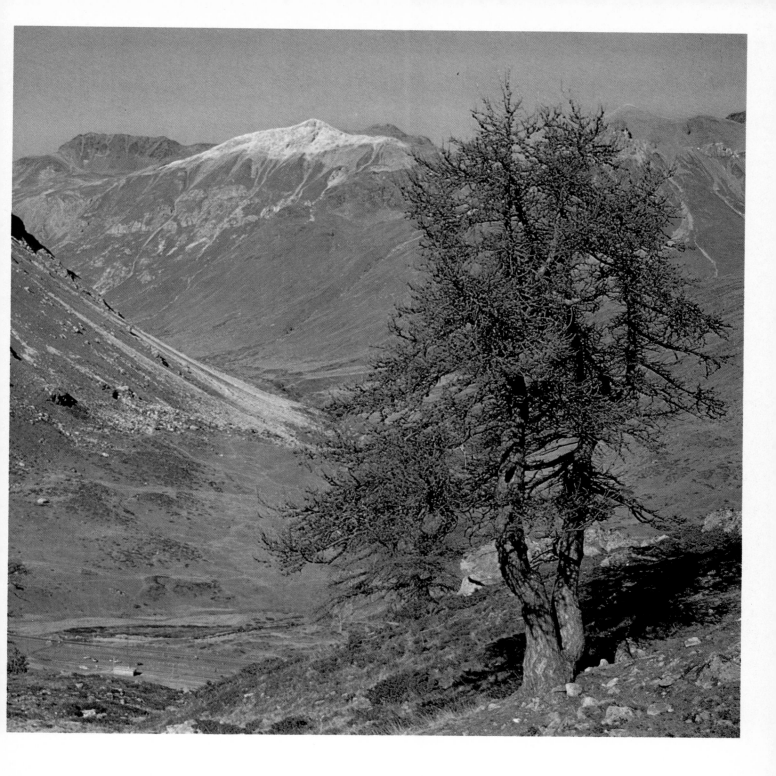

Fig. 2 Ascent to the Diavolezza Hut. A harmony based on only two colors: the gray-brown of the mountains, and the blue of the sky.

Closely related to physiology is the science of psychology. It is concerned with the function of the human mind, with man's emotions. It investigates and influences the individual's feelings and reactions. We have already pointed out that color perception mostly acts directly on the emotions and initially evades rational judgment. The influence certain colors exert on the human subconscious is thus psychological. Accordingly the question of what colors are suitable for what purposes calls for a psychological answer. The decoration of working premises, the color of mass transport vehicles, light signals, color codes of ducts and electrical cables, will all be chosen on the basis of psychological considerations. The same applies to the color scheme of the wrapping of a cosmetic article or of a certain poster. To appeal to people effectively the choice of color must be psychologically correct. Everybody knows from experience that a stroll through a wood or a meadow is relaxing. The fact that the colors of these surroundings are predominantly green is without question an important factor. Green is known as a color that has a soothing effect on a viewer's state of mind. This is the reason why conference tables are covered with green baize. Red cloth in the same place would certainly create a more aggressive mood in the members of the boardroom.

Here we are already entering the field of depth psychology. In man's subconscious there exists a certain individual, modulated attitude to color. The mental attunement including any disturbances of the subconscious can be made visible if volunteers or patients are presented with hues for assessment and asked to name the colors they prefer, those that leave them indifferent, and those they dislike. This method has been scientifically elaborated. Professor Lüscher[2] has made a particularly detailed study of it. His 'Lüscher Test' is the basis of a comprehensive analysis of a person's character. It is said to reveal and diagnose complexes, difficulties and disturbances in the psychological and psychosomatic fields.

It is reasonable to assume that such an analysis may be important not only to sick but also to healthy persons.

We have already mentioned the practice of marriage bureaus of finding out, with the help of a brief questionnaire on color that every applicant has to answer, what partners will harmonize well in their frames of mind and basic attitudes to life. The answers are evaluated with the aid of suitably programmed computers.

Such a possibility naturally arises in personnel selection, when you want to obtain a better picture of the degree of the various applicants' suitability for a certain job. In future, color tests could therefore easily replace or supplement a graphological opinion.

Possible negative reactions caused by the effects of certain colors have already been mentioned.

Depth psychology merges into symbolics, the symbolic significance of color. White, at least in the West, is the embodiment of purity, radiance, virginity. Bright colors are an expression of liveliness. Black symbolizes reserve and isolation; it is the color of mourning, especially in Mediterranean countries. Dressed in black on important occasions we wish to do honour to their cause and not attract attention to our own person. Waitresses wear black for a similar reason. They want to avoid, if possible, the creation of a superficial individual impression. The person assumes a 'neutral value' and allows himself to be overshadowed, as it were, by the task that he has to accomplish.

Red, as the color of blood, is aggressive, extroverted. Yellow, on the other hand, is defensive and introverted. Green symbolizes even temper and calm. Blue as the color of the sky signifies the ethereal, transcendental. Purple radiates poise, purification, detachment, whereas orange and orange-red express movement and energy. Brown represents earthiness, melancholy, the search for security.

The colors are instinctively assessed at different values in the subconscious of a person. To appeal to this basis of the subconscious is the aim of the painter, the artist. He will try, to begin with, to render certain ideas, often existing only in the emotions, in colors. He tries to be creative with colors in such a way that he evokes certain emotions, intended reactions, in the viewer. It may be grief, light-heartedness, wild enthusiasm, it may be the artist's intention to provoke resistance, rejection, disgust; it will always be his aim to arouse the viewer's emotions and to appeal to and captivate his subconscious.

An artist's relation to his colors, i.e., to the paste paints and pigments with which he creates and composes, is obviously intense. Naturally it differs fundamentally from that of the scientist, technologist, or chemist. The painter, too, obviously strives to obtain certain hues he sees in his imagination, and tries to realize them; except that he usually shows very little interest in the theory of color. He has a selection of innumerable tubes and, beginning with the hue he can take straight from one of them, he tries, with the admixture of other paints, to produce the desired hue. Sometimes by accident, he will create on his palette hues that he likes even better, and then uses. Only rarely will he work with the primary colors unless he wants to take advantage of precisely this or that color tone for a certain purpose. The paints the painter mixes are mostly opaque, and their tones are far removed from the primary colors proper. As a result, many artists have no or only very slight acquaintance with the theory of color. Regrettably, they are often not very open to scientific and logical ideas. This is perhaps the reason why many artists, modern and ancient,

are held in high esteem who are at home exclusively in mysticism and want to explain the theory of color with the aid of the emotions rather than the exact definition of science.

We have now taken the first steps towards the working out of a theory of color.[3] But for the establishment of a cast-iron theory of color harmony it is essential to build on the foundation of objective scientific facts. If you want to evolve such an objective and final theory of color harmony, you must be an artist, scientist, and color technologist all at once. We are certain that one fine day such a theory will come to be formulated, just as a theory of harmony exists for music. Here, too, the question of taste does not arise; whether something is considered pretty or ugly is beside the point; the essential factor is the effect of colors and color combinations on the person, on the feelings of the viewer. Such a theory of color harmony should reveal laws according to which harmonizing color combinations and those that clash are created. It should explain when adjacent colors behave neutrally, i.e., do not appeal to the emotions of the viewers, and when they set up tensions.

Poetry is an art form employing different means. Instead of the optical effect or of sound, the poet's medium is the rhythm of the language, the word. Is there a poet in the world who has not sung the praises of a world full of colors? But he finds himself in a great dilemma. The scope of language at his disposal is comparatively narrow. How difficult it must be to clothe experiences of color in words firing the imagination.

And where is the dividing line between poetry and theology? What is the difference? The Book of Genesis begins with, 'In the beginning God created the heaven and the earth. And the earth was without form, and void; and darkness was upon the face of the deep. And the Spirit of God moved upon the face of the waters. And God said, Let there be light . . .' The creation of light, after that of heaven and earth, is described as God's first act. What preeminent importance the author of Genesis ascribed to the light! Did not perhaps the light, this mysterious force on which life largely depends, itself create this life and is it not still creating it all the time? All visible colors are part of the light — is not perhaps this light the source of all the colorful animation of our surroundings?

Without doubt philosophy is the link between theology and nuclear physics. The philosopher searches for the interpretation of the material, intellectual, and spiritual world we experience, for a universal view enabling us to see these aspects as an integral entity, as three facets of One World.

It will always be the philosophers who in their striving after the light of knowledge with their intellect explore and roam the space between religion and nuclear physics. It is

their task to fit the new insights of scientific research as well as the ancient traditions of religion and mythology into a logical conception of the universe.

In his search for explanations, for pictorial examples a philosopher[4] has gone so far as to make an attempt to explain and interpret the entire evolution of the universe in terms of a system analogous to the theory of color. Unfortunately, however, his knowledge of the scientific facts did not match his ambition.

This completes the circle of the various aspects grouped around the problem of color. It represents an organic whole. It is a diagram showing in a plane, i.e., two-dimensionally, various perspectives from which one can view one and the same problem in most diverse conditions, and with most diverse experiences, knowledge, aims, and reservations. An important component is, however, missing: the historical development in all these disciplines of knowledge. One can therefore extend this thought system into a cone, with all the lines of evolution of the various specialities radiating from its apex. The zero point, the apex, represents man's state of complete ignorance. Time, i.e., historical development, is therefore the third dimension of this model.

Color and language

Color in the English language is a well-defined term. It denotes the colored appearance of an object; for a printing color the word 'ink' is used, which describes the material used for staining.

If someone asks, 'Why is the wine rosé?' he wants to know the color of the wine, i.e., its special property of appearing rosé. The question therefore refers to color perception. If, on the other hand, he asks 'What color do you like best?' he is interested in the effect of the color on the viewer, i.e., in his color sensation. If somebody wants to buy suitable material for dyeing some fabric, he will ask for a dye, which is sold in tubes, tins, or packets.

Color manifests itself in a great variety of ways which we must define in the interest of clarity.

1. Body color

Body color is the colored appearance of matter, of a substance. It is the property of objects of showing a certain color in a certain illumination. Difference in appearance is caused by a difference in the molecular structure of the substances. This structural difference between various materials is the reason why they reflect or absorb the same light in different ways. Body colors become also visible through a difference between the spectral composition of the light reflected by the object into the eye and that of the ambient illumination.

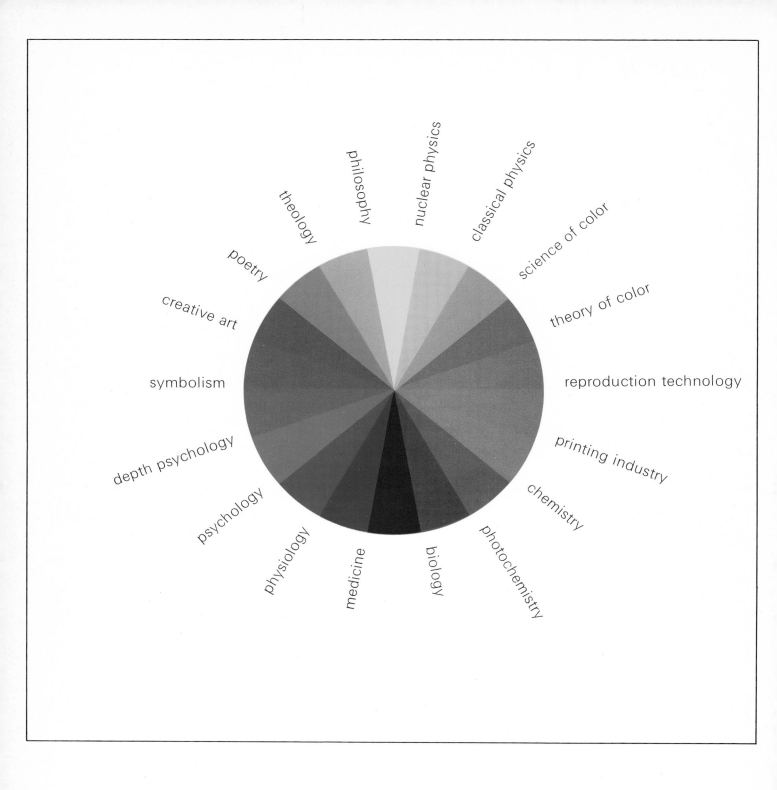

Fig. 3 The problem of color must be viewed from the different perspectives of the various disciplines. These merge organically, like the color circle shown above. The result is a 'Problem Circle of Color'.

2. Color of light

The color of light is the colored appearance of the radiation of a light source. It is produced by the differential spectral composition of the light.

3. Color stimulus

Color stimuli are those visible electromagnetic vibrations that trigger off the visual process in the eyes of living creatures. These vibrations may reach the eye either directly from a light source or via a substance that reflects or absorbs them. Color stimuli are measurable physical quantities.

4. Color sensation

Color sensation is the experience, or the impression of color created in the observer's brain as soon as the process of seeing is triggered off by a color stimulus.

Color sensation is thus the result of a physiological process.

5. Staining agents

Staining agents are divided into two large groups, i.e.
a) soluble dyes, and
b) insoluble pigments.
They are materials used for dyeing other materials through mixture with them. A printing ink as such is therefore not a staining agent; it will become one only after coloring matter has been added to it. It usually contains other additives, such as varnishes, vehicles, etc.

6. Paints and inks

Paints are applied to the surface of a substance to give it an appearance in a certain color. Oil paints, water colors, and printing inks belong to this category.

Language is surprisingly inadequate to describe all the aspects of color. This becomes particularly evident when we attempt to define hues with the aid of our everyday vocabulary. Whereas a person can as a rule distinguish between well over 10,000 hues, our language offers less than a dozen definitions specific to colors: black, white, gray, blue, yellow, red, green, and brown are the important original names of colors.

Because of the total inadequacy of this vocabulary, color names are elaborated with supplementary illustrative words: fiery red, sky blue, grass green, etc. If you have keen powers of observation you will know how different the blue of the sky, the green of the grass can appear; even these elaborations, then, are by no means precise. Nor did the possibility of combining the names of two colors, such as blue-green or green-gray to obtain greater differentiation lead us much further. In the end, additional adjectives were used to en-large the range of definition: light, dark, pure, muddy, sooty, dirty, deep, subdued, riotous, warm, cold.

In yet another group of hues the name of an object has come to be used to describe the color: camelhair, charcoal, turquoise, heather, terracotta, etc. Orange and violet, too, really belong to this group.

We must also mention the few names of colors that have become accepted as describing a certain hue; most of them are also descriptive terms of objects. Navy blue, sea green, chocolate brown, but also khaki and ivory are members of this class.

All this shows that the tool of language cannot define a hue with any accuracy. The reader of a novel is very much left to his own imagination when he reads a passage such as, 'Her pale pink dress stood out like a delicate camellia blossom against the green-black background already merging into the evening twilight.' Surely the author does not expect the reader to visualize with optical precision the color conditions he has described! If, on the other hand, Prague or Belgrade is mentioned in a novel, it is quite conceivable that the reader will consult an atlas to obtain a clear picture of the geographical situation. Why, then, should we not, with the aid of a color atlas, find out what hues are meant by a certain description? Although such color manuals exist, this idea seems still a little exaggerated in the age we live in; yet it is quite possible that it will be accepted in due course.

In the industrial field communication, long-distance, precise and unmistakable, about clearly defined hues is of course already indispensable even now. A number of color systems that permit this have been devised. We shall describe them presently.

The few original names which our language has for colors and which we have already mentioned, semantically cover a wide range as we have said before. The term brown on its own offers no clear-cut definition. The blanket word covers a multitude of different hues: someone may have a brown skin, brown is the skin of a bear, a tree trunk, loamy soil; chocolate, too, is brown, both the milk and the bitter variety. These examples show how difficult, indeed almost impossible, it is to define color phenomena exactly with our language. The few descriptions of colors at our disposal cannot mean a certain color tone but cover a large group, a wide range of colors. Red, for instance, is everything in the region between orange and magenta. (The left-hand column of fig. 4 illustrates the breadth of color ranges that can be covered by the color names of colloquial English.) In the theory of color this inadequacy of the language raises special difficulties, since the color names used must describe very narrowly defined hues, i.e., the primary colors. The absence of differentiated color terms has created a great

linguistic dilemma, because everybody, whether scientist, technologist, artist, or layman, can mean something entirely different by the same description of a color. What the scientist, for instance, calls blue is violet to the printer, navy to the artist, and even purple or lilac to the layman. All these different names are thus used for the same color tone (see fig. 4).

Even if you study the literature of the theory of color, reading and study alone are not enough. You will need to find out at the outset what the author means by the color names he uses if you want to gain a clear picture of the relations between them. You may even find two different names in an essay, sometimes even on the same page, for the same color, or, conversely, the same term for two different colors.

Which color names are 'right'?

Those who are professionally involved with the theory of color are divided into two groups. One comprises the theoreticians, the scientists, photographers, television and film technicians. The other consists of the technologists and practitioners, above all the printers, reproduction workers, designers, advertising men, and a large section of painters and decorators. The paint and dye manufacturers were firmly on the side of the practitioners until a few years ago; but they have become uncertain of late and some of them have defected to the side of the theoreticians.

The two camps differ quite considerably in the use of the color terms (see fig. 4, columns 3 and 4). The theoreticians call the additive primaries, which are also the basic colors in television, red, green, and blue, whereas the practitioners called their basic colors, the starting colors for the printing process, yellow, red, and blue.

The terms for red and blue were used by the two groups for quite different color tones. This state of affairs was not only unfortunate, it was indeed quite intolerable.

Efforts of the various national Standard Institutions to influence usage were therefore long overdue. The basic colors for printing are no longer yellow, red, and blue; the three subtractive primaries are now officially called yellow, magenta, and cyan. This definition is to be warmly welcomed, because it precludes any confusion in future.

The names of the basic colors used in this book are as follows:

> yellow
> green
> cyan
> blue
> magenta
> red

Everybody, no matter which camp he belongs to, can clearly understand the meaning of these terms.

Fig. 5 illustrates the primary colors with the names used in this book.

1 Everyday language	2 The pure colors	3 Science	4 Technology	5 Suggestions Küppers	6 Dr Schauer
yellow		yellow	yellow	yellow	yellow
green		green	green	green	green
blue		cyan	blue	cyan	cyan blue
violet		blue	violet	violet	violet blue
mauve					
purple		magenta	red	magenta	magenta red
red					
orange		red	orange	orange	orange red

Fig. 4 This table shows how different groups of persons conventionally use quite different names for the same colors. Conversely, a given name may indicate quite different colors.

Fig. 5 The names of colors used in this book are red (A),
yellow (B), green (C), cyan (D), blue (E), magenta (F),
white (G), and black (H).

18

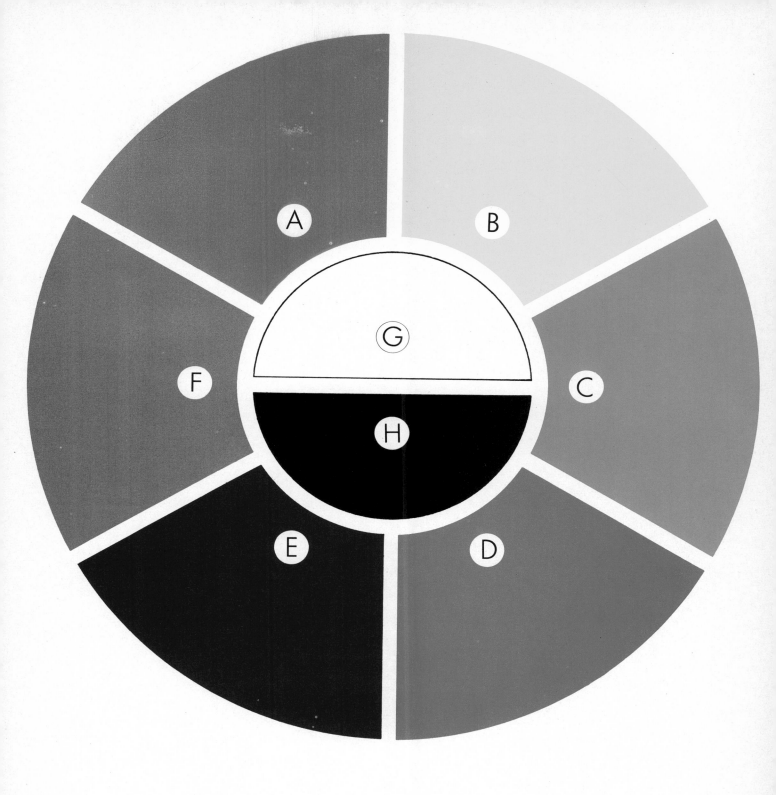

Physiological section

Everything is really gray

We said at the beginning, not without reason, that our environment *appeared* colored to us. We did not claim that it *was* colored. For appearances are deceptive: the world as such is completely colorless. The visible world consists of achromatic substances and electromagnetic vibrations, which are also achromatic and differ from one another only in their wavelengths.

Generally, matter is not directly visible. We see it in this way only in those exceptional conditions in which it emits visible radiation, i.e., when it glows or sends out rays in some other way. In other cases we recognize it only by its reflection of visible electromagnetic radiation into our eyes. Visible radiation entering our eyes is called light.

This light can reach our eye directly from a radiation source, but also indirectly after reflection or transmission by a substance.

As already mentioned, the only distinctive features of electromagnetic vibrations are their wavelength and their energy, but not their color. Multicolored appearance is only the result of the physiological process of vision. Color experience and color sensation therefore exist, as we have said before, only within the observer's brain.

To the viewer, matter in its innumerable visual aspects appears in different colors only because it differentially absorbs or reflects light incident on it according to its different molecular structure.

An opaque colored object absorbs part of the white light incident on it, and reflects the rest, which can enter the observer's eyes. The process is analogous when the object is transparent. The unabsorbed part of the light is allowed to pass through the substance and this accounts for its colored appearance. Color filters, colored glasses, but also color films are examples.

The red flower and the green stem of a tulip (fig. 6) differ in the molecular structure of their tissues. The flowers thus absorb the green component of the white sunlight. They deprive the sunlight of part of its energy and reflect only the unaffected part of the rays, which to the observer appear red.

The condition is reversed with the stems of the tulips. They absorb the red portion of the light, but reflect the part of the visible radiation that creates the impression of 'green' in the observer. Absorption is the method the plants use to obtain part of the energy of sunlight, which they need for the process of photosynthesis. Without the supply of this energy they would be incapable of growth and development.

In the absence of visible photoelectric radiation 'colors' cannot exist either. In a completely dark room a blue carpet is as invisible as a red tomato or a white mouse. Colored objects merely have the property of appearing in their colors in a certain light. They naturally retain this property also in the absence of light; but it is only latent then. To render the chromatic property of matter visible in the best conditions, light must consist of all the visible electromagnetic vibrations at equal intensity.

Light is not inherently white; it can also be colored. A yellow lemon lit in a darkroom with magenta light appears orange, with cyan light, green, and with blue light, black.

Matter of the same atomic structure appears identical in the same light. If the spectral composition of the light is changed, the appearance of the matter also changes. This is why the fabric of a coat, for instance, looks different in artificial light compared with daylight. (We shall return to this in greater detail later.)

Colored appearance is therefore always relative. It does not solely depend on the property of a substance of absorbing, reflecting, or transmitting incident light; the quality, i.e., the spectral composition of the existing light, is also a decisive factor.

This makes the exact treatment of color so extraordinarily difficult. Not to be misled we must have a totally constant light source of a radiation energy that is evenly distributed across the entire breadth of the spectrum.

Nor is 'daylight' the ideal illumination. Far from it. It can in fact be very tricky, because it is not constant, but always subject to considerable changes. Both the position of the sun in the sky and the prevailing weather affect its spectral composition.

Industry in particular greatly depends on a constant light source for the assessment of colors. This applies equally to the textile, the printing, and the reproduction industries. To assess colors a light is required that consists of all the visible rays at equal intensity on the one hand and is not subject to any fluctuations on the other. Light sources meeting these special demands are called color analysis lamps.

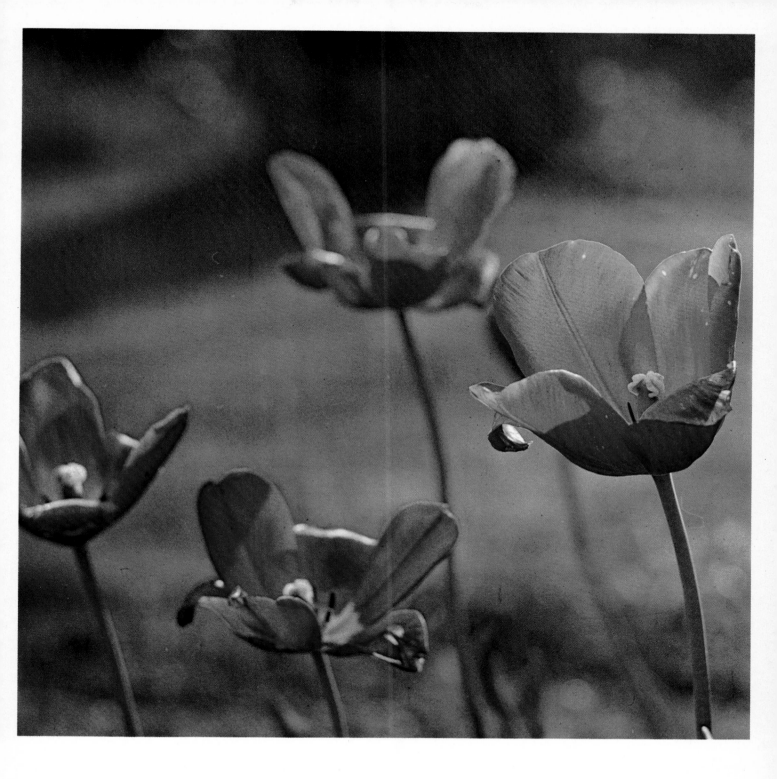

Fig. 6 The different molecular structures of matter have the effect of different regions of the spectrum being absorbed or reflected. The red petals of the tulips absorb the green region from the white light and reflect the red. The stems absorb the red region and reflect the green.

The process of vision

The process of vision — like that of hearing — takes place in a sequence of time. Everybody knows that the interval between the generation of a sound and the hearing of it is the longer, the longer the distance between the sound emitter and the ear. Sound is propagated at the relatively slow speed of 333m.p.s. (about 1,100ft.p.s.), i.e., it travels 1km in 3 seconds.

When we watch a flash of lightning at the approach of a thunderstorm and immediately begin to count the seconds until we hear the thunder, all we have to do to determine the approximate distance of the center of the thunderstorm in kilometers is divide the number of seconds by three. Farmers can use this simple rule of thumb to find out whether the storm is likely to endanger their dry hay, or the storm center is moving away. Such calculations fascinate, particularly children.

During the process of vision, too, an organ receives vibrations sent out by a certain source. These vibrations are converted into a perception. But we cannot perceive the time lapse during the triggering of the visual process because of the extreme speed of light. In a vacuum, light travels at 300,000km.p.s. (about 186,000m.p.s.); it could circle the earth seven and a half times within one second.

The eye is an optical system; its purpose is to guide visible radiation to the retina, which accepts the physical (color) stimulus and transforms it into a physiological stimulus. This is directed to the optic nerve and along it to the brain by the individual receptors of the retina through nerve fibers. In the calcarine region, which is linked with the cerebral cortex, the stimulus is transformed into a sensation and this in turn into conscious seeing.

Fig. 7 is a longitudinal section through the eye. The sclerotic (A) encloses the eyeball. It has a transparent layer, the cornea (B), in front of the optical system of the eye, absorbing part of the invisible electromagnetic vibrations and transmitting vibrations only of magnitudes between about 300 and 1500nm (millionths of a millimeter). In addition, the curvature of the cornea already acts as a collecting lens. The light rays must now pass through a layer of fluid, called 'aqueous humour' (C), situated between the cornea and lens (D). The visible rays finally enter the 'vitreous body' (E) of the eye and reach the retina (F).

The iris (G), situated in front of the lens, automatically reacts to brightness, i.e., the intensity of the light. The lower the intensity the wider it opens, the higher the intensity the more it closes (fig. 8). But it can also alter the pupil aperture owing to reflex action (subconsciously) to achieve sharper vision. The iris of the eye functions on the same principle as the diaphragm of a camera lens, which, too, regulates the quantity of the light passing through. Photographers know that the depth of field of a picture has a certain relation to the aperture of the lens.

The lens of the eye transmits the electromagnetic wavelengths between 380 and 760nm. Through its variable curvature it is capable of focusing objects at different distances successively on the retina.

The retina consists of superimposed layers. The light first penetrates a layer of nerve fibers, and then several layers of cells. But not until it has reached the layer of rods and cones embedded underneath will the physical energy of the electromagnetic vibrations be converted into physiological stimuli.

The rods and cones are irregularly distributed across the layer of the retina. In its central area i.e., the zone facing the lens, the cones predominate. In the so-called foveal pit, the fovea centralis, an area in the center of the retina measuring not quite 0.5mm across, there are no rods at all (fig. 7I). In the other regions rods and cones are arranged side by side. In the peripheral region the rods predominate. Fig. 9 shows the cross section through the retina in which the arrangement of the rods and cones can be seen.

Whereas the rods (A) are connected in groups with ganglion cells (nerve fibers), each cone (B) has its own connection to a nerve fiber. All nerve fibers lead into the optic disc (papilla), also called 'blind spot' (fig. 7K). From here they pass on to the brain in the form of a bundle. Each individual nerve fiber is insulated so that the information it transmits remains discrete.

The precise function of rods and cones has not yet been scientifically established. It cannot be said with any certainty how color vision really works. We depend on theories, which differ quite considerably.

We know most about the function of the rods. They record brightness differences only and are important mainly when the illumination is very weak. They do not help us to perceive color differences. This also explains why we cannot see any color differences in dim moonlight at night, because at such a low level of ambient light only the rods function.

The rods are filled with a fluid, called 'visual purple'. This substance is an albumen-bonded carotene pigment that has entered into a combination with vitamin A, and undergoes chemical changes when exposed to light. It is transformed into visual white via visual orange and visual yellow. Energy is liberated during this process that triggers the physiological stimulus. As soon as the light stimulus ceases, the visual pigment regenerates itself and returns to its original state.

The function of the cones, of which there are up to 15,000 per sq.mm, is much more obscure.

The dominant theory is based on the fact that suitable

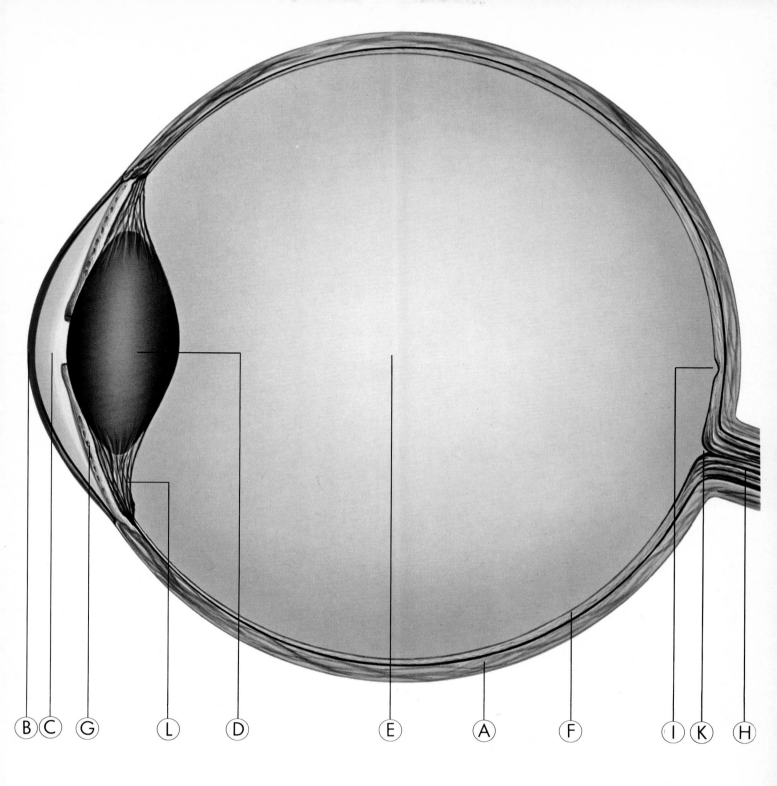

B C G L D E A F I K H

Fig. 7 Cross section through the eye: sclerotid (A), transparent layer of the cornea (B), aqueous humor (C), lens (D), vitreous body (E), retina (F), iris (G), optic nerve (H), central fovea (I), blind spot (K), ciliary muscle (L).

experiments produce three spectral curves from which the sensitivity of the visual organ and thereby that of the three corresponding types of cone is deduced: in a darkened room given colored lights are reconstituted by optical (additive) color mixture of three 'primary valencies', i.e., three colored lights. The values of the primary valencies are recorded and mathematically analyzed for each such mixture. When the values found are entered in a coordinate system, the previously mentioned spectral curves shown in fig. 10A are obtained. It will be seen that the maxima of the three curves are located in the blue, green, and red regions, from which the existence of three types of cone, of differential sensitivities for these three spectral regions, must be deduced.

Various authors have independently arrived at very similar spectral curves, as fig. 10B, where the results obtained by König, Ives, Judd, and Justova are plotted together, shows.

The act of color vision is accordingly thought to proceed as follows: a color stimulus reaches the eye. Depending on its spectral composition it will excite the three different types of cone differently. As a result, different values are transmitted to the brain by the corresponding nerve cells. The color sensations for the various hues would thus be generated in a way quite similar to that of additive color mixture, with which we shall presently deal in great detail. Vision would thus be based on the same principle as the production of mixed colors in color television. The relation would be quite obvious and logical.

The theory of the three different types of cone is strengthened by the detailed investigations of the visual power of color-blind persons and those of defective color vision. These disturbances of and deviations from 'normal' vision — color blindness and defective color vision — can be explained by the fact that one or two types of cone wholly or partially fail to react.

There is, however, another theory that assumes only a single type of cone, functioning uniformly and similarly to rod vision. The difference would be that all cones are sensitive to differences in wavelengths and intensities, whereas the rods are able to register only intensity differences.

Although we have not yet succeeded in establishing complete scientific proof of the theory of the three different types of cone, we must assume that our eyes function in this way.

It is interesting that equally intense visible electromagnetic vibrations are not perceived by the eye as equally bright. Instead, the brightness sensation increases considerably from a minimum value in the short-wave region towards the middle portion of the spectrum, again dropping to a minimum value towards the end of the spectrum. Fig. 11A shows the statistical distribution of about 200 persons regarding the brightness sensation of colored lights of the same intensity. The structure of the curves appears logical if we bear in mind that those electromagnetic vibrations whose wavelengths are shorter or longer than those of the visible spectrum do not excite the visual organ.

Fig. 11B illustrates how brightness sensitivity changes from daylight vision to night vision. Unlike the brightness sensitivity of the cones, whose maximum is located fairly precisely in the middle of the visible spectrum, that of the rods is displaced towards the short-wave region of the light.

Visual defects

The adaptability of the human eye is enormous. It not only adjusts itself automatically to a certain level of ambient brightness, it is also capable of successively focusing very near and very distant objects sharply on the retina. The single eye, however, has minor defects owing to its anatomical construction and its position in the eye socket. The deficiencies of one eye are compensated by the other.

For only binocular vision takes in a whole field of view and can also cover events taking place outside it. Persons able to see only on one eye are at risk in that they will not notice a danger approaching from the opposite side, normally registered by the instant perception of movement. The nose severely limits the field of view of the one eye. All we have to do to appreciate the increase of the field of view established by the second eye is to close one eye. The area of the retina on which all nerve fibers converge and from where the optic nerve leads to the brain contains a 'blind spot'. This defect is also compensated by the second eye. Evidence of the 'blind spot' is easily obtained by means of a little experiment. Hold fig. 12A in front of you at a distance of 60–70cm. (24–28in.) and focus your right eye on the small dot in the circle on the left, closing your left eye. If you now move the book slowly towards the eye, the cross on the right will suddenly disappear at a distance of about 30cm. (12in.), because it cannot be seen through the blind spot. It becomes visible again as soon as you move the book still closer to your eye.

Opposite the lens system of the eye surrounding the entire foveal pit, we find an area in which the retina contains a yellow pigment (fig. 7), and which is called 'macula lutea' or 'yellow spot'. Differential concentration of this yellow pigment in different persons may be a reason for individually different vision.

A functional defect of the eye occurring in certain persons is night blindness. This is obviously caused by vitamin A deficiency in the visual purple of the rods, which results in failure to react to brightness differences. Night blind persons can see quite normally in daylight, for function of the cones

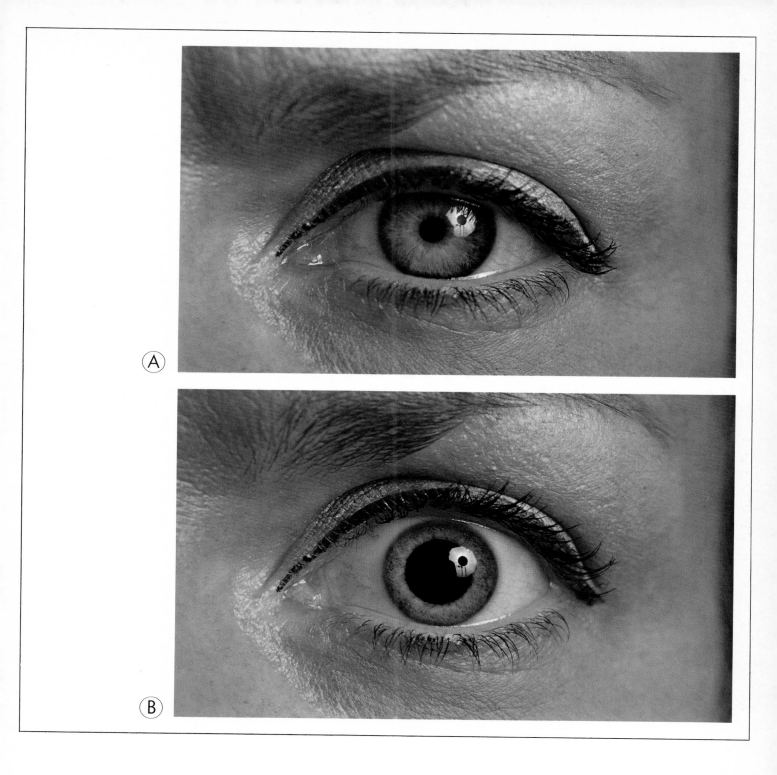

Fig. 8 The iris of the eye acts like the diaphragm of a camera lens. In strong light it contracts to reduce the amount of incident light (A). In weak light (B) it dilates. The regulation is controlled subconsciously.

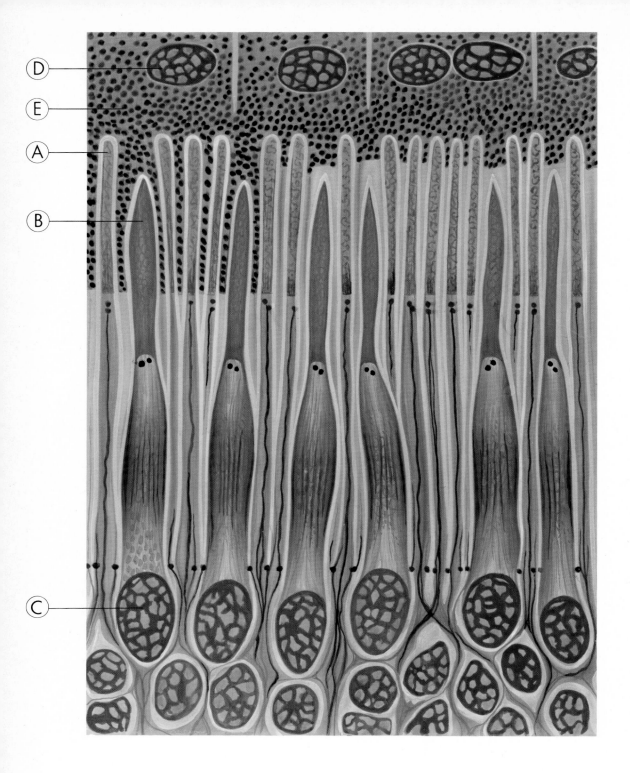

Fig. 9 Cross section through the retina. The rods (A), the
cones (B), the ganglion cells (C). The light first traverses a
layer of nerve fibers (E), in which nerve cells (D) are em-
bedded; it does not, however, trigger a physiological pro-
cess. This starts only when the light strikes the cones and
rods.

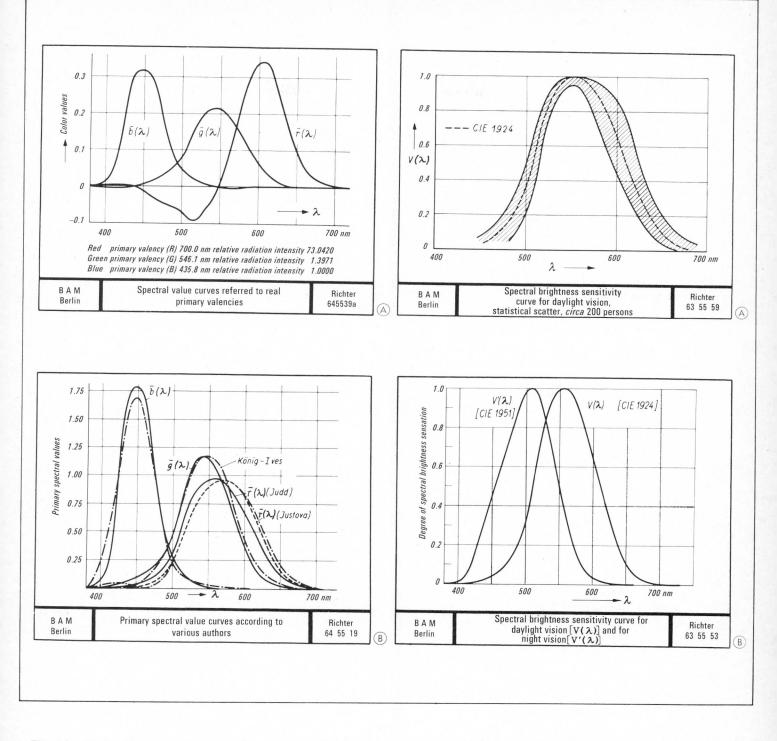

| B A M Berlin | Spectral value curves referred to real primary valencies | Richter 645539a | Ⓐ |

Red primary valency (R) 700.0 nm relative radiation intensity 73.0420
Green primary valency (G) 546.1 nm relative radiation intensity 1.3971
Blue primary valency (B) 435.8 nm relative radiation intensity 1.0000

| B A M Berlin | Spectral brightness sensitivity curve for daylight vision, statistical scatter, *circa* 200 persons | Richter 63 55 59 | Ⓐ |

| B A M Berlin | Primary spectral value curves according to various authors | Richter 64 55 19 | Ⓑ |

| B A M Berlin | Spectral brightness sensitivity curve for daylight vision [V(λ)] and for night vision [V'(λ)] | Richter 63 55 53 | Ⓑ |

Fig. 10 The primary spectral value curves show the sensitivity of the three types of cone to the visible radiation of the spectrum. The representation (A) is produced when the above-mentioned wavelengths are used as primary valencies. (B) shows how some authors have arrived at similar assessments even decades ago.

Fig. 11 The eye does not perceive visible rays as equally bright at equal radiation intensity. (A) shows how the brightness sensation is heightened and drops again as a function of the wavelengths. The brightness sensation of the cones differs from that of the rods (B).

27

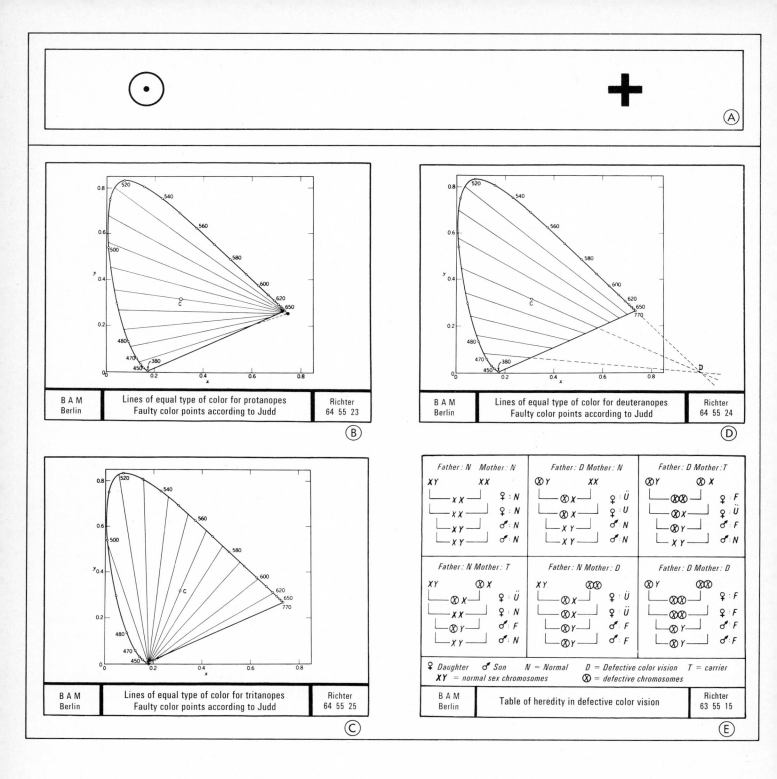

Fig. 12 (A): Test chart for the blind spot. (B), (C), and (D) are schemes demonstrating how persons suffering from defective color vision fail to distinguish between certain colors (situated on the same lines in the diagrams). (E) is a table of recessive heredity of color blindness.

in their eyes is not disturbed. However, as soon as the intensity of the ambient illumination sinks below a certain threshold value, they no longer see anything at all. As we have already stated, in persons of normal vision the rods take over the entire visual function as soon as the quantity of the ambient light is no longer enough to produce a reaction in the cones. In such a situation persons whose rods do not function obviously can no longer see anything.

Color blindness or defective color vision can always be traced to abnormal function of the cones. The theory according to which three different types of cone are sensitive to three different regions of the spectrum (figs. 10A, B) explains such defects in color vision elegantly with the assumption that one or two types of cone are either totally missing or react incorrectly if at all.

A successful, logical explanation of such visual defects has not yet been found on the basis of the other theory, which postulates only a single type of cone sensitive to the entire visible spectrum.

Color-blind persons cannot distinguish between certain hues. Those who cannot differentiate long-wave light, i.e., the red region of the spectrum, are called protanopes. Deuteranopes cannot distinguish colors in the medium-wave, green region; persons whose eyes do not react correctly to the short-wave region of the spectrum are called tritanopes.

A protanope can see no difference between red and blue. He will perceive all hues located on the line joining these two points as appearing identical, as shown in fig. 12B. These connecting lines between hues that cannot be distinguished by color-blind persons are called 'hues of the same type of color'. The various abnormalities of color vision are illustrated in fig. 12B, C and D.

It is an interesting fact that at 8 per cent the proportion of color blindness and defective color vision is extremely high in men; it is no more than 0.4 per cent in women. The reason is that the disposition of defective color vision is inherited recessively and sex-linked as the chart fig. 12E shows. Normal color vision is a property 'programmed' in the two human sex chromosomes. A child will be male when an X and a Y chromosome combine, and female if two X chromosomes combine. The disposition for defective color vision is passed on by the X chromosomes. A mother of whose two X chromosomes only one has the disposition of color blindness, will have normal vision, because this is ensured by the other, undisturbed chromosome. But if the disturbed X chromosome combines with a Y chromosome, the male offspring will inherit color blindness. Color blindness therefore occurs in females only if both X chromosomes are disturbed; always only the lesser disturbance will become effective.

Most persons affected by color blindness or defective color vision suffer from such conditions only in one spectral region. The number of people in which the visual defect is in the short-wave region is small. Occasionally we find color blindness that is caused by the non-function of two types of cone. Total color blindness, however, is extremely rare. Figs. 13, 14 and 15 show test patterns with which color blindness and defective color vision can be easily diagnosed.[5] All three patterns are based on Stilling-Hertel's method.

Figs. 13 and 14 show color blindness or defective color vision between red and green. Those who on chart 13 see an 8 instead of a 3, and on chart 14, 30 instead of CH suffer from defective color vision in this region.

In view of the fact that we find between the totally color-blind and those enjoying normal vision innumerable degrees of defective conditions, we have obviously not yet succeeded in drawing accurate conclusions regarding the precise type and degree of the defect on the basis of optical tests. The main difficulty besetting the establishment of a comprehensive system for the definition of defective color vision seems to the scientist to consist in the absence of a continuous supply of persons afflicted with defective color vision or color blindness available for testing. It is to be hoped that in view of the high quota of 8 per cent of color-blind males a simple system can soon be evolved that yields the desired and necessary knowledge with the aid of visual test patterns.

It seems to be easier to find those color-blind persons whose weakness is in the short-wave, blue region; they cannot distinguish between blue and yellow. Test pattern 15 is used for the diagnosis of minute disturbances of this kind. Those unable to recognize the number 49 have disturbed vision in the blue region of the spectrum.

A farther-reaching qualitative and quantitative diagnosis of defective color vision can be provided only by a specialist who has special optical color-mixing apparatus at his disposal for the examination of his patients. Persons who think they suffer from color blindness and of course all those who want to take up a career in which colors are involved should therefore undergo a thorough test and examination by an ophthalmologist.

Optical illusions

One must not believe everything one sees. Our eyes play us many a trick. The examples in fig. 16 show how we can be deceived.

In fig. 16A the horizontal lines are exactly parallel. Nevertheless they appear curved. We are under the clear impression that the distance between the horizontal lines is

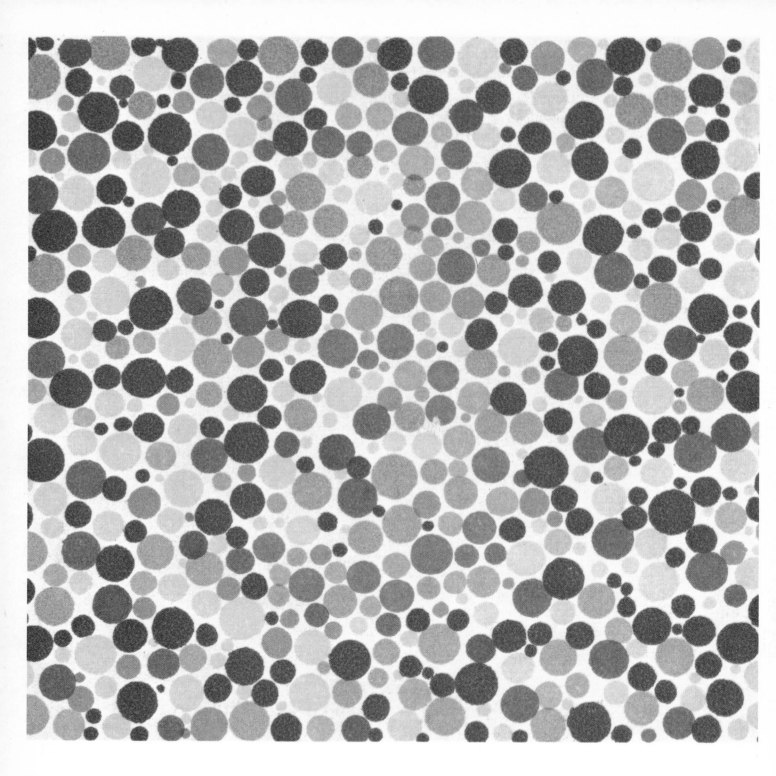

Fig. 13 One of Stilling-Hertel's color charts[5] for the diagnosis of defective color vision in the red-green region. If you read 8 instead of 3, you cannot distinguish between red and green.

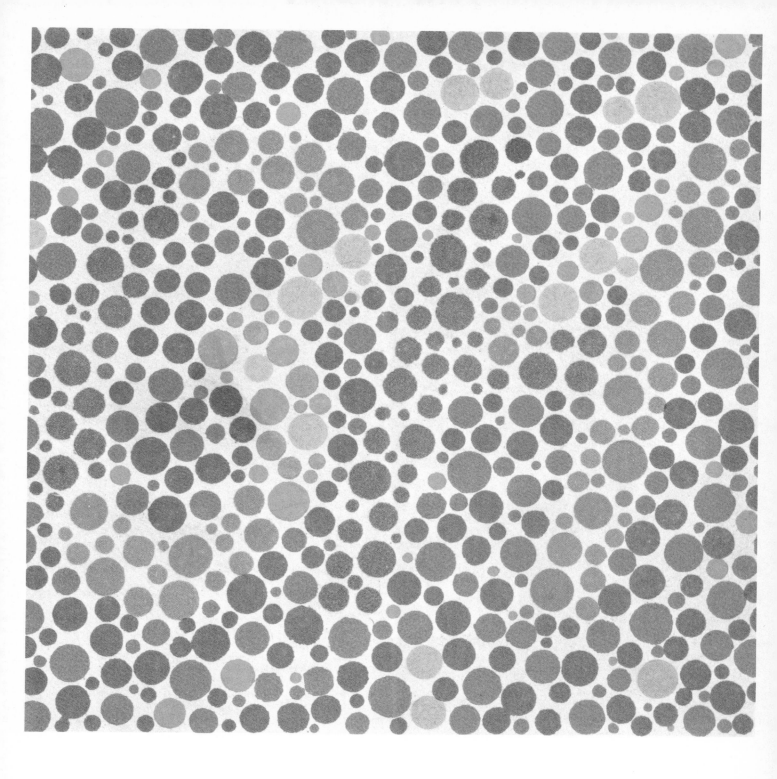

Fig. 14 Test chart for the diagnosis of defective color vision in the red-green region according to Stilling-Hertel's method.

Fig. 15 A person of normal eyesight reads the figure 49 on this chart. If he cannot recognize it, he suffers from a visual disturbance in the blue region. Although he can distinguish between the colors red and green, he cannot distinguish them from blue.

greater in the middle than on either end. Fig. 16B is an example of a picture that one can see as a negative or a positive at will. We either see it as three white steps ascending towards the right, or as the underside of a board cut out in steps, as we wish. In one case the hatched area appears closer than the white background, in the other the same area, this time the background, seems farther away than the white side of the steps in front of us. As we look at it it can happen that the perspective suddenly reverses and just as suddenly changes back again. But it is also possible to see the illustration as a simple plane.

Circular areas are shown in figs. 16C and D. It seems almost unbelievable that the circular areas in the center of (C) and (D) are exactly identical in size. The one surrounded by many small circles appears larger (16D), the one surrounded by larger circles smaller (16C) than it actually is.

We have not yet found a satisfactory explanation for the cause of these quite strange phenomena. We assume that it is an instinctive effort of the visual organ to appraise a total situation instantly, at first glance. This is possible only with the aid of the mind, of memory. It follows that vision is always coupled with instinctive cerebral activity. The information transmitted by the eye is continuously checked by the mind, which automatically, computer-like, looks to its memory for something to compare it with.

To 'recognize' something is therefore possible only if it is already 'known'. This knowledge can in turn be deduced only from past experience. The recollection of this experience is brought to bear by the mind when an object is seen.

The viewer can see fig. 16B three-dimensionally only because he has already an idea of what it represents. If he has never seen steps or a board cut in steps before, he will not recognize these items in such a picture. He cannot remember them. As a result, the representation is bound to appear completely two-dimensional to him. With figs. 16C and D it may be that the two items of information are compared with each other. The statement 'The central area is smaller than the others' is opposed to that 'The central area is larger than the others.' Obviously the intervention of the mind through a kind of wrong circuit creates the mistaken conception that the central area on the left is smaller than that on the right.

It is, however, possible to advance a different explanation of this strange phenomenon of two identical-sized areas appearing to have different sizes. As we shall see in the chapter on simultaneous contrast the eye has the peculiar property of registering color differences to an exaggerated degree. Identical colors can appear quite different in front of different backgrounds. The eye could conceivably function similarly in this case. One could imagine that the visual

organ has the property of instinctively and instantly selecting from a large number of identical objects the one that stands out in some way or other. Perhaps it is a kind of 'contrast enhancement' that induces exaggerated registration of a deviation to distinguish it more clearly.

Adaptation and simultaneous contrast

The range of adaptation of the eye is astonishing. Our eyes are capable of compensating extreme brightness differences. But they do require a certain time to adapt themselves to a new situation. If we enter a dimly lit cellar from bright sunlight we at first see nothing at all. Only gradually does the eye adapt itself to the new lighting condition. This property of the eye is called adaptation.

Complete adaptation of the eye to strong brightness differences may require half a minute or longer, with both eyes reacting quite independently. You can easily check this by exposing one eye to bright light, and screening the other with your hand or by blindfolding it. If you now enter a very dimly lit room the previously protected eye is already adapted and at once affords optimum vision. The other eye, however, needs a certain time to adapt itself. You can also easily observe the process of adaptation if you alternately open or close one eye and the other. A third experiment to observe the adaptation of the eye is if you sit in a moderately lit room at a writing desk with a light gray table top and white writing paper lying on it, the paper will appear white to you. The writing top, which here reflects only about a quarter of the light reflected by the paper, appears gray. If you now switch on a desk lamp that radiates five times as much light on to the desk, the table top will still appear gray and the paper white, although the gray table top now reflects more light into the eye than the white paper did previously. If floodlights were set up around the writing desk for filming, which again radiate many times as much light, the table top would still be perceived as gray and the paper as white. Hence the eye is capable of adapting itself to every situation to perceive brightness differences as clearly as possible.

As we already know, a visual pigment in the eye is decomposed by the action of light and thereby a physiological stimulus is caused. This is transmitted to the brain where a color sensation or a light sensation is produced. Strong light action in time reduces the amount of visual pigment through decomposition, so that only a small residue is exposed to the light. Thus a given quantity of light can no longer decompose the same proportion of the visual pigment after the end of this process of decomposition. Obviously the regeneration of the visual pigment is regulated so that always only as much fresh pigment is produced

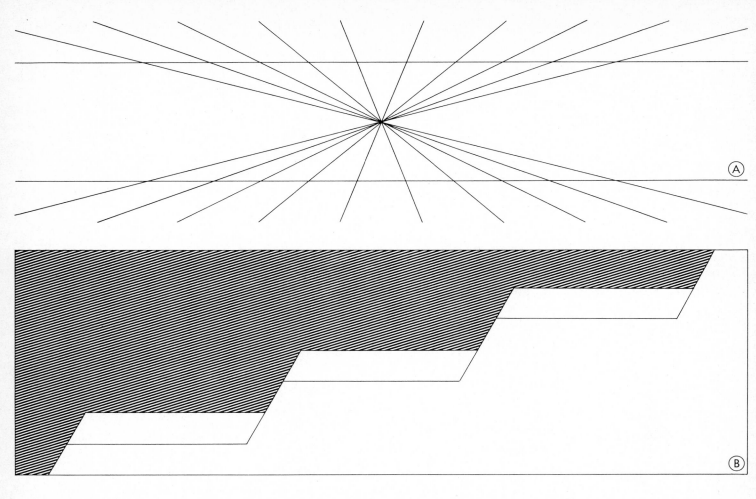

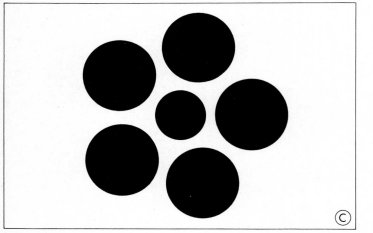

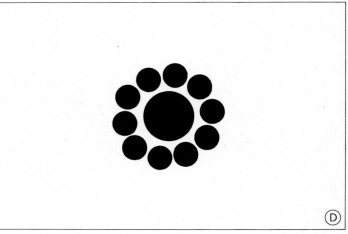

Fig. 16 The horizontal lines (A) are parallel, the central circular areas in (C) and (D) are of equal size. (B) is an example of how the perspective of a picture can suddenly reverse. Alternatively we see white ascending steps or the stepped cut surfaces of a dark board.

as is necessary for generating a roughly uniform degree of physiological stimulus at the lighting conditions prevailing at the moment. What we are faced with here is an automatic control process of the organ enabling it to adapt itself largely to any lighting condition. The time lapse between the first light stimulus and the adjustment of visual pigment regeneration is called the time of adaptation.

The examples mentioned here can be satisfactorily explained with this theory of adaptation of the amount of visual pigment to the general lighting conditions. A direct connection exists between the quantity of the decomposition product and the brightness sensation.

As we have already mentioned the two eyes adapt themselves independently to given lighting conditions. If we light two white areas with light of different intensity and observe one of the two areas with each eye by looking past the right and the left side of a sheet of card, we shall see both areas as equally bright after the end of the adaptation time. We can recognize the difference in brightness only if we see both areas simultaneously with one or both eyes. This perception of the brightness difference is independent of the viewing duration. This leads to the conclusion that within the individual eye the various regions of the retina do not react independently of one another, but are mutually influenced by brightness differences. For if they reacted independently, the brightness differences perceived should be reduced, and finally completely obliterated, within one eye through adaptation.

A contrast control is built into television sets. It is possible to increase the differences between the various tone values by electronic means. The purpose of the contrast control is to produce a clearer picture, to enhance the details. The human eye has a closely similar device, enabling it to see two different adjacent gray values so that the difference is reinforced. The darker tone value is perceived a little darker and the lighter one a little lighter than it really is. This effect can be studied by means of the examples of fig. 17. Two large gray circular areas are seen in the top section of the illustration. Their gray tones are identical. But the light gray looks darker on the white background than on the black.

Here the visual organ has achieved a contrast enhancement that creates the impression of different brightness. The same phenomenon can be seen even more clearly in the bottom section of the illustration. We naturally notice at once that the white bars between the black fields are just as white as the white paper, yet we see gray patches where the bars intersect. The gray disappears only from the area on which we fix our eye, but reappears again on the neighboring intersections.

This phenomenon is obviously derived from the fact that the contrast effect occurs along the boundaries between black and white, but cannot continue across the areas of intersection because here the white area is larger. To all appearances we see the gray patches 'correctly', whereas we have an exaggerated perception of the lighter white bars.

We can explain these phenomena of the achromatic simultaneous contrast also with the theory of the adaptation of the eye to the lighting conditions if we assume that the visual pigment seeks to equalize itself within the retina. It is not used up in the black areas of the image, whereas it is strongly decomposed by the light. This means that the gray area on the black background, fig. 17 top, is registered by an area of the retina in which much more visual pigment is available, because the black background does not lead to decomposition. The quantity of the decomposition product of the equally large and equally light area on this black background can therefore be greater than that of the gray area on the white background. If this is so, we can conclude that the physiological stimulus is correspondingly more intense and greater brightness is simulated.

We can state quite generally that vision involves an exaggeration of brightness differences. A given tone value appears lighter on a dark background, darker on a light one.

But the eye not only adapts itself to different intensities of illumination; it also has the interesting capacity of color assimilation. For it sees a given hue differently at first sight from how it sees it after a period of adaptation. This effect is again easy to observe because here, too, both eyes react independently. If we close one eye and look with the other at a certain intensely colored object such as an orange and compare what we see after a certain time by closing the open eye and opening the closed one, we shall clearly perceive color differences. Klappauf's work[6] shows that a color appears less saturated after assimilation of the eye than before. He also observed that there are only three colors that are not subject to change owing to assimilation if they are allowed to act on the eye for a long time: a certain yellow, a certain green, and a certain blue. According to his observations the assimilation of the eye refers not only to color saturation but also to hue. Hues between red and green are displaced towards constant yellow, those between green and blue towards constant blue.

According to von Studnitz's Theory color assimilation, too, can be explained by the presence of 'visual pigments'. If we postulate that corresponding to the three assumed types of cone three different visual pigments are in action, responding to their own spectral regions, it is possible to define this color assimilation in exactly the same way as adaptation to changed brightness levels. Each of the three different visual pigments adjusts itself to the level of a constant physiological stimulus after the time of assimilation.

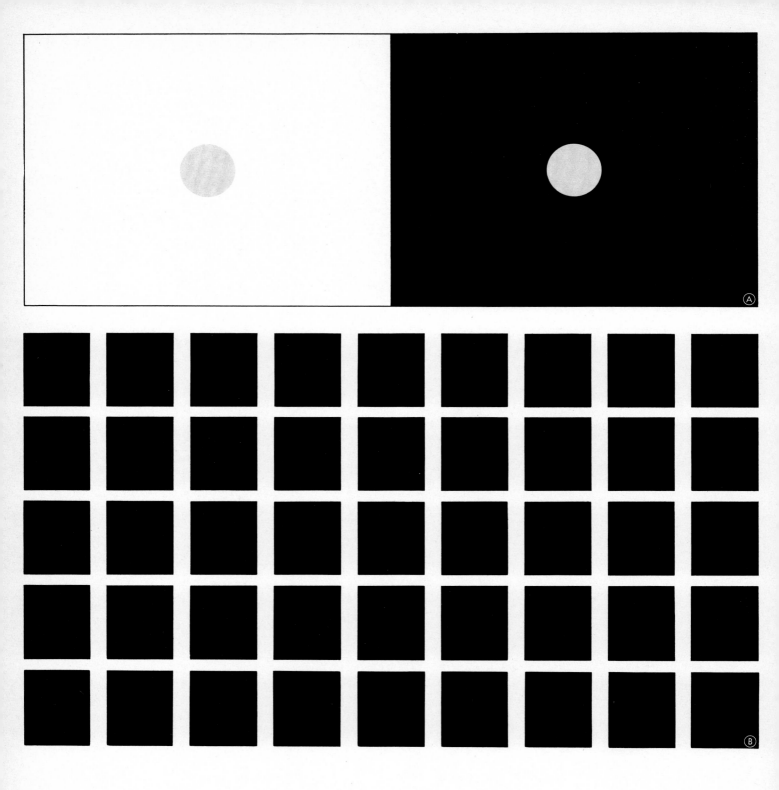

Fig. 17 The eye is also deceived in its perception of brightness. The two gray circular patches in (A) are of equal brightness. Likewise the intersecting white bands in (B) are equally white, although we seem to see gray patches where they intersect. If we fix our eyes on such a patch, it will at once disappear. This phenomenon is called achromatic simultaneous contrast.

Hence color saturation is initially higher because initially more decomposition products are formed.

Color assimilation normally does not often become effective because the eyes rove to and fro and new stimuli reach the same areas of the retina successively. It is true that color assimilation is initiated afresh again and again. But it is immediately interrupted because the color stimuli reaching the retina continuously change.

The eyes adapt themselves not only to the brightness of the light but also to its color. This too, is a process of color assimilation. If we spend some time in a room illuminated by electric light bulbs, we perceive the light as white. Only if we see really white light next to it do we discover the yellow tone of the light from the bulbs. Lit-up windows seen in twilight on a winter's evening often reveal this strong yellow hue.

The eye also becomes quickly used to the tint of yellow snow goggles or greenish sunglasses. After a very short time the wearer is no longer able to recognize any color differences from normal vision. But if he took a color photograph through the glasses, a color cast would at once be evident. If we look through sunglasses with only one eye, alternate opening and closing of both eyes will reveal the great differences in color.

Naturally the adaptation of the visual organ cannot go so far that normal vision would be possible in red darkroom light after an appropriate lapse of time. This light, after all, consists of long-wave rays only. The eye seems to be capable of assimilation only if all spectral regions are represented in the light. Only intensity fluctuations in the spectral composition of the light can obviously be partly compensated. An assimilated eye, however, is by no means able to recognize colors correctly, i.e., objectively. Why this is impossible will be explained in detail in the chapter 'The light spectrum'.

Nor is it without significance for the perception a certain hue creates whether the assimilation of the eye happened to be neutral or the eye had assimilated some color on seeing the hue.

Of particular interest to all who have practical contact with colors is the strange fact that the appearance of hues is subject to considerable changes even in constant conditions of illumination and viewing. For they can be affected by other hues in their neighborhood. This phenomenon, which is called simultaneous color contrast, is illustrated in fig. 18. In the adjacent color samples the horizontal bar always has exactly the same hue. The appearance is affected and falsified only by the different backgrounds. We can easily confirm this by covering the backgrounds with a mask so that only the central horizontal bars remain visible.

Simultaneous color contrast occurs mainly with light hues. It depends on the size of the colored areas. The smaller they are, the more pronounced the phenomenon. Hues in front of a neutral background will appear more strongly colored than they really are, and more neutral in front of a strongly colored background. They will look lighter in front of dark backgrounds than in front of light ones. But there is also a shift in the color tone. Thus a dull blue tone will appear more bluish in front of a green background and more greenish in front of a dark blue one, as can be seen in the example fig. 18 top. In the example in the center, the central bar appears more greenish in front of the yellow background on the left and more yellowish in front of the blue background on the right. The example in fig. 18 bottom shows a shift towards red in front of the dark green background compared with the section on the left. The simultaneous color contrast of the examples of fig. 18 is seen most clearly if a strip of paper of about 1cm (0.4in) width is placed vertically over the color patterns so that the boundaries with the background colors are covered.

Simultaneous color contrast can be explained with the theory of the three visual pigments in the same way as has already been done for color assimilation. If regeneration of the three visual pigments occurs independently, the 'normal levels' of the three different types of cone can well differ from one another. A green patch on a red background would therefore appear more saturated, because for the green spectral region visual pigment is decomposed only in this area. The entire red background must, after all, act like black on the green visual pigment, because it cannot trigger any reaction at all. The process would be the same as during the creation of the gray patches in the intersections of the white bars in fig. 17, and the same explanation would apply that (also in fig. 17) makes the two gray areas appear at different brightness.

To conclude this chapter mention must be made of the existence of 'persistence of vision'. Here we speak of 'successive contrast'. If we look suddenly into bright light the image is, as it were, imprinted on the retina, and in certain circumstances it may be minutes before normal conditions are restored. Strangely, persistent vision may also become negative. If we look at a window frame in strong back light and from there shift the glance to a white wall, we shall see a bright cross between dark window panes. We can experience this reversal of persistent images also when we first look at a strong lighting contrast and then close our eyes.

Persistent images may also be in color, in fact they may even appear in the complementaries of the colors actually seen. But the ability to see such complementary-colored persistent images varies very widely between one person and the next. Those who come into daily contact with colors

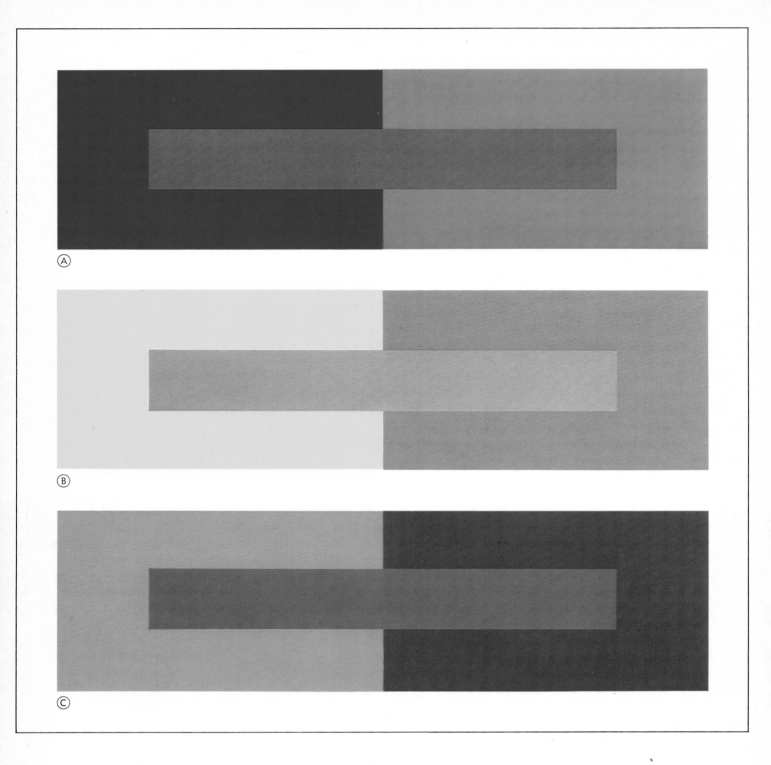

Fig. 18 If the appearance of colors is influenced by other colors surrounding them, we speak of simultaneous color contrast. Each of the three horizontal central bars has the same color throughout its length (cut out the pattern to confirm). The color impression is altered by the color of the background.

in the course of their work find it perhaps more difficult to see persistent images in color than those who approach these phenomena without preconceived ideas. In addition it would seem that persistent colored images are perceived the more readily and frequently the greater the strain on the nervous system of the observer. In a well-rested and balanced state it is often difficult to discover this effect at all.

Persistent vision can be explained as follows: great brightness and color differences produce an optimum quantity of decomposition product in certain areas of the retina. For instance, if we shift our glance from the bright window to a wall those parts of the retina that had previously been inactive because of the shadow of the window frame are stimulated. Here decomposition and therefore the sensation of brightness occurs. The areas of the window panes were previously much brighter. But the wall reflects considerably less light. In these areas the retina at first ceases to form the decomposition product. The window panes therefore appear dark on the wall, but the window frame appears bright as a persistent image. It fades away only after the control mechanism has become adjusted to the new situation.

Physical and technical section

The family of electromagnetic vibrations

Light rays are a form of energy. From the point of view of physics they belong to the large family of electromagnetic vibrations, differing only in their wavelengths.

The wavelength is the distance from one wave crest to the next.

Wavelengths can measure some thousands of kilometers, or only a fraction of one millionth of a millimeter, and their range extends across a continuous scale of electromagnetic vibrations of all wavelengths, called wave scale. This is shown in fig. 19. The representation begins on the left with an atomic bomb explosion, which liberates such short-wave rays that persons exposed to them are killed. On the scale, which progresses horizontally through the picture, the order of magnitude of the wavelengths is marked in units of 10^3.

Cosmic rays have the shortest wavelengths, of the order of 10^{-12}mm. Gamma rays are in the region of 10^{-9}mm, X rays 10^{-9}m, a unit called nanometer (nm). X rays merge into the range of ultra-violet and then of visible light, which is found on the wave scale between about 380 and 720nm. This is followed by the infra-red region; beyond this electromagnetic vibrations of the order of 1mm manifest themselves in the form of heat rays.

Television operates on wavelengths of 1m, radio on 1km, finally, electric current has a wavelength of 1000km.

It is very strange that man and the animals have a sense organ, the eye, with which they can receive, from this large variety of electromagnetic vibrations, a very closely defined range and convert its vibrations into sensations of light and experience of color. The eye collects these radiations of the magnitude for which it is designed. We already know this radiation that enters the eye as color stimulus. The sense of vision is the result of the physiological process in the eye.

The wave scale illustrates how the visible radiations disappear into the ultra-violet region in one and into the infra-red region in the other direction, becoming invisible (see also fig. 11A). It is the invisible ultra-violet radiation that is responsible for burning skin too long exposed to intense sunlight. The long-wave, infra-red region on the other side of the spectrum includes a zone in which we perceive its radiation both as light and as heat. All electromagnetic vibrations, including the visible rays between 380 and 720nm, are systematically arranged on the wave scale in the order of wavelengths. The sequence of the visible rays is at the same time one of 'hue'; it is also called spectrum.

The light spectrum

White light is not a homogeneous phenomenon. It does not consist of a large number of identical white light rays. It is in fact composed of electromagnetic vibrations of the most varied wavelengths. We have already seen this in fig. 19. We have also learned that visible electromagnetic radiation of different wavelengths is registered by the eye as different colors.

The wide range of all the colors man can perceive is contained in white light, sunlight. But we see colors, instead of the entire white light, only if part of it enters our eyes. The colors contained in a white light ray can be rendered visible by a simple experiment. If you are the owner of a 35mm projector, prepare a transparency frame so that only a slit of about 1mm width remains open. Insert the slide into the projector, and critically focus the edges of the slit on the projection screen. Introduce a glass prism upright into the light beam: the light ray is now dispersed, and a spectrum produced. Move the prism backwards and forwards or rotate it to obtain the optimum colors of the spectrum. Fig. 20 clearly shows the sequence of colors, which is the same as in a rainbow. First of all the three prominent regions of blue, green, and red strike the eye. If the light of the projector is yellowish, the blue range may be only dimly visible, because this type of light is relatively weak in the short-wave region. Yellow appears between red and green, and cyan between green and blue.

All colors of the spectrum merge gradually without a break into one another, beginning at one end with violet, running through blue, cyan, blue-green, green, yellow-green, yellow, yellow-orange, orange, and ending in red.

It is not common practice to enumerate all transitional colors when the colors of the spectrum are listed. We usually restrict ourselves to the five most important ones: blue, cyan, green, yellow, and red.

If we isolate electromagnetic vibrations of only a single wavelength, i.e., a single color, from a spectrum we speak of a monochromatic color. This can be isolated from the spectrum only with the aid of suitable physical phenomena,

Fig. 19 Electromagnetic vibrations (radiations) differ from one another in their wavelengths (frequencies). Gamma and alpha rays (A), X rays (B), light (C), heat (D), television (E), radio (F), electric current (G).

such as birefringence (double monochromator). Colors do not naturally occur in such purity.

Not only the constituent colors of white light, but obviously also those of colored light can be made visible by means of the spectrum. In the dispersion of green light, for instance, we shall discover that here only the middle region of the spectrum is present, but the entire short-wave and long-wave regions are missing from the radiation.

Every substance begins to glow, i.e., to emit visible radiation, when it is heated to a certain degree. We speak of 'spectrum analysis' when we produce a spectrum of such radiations for the purpose of finding the atomic composition of the substance to be examined.

The production of the spectrum during the experiment just described is explained by the fact that rays of different wavelengths have different refractive indices. During transition from one medium to another the direction of the rays changes more or less, depending on their wavelength. Since the long-wave rays are deflected least, the short-wave ones most, from their original direction, all monochromatic colors in the spectrum are arranged in the order of their wavelengths.

The keen observer looking at fig. 20 will of course at once ask why the color magenta (also called purple) is missing from the spectrum. He will be puzzled because he assumes that this color is of the same importance as the others. This assumption is quite correct. The value of magenta is in fact equal to that of red, yellow, green, cyan and blue. But it is not part of the spectrum because it is not a monochromatic color; it is produced when the red and blue regions of the spectrum are superimposed. We shall explain this in detail later.

Emission and reflectance curves

Everybody knows from daily experience that the quality of light varies widely. What woman does not know that the color of a fabric appears different depending on whether she sees it in artificial light or in daylight. She therefore will, if she wants to make quite certain of the color of some material she intends to buy, take the fabric to the window or even out into the street. Only then will she be satisfied to have seen its true colors.

The reason for this different appearance of, for example, a piece of fabric in different light is the 'color' of the light. Light can be composed of the visible radiations of the spectrum in all proportions imaginable. If certain regions of the spectrum are absent from a light, they can, obviously, not be reflected. This is the reason why one and the same material can appear quite differently in different light.

To understand the laws of color and solve the riddles color poses us we must first study the nature of light. What is white light? When is it white, when colored? A large number of questions arise, calling for an answer all at the same time.

Let us begin with the fundamental statement: light is white when all visible radiations are present at equal intensity.

The color of a light therefore depends on its spectral composition, i.e., the spectral distribution of the visible electromagnetic vibrations.

To obtain clear information about the spectral composition of a light, the various spectral regions must be measured with suitable instruments, and their intensities determined. The procedure involves the measurement of the intensity of the various wavelengths of the spectrum at certain intervals, e.g. of 10nm. The values thus obtained can be entered in a coordinate system. When the coordinate points are connected, a curve is obtained which we call a spectral or emission curve (see fig. 21). All wavelengths of visible light are entered on the abscissa (the horizontal line); conventionally the wavelengths increase from left to right. The relevant range of the spectrum extends from 380 to 680nm. Beyond 680nm the hue of the radiation no longer changes. Obviously this transition region to heat radiation is of no importance in color vision.

The relative intensity is entered on the ordinate (vertical). Relative because the sole aim is to indicate the mixture ratio of the visible rays within the given circumstances. This, of course, always remains the same independently of the intensity of the light. The relative intensity of 100 per cent on such a spectral curve in a given light therefore shows the wavelengths of the highest intensity of radiation. All the weaker radiations will then have a certain intensity ratio to it.

Such emission curves offer the only possibility of clearly determining the 'quality', i.e., the spectral composition, of the light.

The curve in fig. 21A shows the radiation composition of the yellowish light usually emitted by weak electric light bulbs. It is called a 'warm' light in contrast with the cold light of the 'daylight fluorescent lamps' shown in fig. 21B.

When we look at the spectral curve in fig. 21A, we notice that the intensities of this kind of light in the medium- and long-wave regions are very much higher than in the short-wave. The yellowish light lacks the component of the blue region.

Fig. 21B shows that the so-called 'daylight lamps' are often far from producing really 'white' light, which is truly astonishing. Here, too, we find different intensity distributions. The characteristic features of these emission curves are the 'spikes' — spectral regions which stand out from the

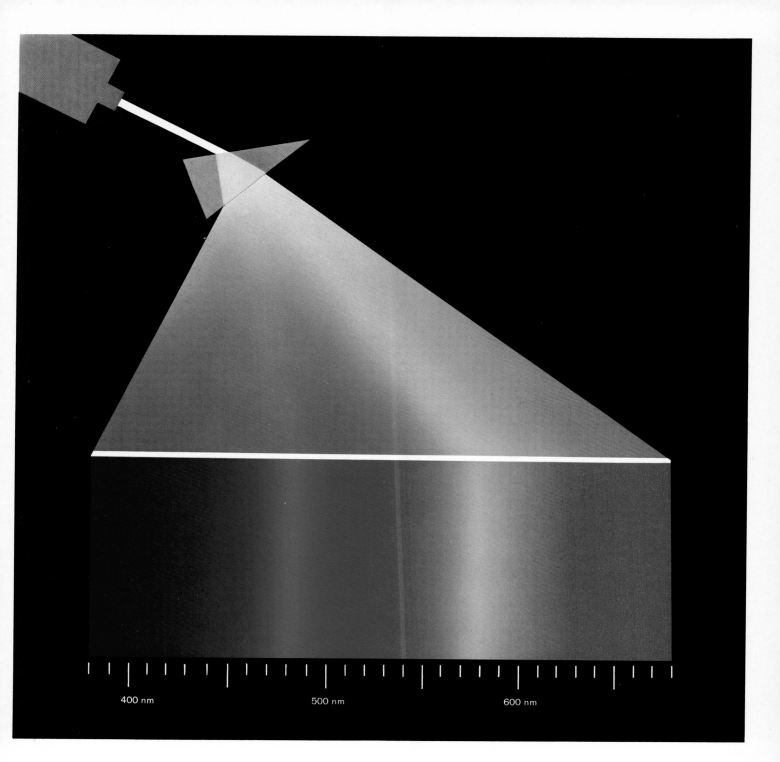

400 nm 500 nm 600 nm

Fig. 20 When a white light ray is refracted by a glass prism, it is dispersed into its colored components. The colors of the spectral regions are: blue, cyan, green, yellow, red.

rest of the curve through their increased intensity. They are caused by the specific properties of the gases used in the fluorescent lamps.

Nor is daylight always 'white'. It can be white, but it is clearly not in fig. 21C, which shows the emission curve of noon daylight at the height of summer. In daylight, too, the ratios of the spectral regions change. Depending on the position of the sun in the sky, whether the day is foggy, rainy, hazy, or clear, the mixture of the wavelengths making up daylight will vary widely. In the example in fig. 21C the short-wave region is predominant. In addition to the un-favorable cast of the shadows with the sun vertically over-head, the large proportion of short-wave radiation is re-sponsible for the reluctance of color photographers to work in these lighting conditions. The pictures suffer from blue cast and appear cold.

Fig. 21D shows the opposite extreme possibility of day-light. Here the long-wave portion of the electromagnetic vibrations predominates. When on a dry summer's day the sun sinks below the horizon as a red disc, the light reaching us is mainly long-wave, because a large part of the short-wave light is absorbed by dust particles in the atmosphere. This kind of sunlight produces the magic Alpine glow in the mountains. The reddish light is reflected by the white snow-fields.

The more oblique the incident light, the 'warmer' its color. Color photographs are most effective when they are taken in the early hours of the morning or just before sunset, because during these periods the daylight consists mainly of long-wave radiation. The rendering of the hues in the red, yellow, and green region is therefore warm and luminous.

All these manifestations show clearly that not even the quality of daylight is constant, but that its spectral com-position changes continually. There are, however, situations in industry and commerce which simply demand optimum, constant light. It may be essential in all production plants using colors, for instance in dye factories, printing works and dye works. Here the already mentioned 'color analysis lamps' are used, which emit a light of balanced spectral distribution. The intensities of the various visible rays should be as nearly equal as possible.

Fig. 21E shows the spectral curve of xenon light. This is used, for instance, in process work for the production of color separation negatives. It can be seen that this light is of excellent quality because it approximates a balanced spec-trum of equal energy very closely. In fig. 21F the spectral composition of the light of a color analysis lamp is shown. In some such lamps different types of light are mixed with one another to meet the theoretical requirements.

We have already learned that a considerable difference exists between light color and body color. The former is the composition of light of various visible radiations. The latter is the property of a substance of absorbing a certain part of the incident (or transmitted) light and of reflecting (or transmitting) the rest.

The reflected part is the color stimulus, which triggers in the viewer's eye that physiological stimulus which is passed on to the brain and there converted into a color perception.

Naturally the electromagnetic vibrations which produce our perception of color are the same whether they are caused by light colors or body colors, except that the former enter our eyes directly and the latter only after reflection or transmission by a substance.

In exactly the same way as we can represent the com-position of light by spectral curves, we can plot curves of the composition of radiation reflected by a substance, i.e. of body colors. They are called reflectance curves.

These curves are constructed exactly like the emission curves: the wavelengths of the monochromatic colors are entered along the abscissa, the relative intensities of the radiations along the ordinate. But whereas with light colors always the strongest vibrations present in the light to be analyzed are equated with 100 per cent, on reflectance curves of body colors, 100 per cent refers to the intensity of the light incident on the body. The reflectance curve thus indicates for every wavelength the proportion reflected by the relevant monochromatic color contained in the white light.

If a substance reflects all visible radiation at full intensity we call it white. If all the radiation is equally reflected not at full, but only, for instance, half intensity, we see it as gray or achromatic. If no rays at all are reflected the substance will appear black.

Neither pure white nor pure black, however, occur naturally. The best white is produced with barium sulphate, a powder that, compacted, is used as a white standard in measuring instruments. High-quality art paper, too, has ex-cellent reflectance, sometimes of more than 90 per cent. The best black can be made 'visible' in a hollow sphere completely lined with black velvet; a small hole in the shell will in fact look so black that it cannot look 'blacker', be-cause any reflection of rays is prevented by the internal curvature of the sphere. Diffuse light entering the sphere is not reflected outside again. Quotation marks were used with the word 'visible' because black can really not be seen at all. We can read black print on white paper because we see not the black letters, but the white background. If the background, too, were black we would not be able to distinguish them. No area of the retina would be stimulated; hence no visual process could take place.

Ideal white on the reflectance graph would be represented

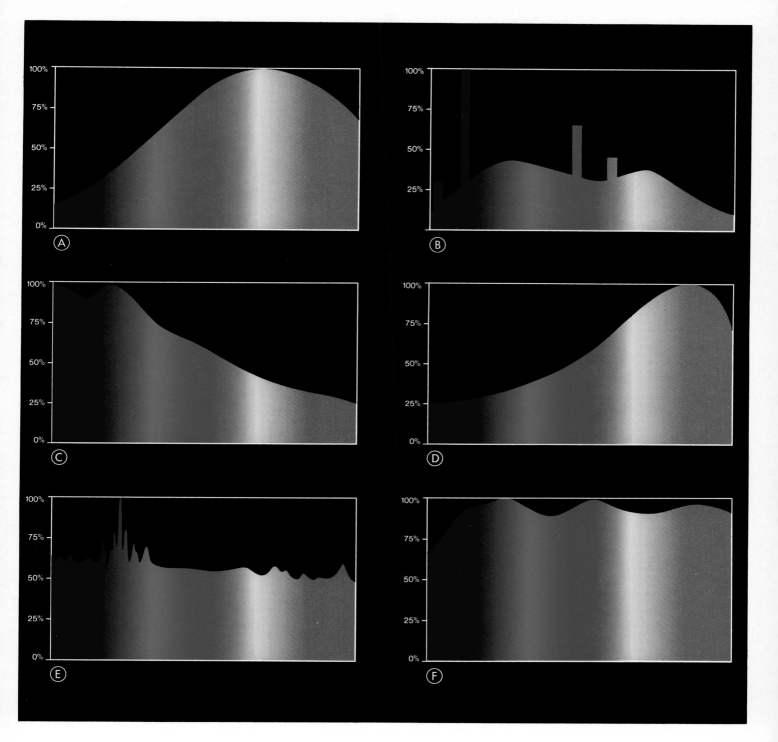

Fig. 21 Emission curves: yellowish light of a tungsten filament lamp (A), daylight fluorescent lamp (B), natural summer noon daylight (C), sunset daylight (D), xenon light (E), and color analysis lamp (F).

by the entire area of the coordinate system. The curve would progress as a straight line parallel to the abscissa through the 100 per cent mark of the intensity scale. With black, on the other hand, curve and abscissa would coincide and pass through the 0 per cent intensity mark. A light gray is represented by a horizontal straight line at the 66 per cent, medium gray at the 50 per cent, and dark gray at the 33 per cent mark (fig. 33B).

Between white and black, i.e., the horizontals passing through the 100 per cent and the 0 per cent marks respectively of the radiation intensity, we find all the countless possibilities of color vision. Every hue of light and matter can be clearly defined with the aid of emission and reflectance curves. The possible appearance of the emission curve of a green light is shown in fig. 22A, that of the reflectance curve of an orange body color in fig. 22B.

We want to demonstrate how body colors and light colors interact with the aid of the following four reflectance curves of fig. 22. A violet body color is seen in 22C. A yellowish light is available in 22D. Fig. 22E shows the range of the body color that can be seen correctly in the ambient light. Fig. 22F, on the other hand, reveals the other range of the body color, which cannot be perceived because the available yellow light does not include sufficient short-wave rays to make the reflection fully visible.

A body color can be accurately perceived only if light of a spectrum of equal energy is available, because this is the only guarantee that the reflectance of the substance is fully effective.

Metameric colors

We have learned that emission and reflectance curves are capable of accurately showing the spectral composition of light colors and of body colors. But certain colored lights as well as colored substances appear identical in certain conditions, although their emission or reflectance curves may differ very widely. Such colors of identical appearance but of different spectral composition are called metameric colors. They are conditionally the same, for instance when seen in certain lighting conditions.

On the other hand, some colors are unconditionally identical. Their reflectance curves must be identical (except perhaps for a permissible tolerance). Only thus can they always appear identical even in changing lighting conditions.

The illustrations in figs. 23A to 23D show four different spectral compositions of colored lights of like appearance. Fig. 23A represents monochromatic yellow-green light. In fig. 23B the color of the light is the same, but the spectral distribution is broad and continuous.

Fig. 23C demonstrates how the same yellow-green hue can be made up of a monochromatic cyan and a monochromatic yellow light; the intensity of the yellow is greater than that of the cyan light. Lastly, fig. 23D shows how yet another seemingly identical colored light is created by a mixture of wavelengths of the red and the green regions; here, the intensity of the green is greater than that of the red light. This must naturally be so, for if the two intensities were equal, the result would not be yellow-green, but yellow light.

The reflectance curves figs. 23E and F represent two conditionally identical colors. It is easy to imagine the difficulties involved in drawing accurate conclusions about the appearance of a certain color merely from looking at a reflectance curve. But an approximate deduction is possible. Thus, the color of 23E is in the magenta, that of 23F in the green region.

The special importance of the metameric colors, which consists in the fact that they look exactly alike in a certain kind of light, but may look completely different in another, has already been touched upon at the beginning of this chapter.

Let us explain this with an example from everyday life. A man wants to buy a pair of leather gloves exactly matching a brown hat. He walks into a store and chooses his gloves. To see the colors precisely he steps outside the store entrance, and really finds among the many hues of different gloves a brown that in his opinion precisely matches the color of his hat. While he is standing in the street making his choice the sun is shining. Pleased with himself he arrives at home in the evening showing his wife how lucky he was finding gloves of just the right color. Meanwhile it has started to rain. He unwraps his gloves and notes with dismay that the two colors, which previously had looked alike, now differ strongly from each other.

The two colors are metameric and look alike in sunlight. But since by now the spectral composition of the daylight has changed considerably, they no longer do so. The difference can be so great that somebody who knows nothing about this phenomenon could assume that the sales clerk had sold him the wrong pair of gloves.

This simple example shows that body colors are always relative, that their appearance always depends on the composition of the ambient light.

In technology, too, the problem of metameric colors can assume great importance. Primary printing inks, for instance, may appear exactly alike, but if made of different pigments they will have different reflectance curves. As a result, mixtures of equal proportions may look quite different. Any interchange of color scales in the printing industry is there-

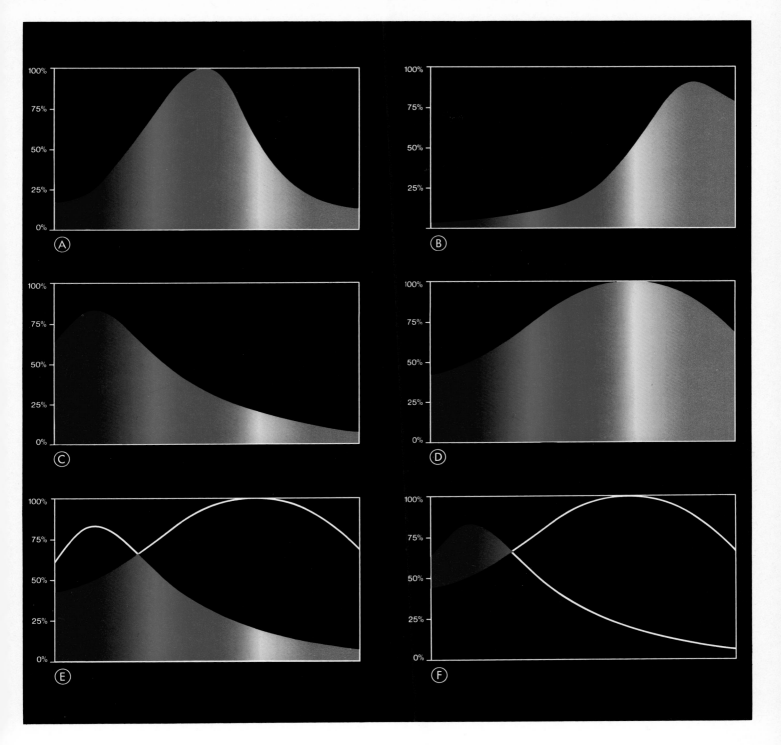

Fig. 22 Emission curve of a green light (A), and reflectance curve of a red body color (B). Both curves are color stimulus functions. If we view a violet body color (C) in yellow light (D), only part (E) of the reflectance capacity can be recognized. Part (F) cannot be perceived (rough simplification).

fore possible only if the various primary inks made by the various manufacturers have reflectance curves restricted to a certain tolerance range. The interchangeability of primary inks is assured by the manufacturers in that the first-order mixed inks are also covered by the standard specifications. The problem is basically the same in all fields of industry, whether in the manufacture of varnish, in textile printing, or in film manufacture.

Spectrum analysis and color temperature

Electromagnetic radiation, seen from the angle of classical physics, is generally interpreted as wave motion, or vibrations. It was Max Planck who showed that electromagnetic vibrations can also be regarded as a sum of ultra-small particles. As matter is composed of ultra-small 'building bricks', of protons, neutrons, and electrons, so energy, too, consists of ultra-small particles; these are called energy quanta or photons, and are the more effective and energy-rich, the shorter-wave the radiation.

When white light is incident on a substance, part of it, as we have already seen, is absorbed, and another part, the one we see as color, reflected. When a substance absorbs light its molecules absorb energy quanta, which amplify the natural vibration of the molecules. Incidentally, the same happens when a substance is heated. The only difference is that during heating the electromagnetic vibrations or quanta are invisible, whereas they are visible in illumination.

The more strongly a substance is heated, the more violent become the natural vibrations of its molecules. Above a certain temperature the substance in turn begins to emit energy quanta. This state can be either glowing or in combustion. We speak of glowing if the substance reverts to its original state as soon as the energy supply ceases; but it is quite possible that the molecular structure has undergone some change during this process. We speak of combustion, on the other hand, if a chain reaction is set up in which the substance destroys itself with corresponding energy release.

This visible radiation of glowing or burning matter can of course be dispersed into a spectrum (this has already been briefly explained). This is obvious, because all light is radiation of surplus energy by some substance.

The analysis of energy radiations coming from a substance is called, as we already know, spectrum analysis. In principle every emission curve of light is naturally also a spectrum analysis of the relevant substance. And as one can clearly define the composition and thereby the appearance of a given radiation with the aid of the emission curves (see fig. 21), accurate deductions can also be made from spectrum analysis about the substance emitting the radiation.

For every substance has its characteristic spectrum, which may be continuous, but can also be a band spectrum. In a continuous spectrum the entire radiation present covers a continuous range on the coordinate system. Band spectra are discontinuous as in the examples in figs. 23C and D.

Among the wide range of possible sources of radiation the 'black body' occupies a special position. As we have already mentioned in the chapter 'Emission and reflectance curves' it is, in a suitable experimental set-up, impossible for diffuse incident light entering a hollow sphere, e.g. of earthenware, through a hole in its wall, to be reflected by the interior. Any radiation emerging from this hole is therefore the characteristic radiation of the substance inside. In the cold state the hole in the black body appears black, since no visible electromagnetic vibrations pass through it at all. If the substance is now continuously heated it begins to glow at a certain temperature. It emits visible electromagnetic vibrations. In this experiment only those rays are measured that emerge from the hole in the hollow sphere. The temperature of the black body is stated in '°Kelvin', with the Kelvin graduation corresponding to that of the Centigrade scale. The only difference consists in the starting point, which on the Kelvin scale is −273°C, the absolute zero. Hence all temperatures measured in Centigrade are 273°C 'lower' than on the Kelvin scale.

Fig. 24 shows how the spectral composition of the emitted light changes. It will be seen that at 1000°K visible radiation mainly of the long-wave region of the spectrum is produced. The color of the light is red. At 2000°K the spectral composition shifts towards the short-wave region.

As the temperature rises further the emission curve flattens out, approximating the horizontal at 5000°K. If the temperature exceeds this range the proportion of the short-wave radiation steadily increases until at color temperatures between 7000 and 10,000°K the short-wave rays considerably predominate. The color of the light, which has shifted from red through yellow to white, now moves towards blue.

It is usual to indicate the quality of types of light in terms of their color temperature. As we have already mentioned, the Kelvin degrees represent the heating of the black body necessary to produce light of a given appearance.

We must, however, be very careful here: what we are dealing with is merely an optical comparison. The radiation of the black body at this temperature and that of some other light look alight; but the spectral composition has been ignored. It is therefore not unlikely that although a given light has the optimum color temperature value, the intensity of some of its spectral regions may be deficient.

Fig. 24 demonstrates that a color temperature of about 5000°K most closely approximates the equal-energy spec-

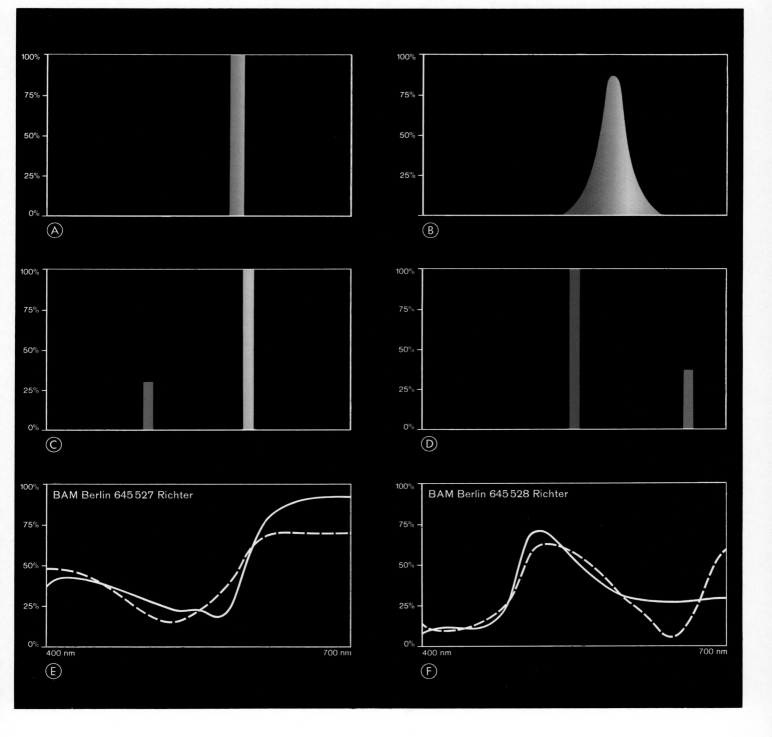

Fig. 23 Metameric colors produce the same color perception although their spectral compositions (A–D) are different. (E) and (F) are reflectance curves of two metameric colors each.

trum, i.e., the spectrum which contains all visible radiations at equal energy. Efforts are therefore being made to standardize types of light described as daylight at a temperature of 5000°K.

Color temperature can be measured with handy and inexpensive instruments, that establish the ratio of the short-wave to the long-wave radiations in the light to be examined. These small instruments are particularly important in color photography, since pictures free from color cast can be obtained without filter only when the color temperature of the light matches the sensitization of the exposure material. Some films are balanced for daylight (daylight films), others, the artificial-light films, for the much lower color temperatures of artificial light.

Fig. 25 illustrates the possible change of colors viewed in different light. Large-format sheets of colored card were used in the experiment. The left of each card was illuminated with a 'daylight' of 6800°K, the right with light resembling halfwatt light of 2800°K. A vertical partition was set up between the two areas to prevent the two types of light from intermingling.

It is striking to see how radically the colors have changed. A light blue for instance can no longer be perceived as a chromatic hue if it is illuminated with a light of low Kelvin value. It appears gray. On the other hand, colors in the red and green regions appear more luminous and intense than they really are.

Polarization and interference

We must think of light waves in terms of an extended coil spring continuously rotating around its axis. The wavelength is represented by the distance between one turn of the spiral and the next.

Since light (the photons) travels always at constant speed, the imaginary coil must rotate very much faster if its turns are narrow (short waves) than if they are wide (long waves). The 'frequency' of a radiation is the number of wave crests passing a certain point within one second. The motion of the light waves is three-dimensional.

Let us imagine a rope fastened at one end to a fixed hook. Let us carry out absolutely regular, circular motions with the free end of the rope under a certain tension. After a certain time the rope will perform spiral motions; here again we have a model of the vibration of light. If we now set up two parallel poles on either side of the middle of the rope and decrease their distance so that the gap between them is only slightly wider than the rope is thick, the three-dimensional vibration will be transformed into a two-dimensional wave motion. Beyond the poles the rope will perform only a wavelike up-and-down motion.

In the arrangement just described the direction of the rope, which up to now had been at an angle of 90° to the slit, can be rotated to the right and left. Naturally, even now the three-dimensional motion of the rope will be transformed into a two-dimensional up-and-down motion beyond the slit. But the transmission direction through the slit has changed.

We must now imagine that the poles have been replaced in their positions by two sheets of hardboard. The distance between these sheets is not much greater than the thickness of the rope. No matter how we now change the starting point of the vibrations at one end of the rope, all vibrations performed by the rope beyond the slit will be in the same direction. This phenomenon applied to light radiation is called polarization.

Vibrations arriving from the left or right, too, could be transmitted wholly or in part through the gap between the two poles. We could compare this with the beam of a pocket flashlight shone through a gap in a door; it can be turned to the left or right and the room thus lit up in various directions. This is, however, no longer possible if the gap is between two planes. Only rays coming directly from the front, i.e., vertically incident, are transmitted.

Certain crystals have the property of polarizing light passing through them. Owing to a special arrangement of the molecules the light is transmitted only in a certain narrowly defined direction. Polarizing filters are today mass produced of glass or plastics. Plastics seem to be the cheapest material; it is eminently suitable also because it can be mechanically stretched before it solidifies; this ensures a very regular lattice arrangement of the molecules.

If two polarizing filters are set up in line so that they transmit in the same direction, the polarized light emerging from the first filter will also pass through the second without obstruction (these considerations take no account of absorption and of specular reflection from the surfaces). The result is the same as if the first filter were twice as thick. But if we rotate the second filter round its central axis, the transmission of the polarized light will be progressively reduced the more the rotation approaches the angle of 90° to the transmission direction of the first filter. At 90°, depending on the material and type of filter, only very little, if any, light will be transmitted.

Fig. 26 shows transilluminated polarizing plastic foils. Strips of polarizing foil are placed on a large sheet of the same foil. The transmission direction of strip A is the same as that of the large foil. With strip B the transmission direction has been slightly rotated. A gray tone is produced, because a little less light is transmitted. The rotation is progressively increased with strips C, D, and E until with strip F an angle position of 90° to the transmission direction of the large

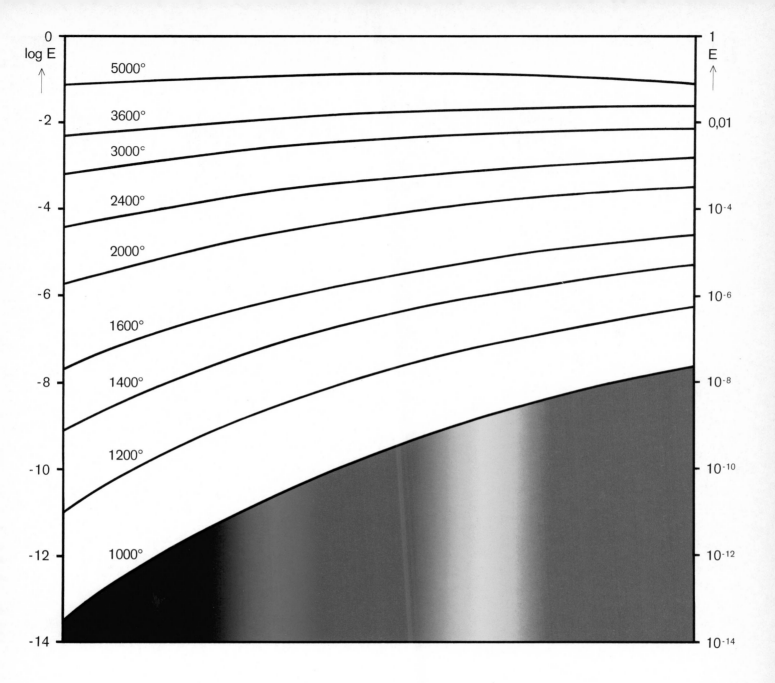

Fig. 24 A spherical, earthenware, hollow body (black radiator) emits light rays through an aperture. The more the body is heated, the higher its color temperature. At low color temperatures the long-wave portion of the spectrum predominates. At about 5000°K the spectrum is balanced. If the color temperature rises beyond this figure, the short-wave part in the spectral composition will predominate.

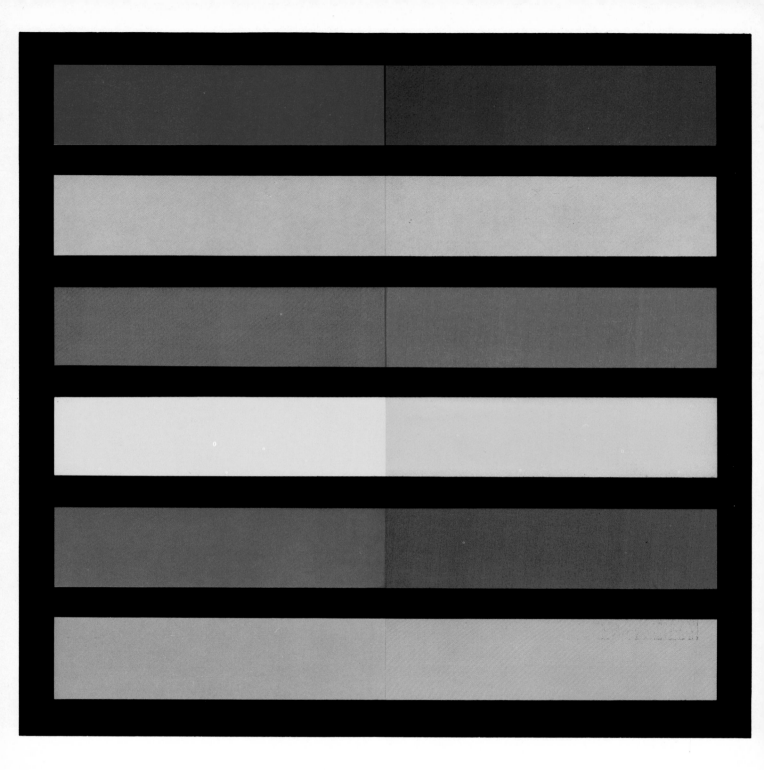

Fig. 25 The body colors in daylight of 6800°K (left half
of the horizontal bars) appear quite different when seen
in tungsten filament (halfwatt) light at 2800°K (right half
of the horizontal bars).

Fig. 26 If polarizing filters are superimposed at the same transmission direction (A), light passes the single and double filter layer in the same way. The more the transmission directions are rotated against each other (B–E) the less light is transmitted, with minimum transmission at 90° (F).

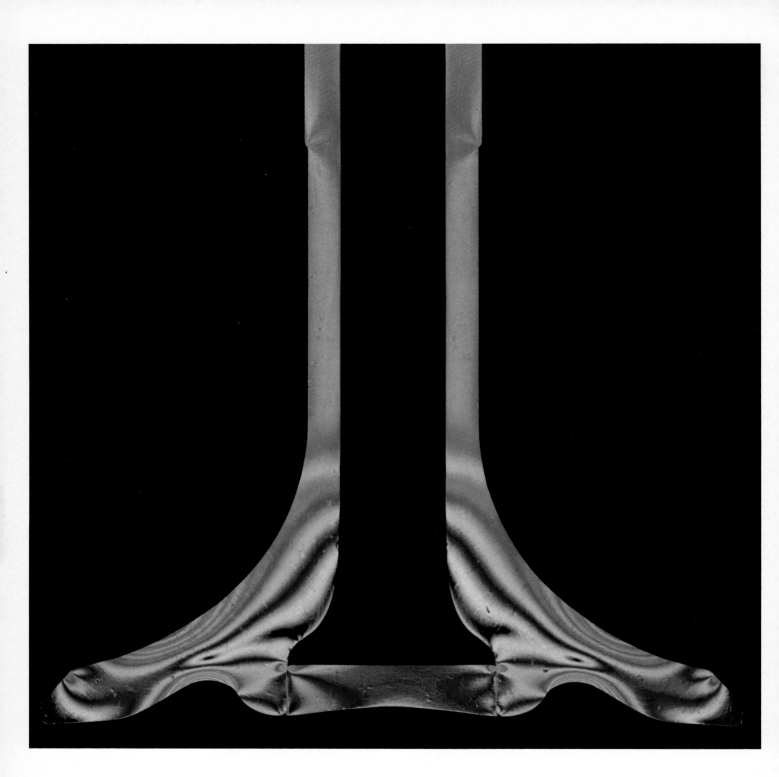

Fig. 27 Photograph of a piston in polarized light. The colored bands reveal pressure differences in the piston chamber. Stress differences occurring in certain bodies, too, can thus be made visible in transparent material.

Fig. 28 A stone was thrown into the water (top right). The waves move away in concentric circles. They move round the corners of an obstacle, becoming superimposed behind it. Where wave crest meets wave crest the motion is added together. Where wave crest meets wave trough it is extinguished.

foil has been reached. Now hardly any light can pass through the area where the two foils are superimposed. That part of the strips not superimposed on the first foil is unaffected in its brightness, as it always transmits the same amount of light.

The polarization of electromagnetic vibrations is of considerable importance in the technological field. The photographer can easily and elegantly eliminate undesirable reflections and flare. All he needs when he wants to photograph a store window at night and finds the light reflections from the rain-wet asphalt disturbing is a polarizing filter in front of his camera lens. He rotates the filter until only the highlights he wants appear on his ground-glass screen. Polarizing filters are also used most successfully in the design of sunglasses.

Polarization has another very useful application: it can be employed to make strains in a material visible.

If transparent objects of safety glass are placed between two polarizing filters rotated to each other in a certain way, the strains present in the material will become evident. With the aid of polarized X rays strains can be demonstrated and photographed even in opaque materials. Fig. 27 shows a piston photographed in polarized light. The colored bands show the pressure distribution in the piston chamber.

By arranging two polarizing filters in line we are able to vary the intensity of the light most effectively without varying its quality, i.e., its spectral composition. All we have to do is mutually rotate these two filters to adjust the amount of light transmitted at will and continuously.

If we throw a pebble into still water, it produces concentric wave motions spreading outward across the surface of the water from the point of entry. If we place an obstruction, such as a board, in the water, we shall see that the waves are not simply stopped by it or cut off by its edges. In fact they move round the edges of the obstacle, aiming to spread across the area in the lee of it; the edges form the center of a new concentric motion, with which the waves seek to traverse this area, meeting one another behind the obstacle from both sides. This creates several different situations. According as the individual vibrations meet, the wave motion is either amplified or reduced; amplified when two wave crests or wave troughs meet — here energy is added — reduced when crest meets trough — the motion is cancelled, the energy neutralized. Light behaves quite similarly. Light waves, too, are capable of amplifying or reducing their energy as they meet and become superimposed. Light, too, when it meets an obstacle, is deflected from its original movement direction. This deflection is called diffraction. The resultant superimposition of light waves, which functions in exactly the same way as that of the water waves, is called interference. If an object is illuminated

with a beam of polarized light, this phenomenon can be very closely observed. Fig. 29 shows how the light waves are superimposed and added in the light regions. The dark bands and rings are caused by the mutual extinction of the light waves.[7]

This phenomenon can be demonstrated with an experiment in which a screen with a small hole in it is set up in front of a projector. Both sides of the hole are covered with a razorblade each; the razorblades are moved so closely together that only a narrow slit is left between them. The interference phenomenon can be clearly observed on a sheet of paper introduced into the light beam.

Interference colors are produced by double reflection from very closely spaced and parallel or almost parallel interfaces. It is a well-known fact that a light ray, when it enters, for instance, a solid medium from air, is partially reflected even if the medium is completely transparent. Part of the incident light rays is specularly reflected by the surface of the transparent material. If the solid medium consists of a very thin layer, such partial reflection always occurs on both interfaces; the partial reflection from one interface becomes superimposed on that from the other. This may produce an amplification or an attenuation of the radiation energy according as minima meet maxima or minima. In some conditions certain rays are completely extinguished. The change in the interference phenomenon can be clearly observed when we vary the angle of incidence of the light. Amplification and attenuation will alternate.

Interference phenomena are, as we have already established, caused by the superimposition of visible rays. The colors of soap bubbles and oil patches on wet roads are striking examples. Newton's Rings occurring in glass-mounted color slides, also consist of interference colors. The two narrowly-spaced boundary faces of the cover glass and of the film in partial contact with each other are responsible for this effect. Sometimes the contact is so close that a light beam can enter the color transparency directly from the glass. In other areas a certain distance, filled with air, exists between cover glass and film.

In the creative arts the effects of polarization and interference are already used as means of composition and expression. The artist Martha Höpfner, for instance, takes advantage of these physical laws for the creation of her 'objects of light'. She thus uses ordinary little polythene bags in which candy and chocolates are sold, and arranges them between polarizing filters so that the resulting interference colors produce interesting, artistically composed effects and compositions. For these 'objects of light' the front polarizing filter is mounted so that it can be rotated. As soon as the angle of rotation is changed, new, changed colors appear on the transilluminated plane. Fig. 30 shows

Fig. 29 These diffraction effects were caused by the passage of a narrow beam of polarized light through the slot of the razorblade. Light waves, too, become super-imposed, mutually amplifying or extinguishing each other.[7]

three different positions of the front polarizing filter and their effect on the light object. Such objects are used like paintings to decorate a room. They are either hung on a wall or mounted on a base. The continuously changing colors make them look alive and interesting.

Properties of body colors

Depending on its molecular structure a substance absorbs part of the light incident on it, and reflects or transmits the rest. This accounts for its colored appearance. Every material, every substance therefore has a certain body color. We include 'black' and 'white' in this concept as they are the two extreme points of a 'color space'. They are the alpha and the omega of the phenomenon of color, or of vision.

As we have already stated in the chapter on metameric colors, 'body colors' may appear exactly the same even if their reflectance curves differ from each other (fig. 23E, F). If different materials have one and the same color, it must be expected that the reflectance curves of the two body color differ. This applies equally to liquid-based pigments used, for instance, in blending and dyeing, to paste paints used by painters, decorators, and printers. Naturally, it includes color filters and transparencies.

Only if pigments or dyes have been manufactured according to exactly the same methods from the same raw materials will they be likely to have the same reflectance curves. But even here there is no absolute certainty.

In addition to their color properties, body colors have a number of other qualities that must be discussed in some detail. They can be transparent or opaque. Oil paints, distemper, and emulsion paints mostly belong to the former category. They are often used when the original color of a material is to be covered with a layer of another pigment. Opaque paints can of course also be mixed. The artist mixes them on his palette, the decorator in his bucket, the graphic artist in his paint box. Paste paints and India inks used for mixing may have the most varied hues.

Generally opaque paints are mixed in such a way that an already existing hue is chosen, and the desired hue produced by the addition of small amounts of a different hue. Here, subtractive primary colors are only rarely used, because it is obviously much more difficult to obtain the desired mixed colors from them, as the aim is so much farther to reach.

Opaque colors are often tinted by the addition of white, shaded or subdued by the addition of black; or the hue is broken, made less prominent, a little more 'muddy' by the admixture of a small amount of the complementary color. The laws applying to the mixture of paste paints or pig-

ments before use will be described in detail in a chapter of its own.

To begin with, the laws of color mixture can be better demonstrated and explained with the aid of transparent colors. Here the results to be expected can be accurately predetermined during the mixing process. Transparent colors are used in many fields of technology in which it is necessary to master the problems of color mixture with confidence, for instance in color photography and the printing industry. In the latter, transparent colors are employed especially when a broad scale of mixing possibilities is aimed at in three-color and four-color printing by the superimposition of proportions of primary color values.

Appearance is an important property of body colors. It is specified by standards institutions for primary inks in the printing process for instance. The Europa Scale established by international European agreement is being progressively introduced. These scales, used by all printing works almost exclusively in classical three- or four-color reproduction today are intended to lead to the standardization of the manufacture of pigments and printing inks, reproduction processes, and printing.

It should be possible in theory to produce all the hues imaginable by mixture of the three subtractive primaries. Unfortunately this is not confirmed by practical experience. Only about 95 per cent of all the possible colors can be obtained. This is, however, completely adequate for average purposes. Normally, neither in color photography nor in classical color reproduction is this minor defect disturbing.

The red, green, and blue hues on the left of fig. 31 show results of mixtures produced by the overprinting of two colors. On the right are the original colors, i.e., colors printed directly in this hue. They look more luminous, purer, more saturated. To obtain this color effect, three additional printing runs were necessary. Had these hues been part of an original to be printed by ordinary color reproduction in a catalog, the results on the left would have had to be accepted.

We must explain why it is not possible always to obtain hues of the same luminosity and saturation as, for instance, those on the right of fig. 31 by the mixture of primary colors. In the manufacture of paste paints, pigments are used that do not have the ideal properties demanded by the theory, because they do not absorb all the radiations they should within the regions. Nor do they reflect everything they should in the appropriate region. This is called inadequate absorption and inadequate reflection.

Fig. 32 shows a comparison between the reflection regions of the theoretically ideal printing ink, and those of

Fig. 30 In this 'Light Object' by Martha Höpfner color-less cellophane bags are artistically arranged in front of a light box. When they are viewed between two colorless polarizing filters, many colors will be produced (A). These change when the viewing filter is rotated (B), until they can turn into complementary colors at 90° (C).

the primary inks used in this book. The hatched areas represent the ideal reflection range demanded by the theory. Unfortunately it is not yet sufficiently realized in the subtractive primary colors available up to now. This is revealed by the difference between the hatched areas and the shapes of curves printed in color. Here very inadequate absorption and reflection is apparent. We shall discuss this problem in detail in the next chapter.

The inadequacies in the reflection behaviour of the primaries are optically not quite as disturbing when these colors appear unmixed. But when two or three of them are mixed the faults will appear enhanced as fig. 31 illustrates clearly. Here we see that there are body colors which are purer than the results of mixtures of the primaries cyan, yellow, and magenta at our disposal, for in the mixture the faults in the absorption and reflection ranges become cumulative and have an increased adverse effect on luminosity and purity.

It is, of course, theoretically possible to consider whether for a technical process in which certain hues are particularly important a different color scale is more suitable. Practice, however, has shown that the industry aims at working with standard material. The rationalization of the production processes simply makes this inevitable. As a result the Europa Scale, despite its considerable shortcomings, has become widely accepted on an international basis.

Two further important properties of the body colors are light-fastness and varnishability. Light-fastness is the ability of a dye or pigment to preserve its appearance even after prolonged exposure to direct light.

Everybody will have seen color prints that have turned completely green in a show-case. In these prints the red pigment was not very light-fast and in time was completely bleached. Colors used in the production of books obviously need not be as fast as those used for painting. Books are opened only for reading, whereas paintings hanging on a wall are continuously exposed to light.

Other influences in addition to light can change the appearance of colors in the course of time: temperature, atmospheric humidity, exhaust gases, and a great variety of other chemical reactions.

A color is varnish-fast when the application of a film of varnish produces no disturbing chemical reactions and the colors remain unchanged. Manufacturers often state fastness only to certain varnishes. Thus, colors can be fast to, for instance, synthetic resin varnishes, or spirit varnishes.

Color saturation and measurement of color density

Before we investigate the laws of color mixture in the next part of this book, we must become familiar with the term of color saturation. We can apply more or less of some paste paint or water color to a given area of a sheet of paper. The resulting layer of color will then be thicker or thinner, and although the original color used is the same, an entirely different color impression will be created. This applies particularly to transparent colors. It is true that opaque colors can be tinted by more sparing application to a white background; but they will not appear shaded or muddier if the thickness of the layer is increased. Once the point of maximum saturation has been reached with opaque colors there will be no further change when this point has been passed.

With transparent colors the light rays reach the surface of the material through the layer of color. The part of the light unabsorbed by the color layer is reflected by the white surface, e.g., of paper. If the layer of a transparent color is applied more generously than is necessary for maximum color saturation, appearance changes in the direction of black.

In our exploration of the laws of color mixture, let us, to begin with, confine ourselves exclusively to the study of transparent colors.

The printing process may serve as an example for the explanation of the laws of subtractive color mixture. Naturally, color photography or the action of filters could serve equally well, but the printing process commends itself if only because the production of this book is, after all, based on it.

When a picture is printed in color, the subtractive primary inks are successively overprinted on the printing base. On account of its distinct character this process is particularly well suited for creating an understanding of and for explaining the laws of color mixture.

But the scope of this book is by no means limited to an explanation of what happens during color printing. The explanation is equally valid in all the branches of science, technology, and art. The printing process is merely the easily grasped model, and has the further advantage of presenting suitable examples within the framework of this book.

The application of a transparent paste paint is at its best when the color is 'saturated', when it appears at its maximum intensity. This obtains in the cyan primary color, for instance, when this reflects the largest possible part of the incident light in the blue and green region of the spectrum and, on the other hand, absorbs the largest possible part in the red region (cf. fig. 32).

If more ink is applied to the white paper now, the thickness of the color layer is increased. The color becomes darker. As soon as the point of optimum saturation is ex-

Fig. 31 The colors in the left-hand column (A) are the result of the mixture of the subtractive primary colors yellow, magenta, and cyan normally used in color printing. The colors on the right (B) show how much more pure red, green, and blue can be if they are printed as 'solid colors'. Here, inadequate absorption and inadequate reflectance are considerably reduced.

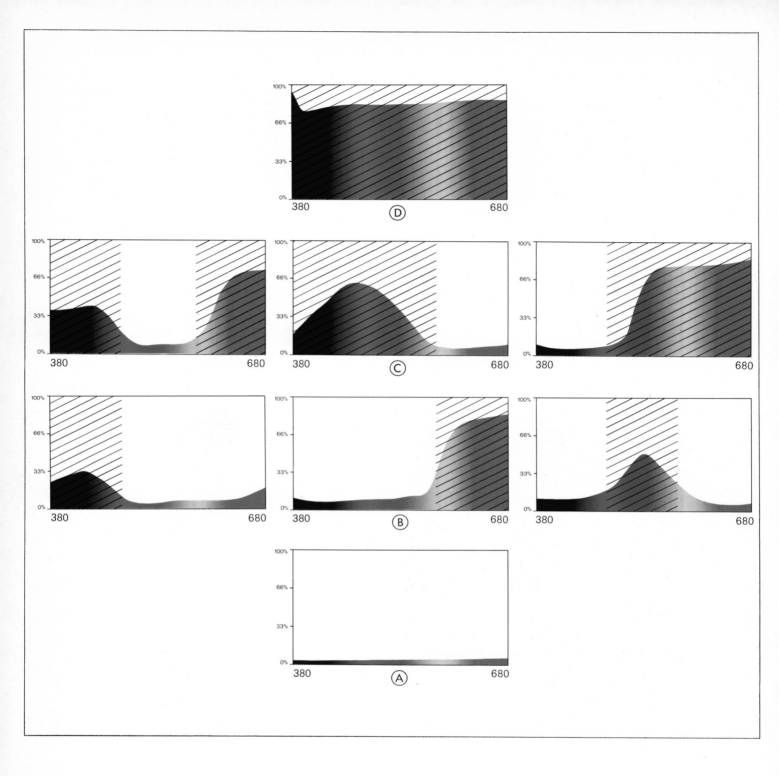

Fig. 32 Here the reflections of the inks used in this book (colored areas) are compared with the theoretical demands they should meet (hatched areas). With black (A) there should be no reflection. The one-third colors (B) and the two-thirds colors (C) should cover vertically-cut-off spectral regions. White (D) should totally reflect everywhere.

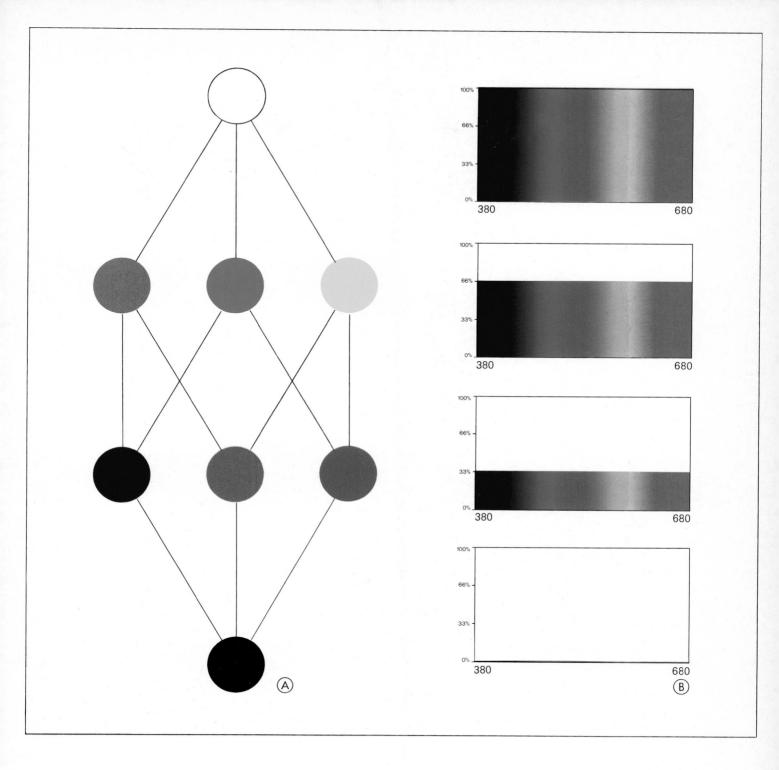

Fig. 33 Scheme (A) shows the same relations as fig. 32. We already see that it is impossible to represent the relations between all colors on a plane. Analogously to the reflectance curves of the primary colors in fig. 32, the reflectance curves of the achromatic one-third and two-thirds colors are shown in (B).

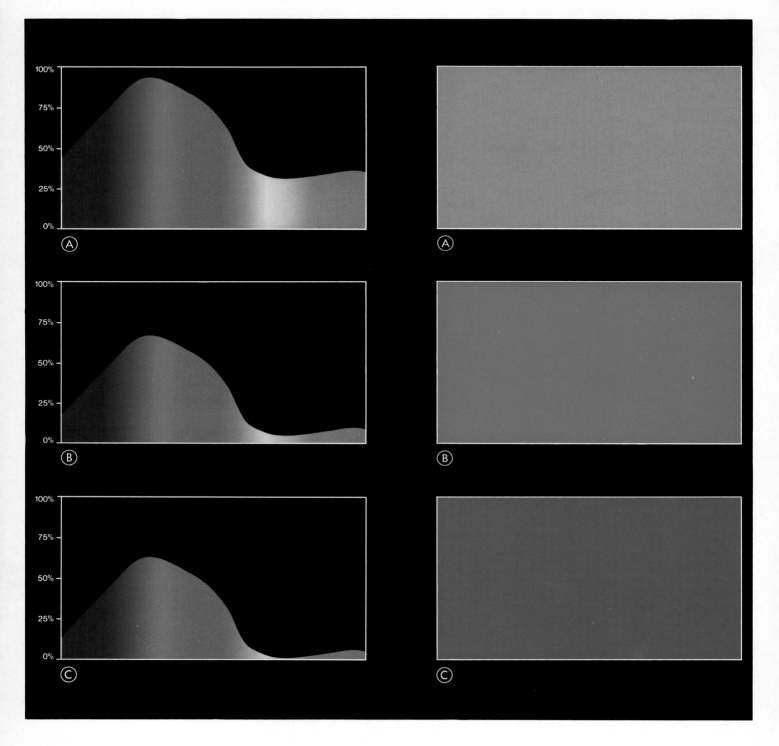

Fig. 34 Up to maximum saturation (B), the thickness of the layer of transparent colors can increase without shading. At (A) a saturation of only 80 per cent has been reached. But (C) shows that shading occurs as soon as the point of maximum saturation has been exceeded. The appearance of a cyan color changes from (B) to (C) if the transparent color layer is applied at double thickness.

ceeded, not all vibrations of the special reflection range are reflected any longer but partly absorbed. Fig. 34 is the diagrammatic representation of some reflectance curves of the same ink with increased inking. In fig. 34A a cyan primary color that is not fully saturated is seen. The degree of saturation is about 80 per cent. In the red region part of the light is still reflected. We could also formulate it in such a way that the white tone of the paper still shines through the ink, that the ink is not yet able to cover the white paper completely with its hue. The colored area to the right of the reflectance curve shows the approximate appearance of a cyan layer of 80 per cent saturation or 'opaqueness'. Here the weaker color saturation has, for technical reasons, been obtained not with a thinner layer of ink, but through screening the area.

The cyan reflectance curve of fig. 34B, on the other hand, shows maximum saturation. In the blue and green regions of the spectrum the light rays are reflected as far as possible, and very largely absorbed in the red region.

Fig. 34C demonstrates how the reflectance curve changes towards a shading of the color. It is true that here absorption is better in the red region. But because the layer of ink is too thick, the light rays of the green and blue region can no longer penetrate freely to the white paper surface for reflection. Part of them is absorbed. This causes the hue to become shaded.

The thicker the layer of ink, the more closely the hue approaches black. The cyan ink in the printer's trough, for instance, appears blue-black. Here, the layer of ink, many inches deep, also absorbs a large part of the light rays of the green and blue spectral region. The energy of the photons is insufficient to send them to the bottom of the trough to be reflected there and to return all the way through the entire depth of the trough.

These considerations show that saturation plays an important role in printing on account of maximum color intensity and reliable final results of the mixture of body colors. It is absolutely essential that, for instance, the individual primary inks are laid on a solid area of the paper at full saturation in each printing run. Too much ink is as bad as too little. If too little, the finished color picture would look pale, washed out. It would lack guts and brilliance. If the laying on of all inks is excessive, the picture as a whole will become too dark, too 'heavy'. It will be 'drowned'. If the color saturation in a printing process is wrong in only one run, it will result in a color cast in the end product. If, for instance, the saturation in a four-color reproduction is too weak in the magenta, brown skin tones of persons in the picture would appear greenish or yellowish.

It is therefore one of the problems of printing to ensure the correct color balance each and every time. This applies both to the adjustment of the quantities of the various inks at the beginning of the printing process and to holding the color during the whole time in which the run is in the printing press. It is essential to hold the color constantly within a certain tolerance range. For if it fluctuates during the run the worst color shifts can occur, since in certain circumstances the faults of the individual part-runs are cumulative. If in a four-color reproduction, for instance, too much ink has been used in blue and black, and too little in red and yellow, the appearance of a certain brown tone will shift towards blue-gray.

Right up to a few years ago the printer had to depend on an optical control of his work. We can easily appreciate the difficulties this created if we remember what we have learned about the different spectral compositions of the light. The color of an unsuitable type of light may in some conditions make it impossible for the printer to recognize and balance the inks on his printed sheet correctly. It is simply not possible to assess a yellow color on white paper in yellow light correctly. For the more yellow the color of the light, the less the white paper stands out from those areas to which the yellow ink has been applied. The saturation of yellow can be assessed only if the reflection of the white paper clearly differs from that of the areas printed in yellow. The higher the proportion of long-wave vibrations in a light, the smaller the difference between the reflectance curve of the yellow ink and of the light used.

Since it was therefore impossible to assess color saturation in varying lighting conditions objectively and correctly, measuring instruments have been developed that give an unbiased indication of color saturation and thus of the thickness of the color layer. Most of these instruments employ a light beam that is directed at a certain angle at the colored area to be measured. The reflected light is transmitted to a photo-cell through a filter which should be as complementary in color as possible to the color to be measured. The photo-cell converts the light into an electric current, which according to its intensity deflects a pointer on a scale. The indicated value is in practice the difference between the incident and the reflected light. It shows how much of the original value has been lost, absorbed, and is called opacity or color density.

It is also important to know that the density measuring instruments, the 'densitometers', currently on the market do not agree with one another. They are suitable only for subjective density measurements. The measured results are reproducible only on the same densitometer. There are many technical reasons for this which are beyond the scope of our discussion. They are, however, of no practical significance since in a printing or reproduction works the only requirement concerns comparison measurements.

Systematic section

Primary colors and the color circle

The real 'original' colors are the monochromatic colors of the spectrum. They make everything that can be seen visible. Every color stimulus imaginable is the result of a mixture of these colors. They may form parts of a mixture at different intensities. Their interaction is responsible for the wide variety of the manifestations of color. This has already become clear from our study of figs. 20–23.

We already know that monochromatic colors are radiations of a single wavelength. Colors of such purity do not occur naturally — neither as colored lights nor as body colors. The technical apparatus required to produce and render visible pure monochromatic colors of a certain saturation is rather complicated. Birefringence is required. After a light beam has been dispersed into its component colors by a prism, the desired color is isolated and sent through a second prism, which purifies it further through further dispersion.

In our practical dealings with color and in everyday life monochromatic radiation is of only theoretical significance.

How do we progress from the 'original' to the primary colors that are important for the laws of color mixture?

There are two basic approaches. The first is via the function of the visual organ. The primary spectral value curves of fig. 10A and B point to the fact that our eye is equipped with three types of cone, each sensitive to a different spectral region. Fig. 10A in particular makes it quite clear that one type responds mainly to the short-wave, another to the medium-wave, and the third to the long-wave rays. One can express it more simply as follows: the primary spectral value curves suggest three types of cone, responding to blue, green, and red.

The second approach to the primary colors is via the practical use of color. When we mix dyes or paste paints we very quickly realize the existence of hues that we can obtain by mixing other basic colors. Certain hues, i.e., yellow, magenta, and cyan, however, cannot be obtained with this method, This shows that these colors must occupy quite a special position in the theory of color.

Let us once more look at fig. 20. We recognize in the spectrum from left to right the regions of blue, cyan, green, yellow, and red. It strikes us that the three regions corresponding to the sensitivities of the cones, i.e., blue, green, and red, each cover about one-third of the spectrum. It will be seen that the transition between blue and green is cyan, between green and red, yellow.

Magenta is not present in the spectrum as a monochromatic color. It is produced when we superimpose the red and blue regions and consists of a mixture of the short-wave and the long-wave thirds of the spectrum; the spectrum is thus divided into three thirds as fig. 32 illustrates.

We have now determined the additive primary colors from the spectrum. They are called blue, green, and red. Each of these three additive primaries is a 'one-third color', because it represents the electromagnetic vibrations of one-third of the spectrum. Each additive primary is a mixture of all the wavelengths of their respective spectral regions. If all three additive primaries, which together make up the whole spectrum, are mixed together, all the visible color tones and hues can be produced by an individual variation between 0 and 100 per cent of the respective intensities of the primaries forming the mixture.

These additive primaries are most intensely colored, i.e., most deeply saturated, when their spectral curves are bordered on either side by complementary monochromatic colors, which extinguish each other to become achromatic (see also the chapter 'Complementary colors'). For if the breadth of the spectral region exceeds this boundary, it will inevitably reduce the color saturation in that complementary pairs of vibrations will tint the color of the light.

The combination of colored lights is called 'additive mixture', because visible vibrations are added to one another. Obviously, additive color mixture can be demonstrated properly only in a completely dark room. We can therefore say that additive color mixture leads from black (dark room, absence of visible radiation) via the additive primaries blue, green, and red to white, the neutral light of equal spectral energy. We shall discuss this phenomenon in detail in the chapter 'Additive mixture'.

The situation is exactly reversed with body colors. Let us recall once more that our present considerations refer only to transparent body colors. These, when applied to black paper, are invisible. A white background, for instance white paper, is necessary to reveal them. Only then will it be possible to recognize the true hue of the color applied, because the white surface of the material alone is capable of reflecting all the light rays passing through the color

layer. For the mixture of body colors, pure white must always be the starting point of our considerations and exercises if we want to make use of the laws of color mixture and their effect.

The white of the paper is therefore the maximum of the visible radiation. It is immaterial what body color is applied to this paper: the reflection from a colored area is always less than that from the white paper. Hence, color always decreases reflection, i.e., something is taken away, subtracted from the reflection. This is the reason why the mixture of body colors is called 'subtractive mixture'.

The subtractive primaries are yellow, magenta, and cyan. We already know from fig. 32 that the reflection of magenta consists of two spectral regions, the red and the blue ones, and that it is therefore a 'two-thirds color'. Quite obviously the other two subtractive primaries, yellow and cyan, are also 'two-thirds colors'. Yellow is made up of the green and red, cyan of the blue and green, thirds of the spectrum.

In subtractive mixture the whole range of color perceptions can be created if the subtractive primaries are mixed at different levels of saturation. We can therefore say that subtractive color mixture begins with white (e.g., white paper) and any application of color reduces the reflection. With the subtractive primaries we also reach the point at which in theory no visible radiation at all can be reflected by the paper surface. This situation is called 'black'. We shall describe it in detail in the chapter 'Subtractive mixture'.

Unfortunately, neither the additive nor the subtractive primaries are available at the desired degree of purity in everyday life. The theoretical ideal requirements have already been set out. The reflectance curves of the colors should be vertically cut off on either side by a pair of complementary vibrations. As fig. 32 shows, this is unfortunately by no means so. The bottom curve represents black. As pointed out above, there should be no reflection at all from it. In practice, a certain amount of inadequate reflection still occurs from every black.

In row B above the black we see reflectance curves of a blue, a red, and a green hue. The curve rendered in color, as we already know, represents the true reflection. The black hatched area indicates the ideal region of reflectance. It can be clearly seen that these primaries on the one hand reflect rays in regions where they should absorb them (inadequate reflection), and on the other absorb them where they should reflect them (inadequate absorption).

The reflectance curves in row C above represent the three subtractive primaries, magenta, cyan, and yellow. Here, too, the black hatched area demonstrates the ideal quality of the colors and shows clearly that the subtractive

primaries available in daily practice also suffer from considerable inadequacies of absorption and reflection.

The reflectance curve fig. 32 top, lastly shows a white obtained from the art paper used in this book. We still see a difference between the ideal, theoretically correct white (hatched area) and the true white (colored area).

Fig. 32 thus illustrates diagrammatically the relations governing the primary colors. This same relation is once more demonstrated in a simplified form by fig. 33A. Here the relations existing between the individual colors can already be seen and the impossibility appreciated of representing these multiple relations in a plane, i.e., in two dimensions. One can instead imagine a geometrical body whose axis is the line joining the points 'black' and 'white', the so-called gray axis. This is the locus for all the achromatic hues.

The representation in fig. 33B illustrates the location on the gray axis between the black (bottom) and the white (top) reflectance curves of those achromatic hues that correspond to the one-third and the two-thirds colors respectively. The reflectance curve at the level of the one-third colors represents a dark gray also of one-third reflection, that at the level of the two-thirds colors a light gray of two-thirds reflection of the whole spectrum. In principle, the same phenomenon as in fig. 32 is demonstrated here, except that the spectrum is not divided vertically into chromatic hues but horizontally into achromatic ones. Whereas fig. 32 shows the origin of chromatic colors from the complete elimination of certain spectral regions, fig. 33 shows the creation of gray tones through uniformly reduced reflection of all the rays of the spectrum.

To illustrate the relations between the chromatic colors, another long-familiar and well-tried device, the color circle, can be used. The outer ring in fig. 35 is such a continuously blending color circle. One color merges into the next without a break, organically as it were. There is no discontinuity. The sequence of these colors corresponds precisely to the arrangements of the colors of the spectrum (fig. 20). Such a color circle is really a spectrum that has been bent into a circle, with magenta used as a transition. The middle ring in fig. 35 shows certain hues isolated from the continuous color circle. The chosen arrangement is also called a twenty-four-sector color circle. Obviously, a color circle can consist of any number of hues. If it is infinite, the color circle becomes continuous again. The innermost part shows the reduction of the twenty-four hues to the six primaries.

Such a color circle is eminently suited to demonstrate the transition between the primary colors. No mixed color of this circle consists of more than two primaries.

The six colors 'left' in the center of the color circle play

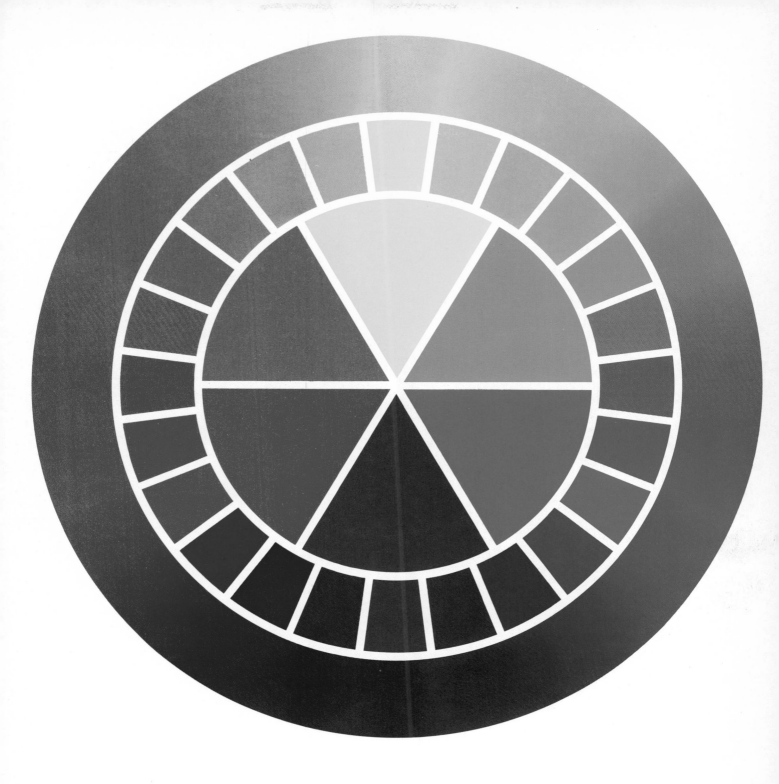

Fig. 35 The outer continuous color circle can be broken up into a graduated color circle. The middle ring shows the hues of Ostwald's twenty-four-sector color circle. The wide range of its colors can be derived from the six primaries in the center of the diagram.

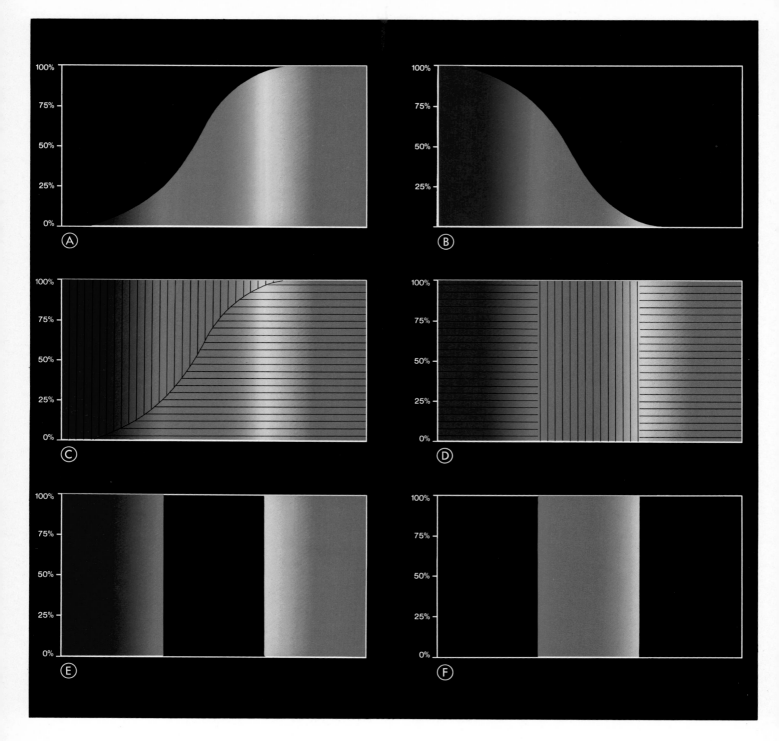

Fig. 36 The body color (B) is complementary to the body color (A). Both reflections add up to the equal-energy spectrum (C), which is shown hatched. The theoretically correct primary magenta (E) should have green (F) as complementary. These two reflections also add up to an equal-energy spectrum.

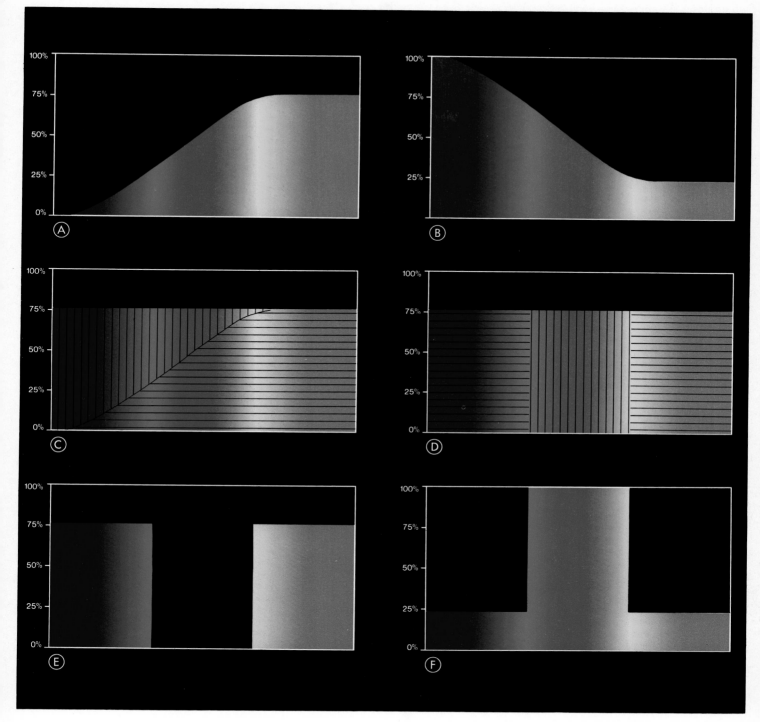

Fig. 37 To a reflection (A) the complementary is (B). But (C) shows that the vertically hatched reflection is already sufficient to add up to (A) (horizontally hatched) to result in an achromatic hue. The same applies to the shaded magenta (E). Whereas a tinted green (F) would be the complement for an equal-energy spectrum, the shaded green in (D) (vertically hatched) is sufficient for complementation to an achromatic hue.

an outstanding part in the theory of color. Although they, too, are no more than certain hues at maximum saturation, each occupies an outstanding position, equal in importance to the extreme color phenomena black and white.

Complementary colors

Two colors that complement each other to produce an achromatic hue are called complementary.

Two monochromatic colors that cancel their chromatic hues, producing neutral light, are called a monochromatic pair of colors. The spectrum contains a large number of such complementary monochromatic pairs of colors. Only the green monochromatic colors of wavelengths between 500 and 570nm have no monochromatic complementary waves. The reason for this is that their complementaries are composite magenta hues.

Fig. 36 shows spectral and reflectance curves of pairs of complementary colors. Fig. 36A is a yellowish light, fig. 36B its complementary violet one. Fig. 36C shows how these two colored lights together completely fill the entire range of the spectrum. If the intensities of the two lights are superimposed a spectrum of equal energy is the result.

We already know that there are many metameric hues, i.e., hues looking completely alike, but of possibly very widely differing spectral compositions. In additive mixture, complementary colors are not only those pairs whose spectral curves together produce an equal-energy spectrum, but also those that look optically alike, and trigger in the observer's brain the same color sensation as the former.

The principle is the same in subtractive color mixture. Body colors complementing each other to achromatic hues or black are complementary. In fig. 36D the optimum two-thirds color magenta is hatched horizontally. Its green complementary is hatched vertically. In figs. 36E and F the reflection ranges of these colors are shown separately. This pair of colors also produces a spectrum of equal energy.

Like colored lights, body colors are complementary not only when they are pairs whose reflections add up to a spectrum of equal energy, but also whenever they have the same appearance, i.e., trigger the same color sensations.

We have been taught in school to find complementary colors in the color circle by drawing a line from a point on the circle through the center to the opposite point (fig. 35). On the color circle those colors that are diametrically opposed are complementary.

If we consistently follow the relations to their logical

conclusion, the conventional term 'complementary colors' can refer only to the color tone, not to a special color hue. The tone of a complementary color of a body color is clearly defined by the difference between absorption and reflection. It is as clearly defined by the difference between a certain color light and the equal-energy spectrum. Complementary colors are easily found by the location of the diametrically opposed points of intersection on the color circle. But fig. 37 shows that the degree of saturation of a complementary color tone can vary, although only between two closely defined points. Fig. 37A shows a colored light of a tone similar to that of fig. 36A, except that it is darker. In no region of the spectrum is there full saturation. The complementary color that, added to this color tone, produces white is shown in fig. 37B. The horizontal hatching in fig. 37C again indicates the same colored light as fig. 37A. The vertical hatching shows that this colored light can also be complemented to produce an achromatic hue by a colored light of a spectral composition other than that of fig. 37B. This vertically-hatched colored light is already sufficient to neutralize the existing light. The empty top part of fig. 37C is the proportion of fig. 37B that is present at equal intensity in the colored light in fig. 37B across the entire region of the spectrum. It is therefore practically the spectral portion of the complementary color that has caused the conversion of this colored light into white. In the complementary color for fig. 37C this 'white component' is absent.

Since the eye adapts itself gradually to any given brightness, we would perceive both the lights of figs. 36C and 37C as white after a certain time. The only difference between the two is really just their intensity. As we know, the brightness of light is always relative. For the demonstration of additive mixture it is therefore absolutely essential to have a white reference light within the field of view.

With subtractive color mixture the situation is simpler in that the white paper is the constant reference basis. Let us adopt for this purpose white paper of maximum reflection in all regions of the spectrum. In principle, subtractive mixtures behave analogously to additive mixtures.

The magenta body color of fig. 37E is considerably darker (more shaded) than the primary (optimum) color magenta. Full reflection exists in no region of the spectrum. Fig. 37F is the complementary color of this shaded magenta. It is a tinted green, for in the reflection of this hue wavelengths of all spectral regions occur at a certain intensity. As we have seen, these cause tinting. If these two transparent color layers were superimposed, they would complement each other to 'achromatic' gray. They would not produce black, which with subtractive mixture could be expected in certain conditions. To produce black, the

 Ⓐ
 Ⓑ
 Ⓒ

 660
006
 339

407
370
 592

046
620
 953

520
035
 479

071
706
 928

027
 750
 972

435
120
 564

Fig. 38 Column (A) shows random color hues. In (B) the minimum complementary (compensative) colors, in (C) the maximum complementary colors are shown. Strictly only those colors that occupy a line between (B) and (C) in the color space are truly complementary hues, because only they always result in achromatic hues.

73

complementary color must not reflect or transmit any spectral components of the reference color. Fig. 37D shows that color which, together with 37E, produces black.

These considerations prove that although each hue has its specific complementary hue, the latter can within certain limits be tinted or shaded. We can therefore speak of a 'minimum' and of a 'maximum' complementary color. This means that the difference between the minimum and the maximum complementary colors comprises all the complementary hues of a certain original color. The range within which these complementary hues can lie is defined in fig. 37 by the empty areas of figs. 37C and D.

We can express this more precisely by saying that in additive color mixture complementary colors are colored lights that transform an existing colored light into an achromatic light, whereas in subtractive color mixture the complementary colors are body colors that transform an existing body color into an achromatic hue.

Fig. 38 shows random hues in the left-hand column. The center column contains the minimum, the right-hand column the maximum complementary colors. All hues in the color space located on a straight line between these two points are also complementary.

For a better understanding Hickethier's color code is used to define each hue. We shall presently discuss this coding system for colors in detail.

A full grasp of these relations will in any case be possible only after a study of the chapters 'Subtractive mixture' and 'Additive mixture', because the laws of color mixture clearly state what color constituents must be added to a certain hue to cancel its chromatic appearance and make it achromatic.

In additive mixture all the possible complementary colors lie between that colored light which neutralizes another colored light at minimum intensity and that colored light which added to the existing one produces a white corresponding to the reference white.

In subtractive mixture all the possible complementary colors lie between that hue which neutralizes an existing body color to become achromatic and that which complements it to black.

As the example of the top row of fig. 38 shows, the minimum complementary color to orange on the left (column A) is cyan in the center (column B). A lighter cyan, however, would no longer be complementary, because it would be unable to neutralize the color of orange. Only those hues lying between cyan in the center and the dark field on the right (column C) are complementary to orange. These and no others.

Additive mixture

Additive mixture is the mixture of colored lights. In this context we must not think only of direct colored emissions (radiations). The laws of additive mixture apply whenever we deal with electromagnetic radiations irrespective whether these come directly from a light source, have been changed by the insertion of, for example, a color filter in the light path, or are reflected by some substance. Additive mixture occurs whenever visible electromagnetic vibrations are mixed in any way.

Additive mixture of reflections is initially difficult to understand, because here we have processes of both subtraction and addition at the same time. A special chapter 'Simultaneous additive and subtractive mixture' has therefore been devoted to these problems.

In the interest of clarity we now want to confine ourselves to the mixture of colored lights only.

As we already know, the additive primaries are called blue, green, and red. Since each corresponds to one third of the spectrum, they are also called 'one-third colors'.

If the behavior of a type of light is to be determined, observation must not be disturbed by the addition of stray light and must therefore take place in a completely dark room. If we look into such a completely dark room, we see 'black'.

Let us set up three projectors in this room, each to emit a colored light in the additive primaries blue, green, and red. We can arrange this by simply mounting the appropriate filters on them. Each of the projectors must be adjustable in ten steps so that 0 is nil radiation, 9 radiation at full intensity. The steps should all be at equal intensity intervals. Fig. 39 shows this arrangement. The three additive primaries are seen in three parallel rows at the ten different intensity steps.

Because of the adaptation of the eye it is essential to have a fourth projector emitting constant white light, in addition to the three color projectors. The white light should have a spectrum of equal energy. It is beamed on the white reflecting wall. We now observe the additive mixture next to this reference light.

To begin with each of the three projectors is switched on one after the other. The various intensity steps from 0 to 100 per cent now become visible as shown in fig. 39. If you do not want to equip the projectors with suitable potentiometers, which is of course technically rather complicated, you can easily obtain these effects by mounting appropriate gray filters or polarizing filters in front of the projector lenses. We begin with blue, pass on to green and lastly to red. We leave the blue light at full intensity, i.e., full saturation, next to the white light and superimpose, as

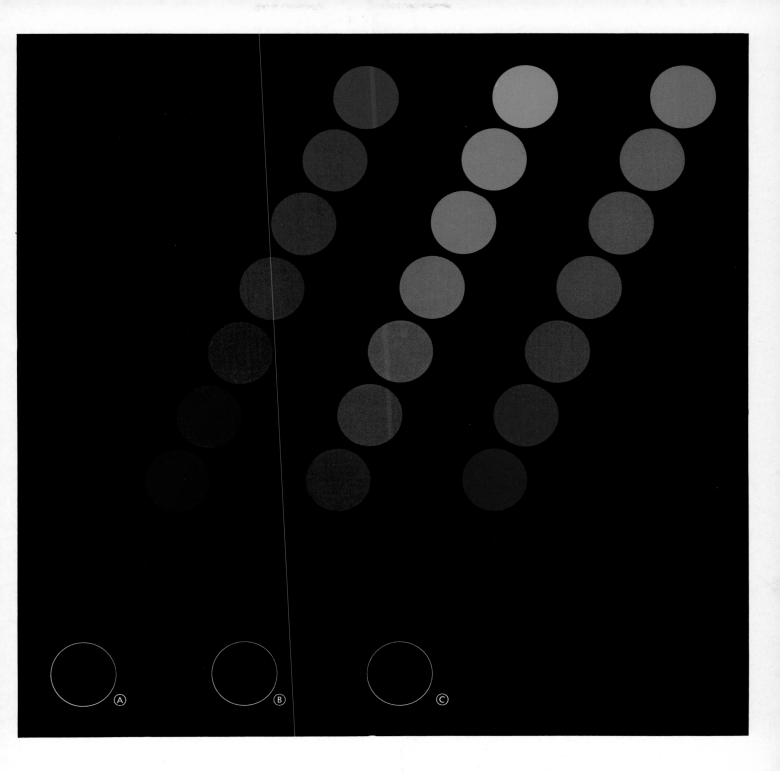

Fig. 39 The additive primaries blue (A), green (B), and red (C) in their ten grades of saturation. The first grade is 0 per cent, i.e., black. The interval from grade to grade corresponds to a value of 11.11 per cent of maximum saturation.

75

shown in fig. 40A, full red light so that both light patches overlap partially. Where the two one-third colors red and blue are superimposed, we logically obtain the two-thirds color magenta.

We now turn the blue light off and beam the red light at full intensity at the reflecting wall, and add, also at full intensity, the green light so that it partially overlaps the red patch as demonstrated in fig. 40B. The two-thirds color yellow appears where red and green are super-imposed.

Finally, fig. 40C shows the two-thirds color cyan as a result of the mixture of the one-third colors green and blue.

We now superimpose the light beams from all three color projectors at full intensity. All the light patches are arranged as shown in fig. 41. We now have the complete system of additive color mixture demonstrated.

As we have stated at the beginning, the basis from which additive color mixture starts is complete darkness, the absence of visible electromagnetic vibrations — the color 'black'. It is characterized by the black background. Red, green, and blue represent one third each of the white light of the spectrum. Wherever two one-third colors over-lap, a new color, a two-thirds color, is the result. This is how the colors cyan, magenta, and yellow are produced. On that part of the area on which all three one-third colors overlap we have the 'three-thirds color' white, because this is where we find the spectrum, which we had pre-viously split up into the three spectral regions blue, green, and red, recombined. It is best to conclude this experiment by adjusting the three light cones so that they are com-pletely superimposed. All the color disappears, and only white light is visible. This is particularly impressive if the white light produced by the mixture precisely corresponds in intensity and hue to the reference light.

Naturally this experiment can be considerably elab-orated. Beginning with white, the intensity of each pri-mary color can be reduced step by step. To do this place the available gray filters in front of the lens of the relevant projector, which reduces the light intensity accordingly. The white light will thus become more and more colored. If we reduce, for instance, the intensity of the light from the red projector, the white is gradually transformed into a cyan color. The initially only slightly blue tone becomes stronger and stronger the more the red component of the light is reduced. When the red projector is completely switched off, cyan will be seen at full saturation.

If we likewise reduce the light from the blue projector step by step, the cyan color tone turns increasingly green until it will be completely green when the blue rays are completely switched off. Once again, another third of the spectral region has been taken away from the light. The two-thirds color cyan has become the one-third color green.

If we now reduce the intensity of the 'green' projector step by step, the green color will become darker and darker, or more shaded, until it reaches black when the projector is switched off.

Obviously, the intensity of either of the other two additive primaries can be reduced first, beginning with white.

Let us return to fig. 33. On the left of this illustration the scheme of the relations between the primaries can be seen. What we have described at great length just now can be read in the simplest possible form from this diagrammatic representation. The starting point for the additive color mixture is the black at the bottom. The three additive pri-maries are equivalent, on the next-higher plane. A mixture of two produces the subtractive primaries magenta, cyan, and yellow, on the plane above. White is the sum of the three full original colors, the additive primaries. White thus includes all possibilities of variation imaginable in the mixture of these three colors and therefore is the end point of this representation.

With the aid of three color projectors whose light can be varied at ten intensity steps as illustrated in fig. 39, a total of 1000 color hues, i.e., $10 \times 10 \times 10$, can be mixed.

We must, however, remember that the precise practical execution of this demonstration can meet with consider-able technical difficulties. The color filters available do not transmit the ideal additive primary colors precisely. They suffer from inadequate absorption and inadequate trans-mission, which may cause color shifts. It is also difficult to graduate the light of a projector in ten steps at equal intensity intervals whether by means of gray or polarizing filters or the use of resistances. With the latter method we have the added complication that the spectral composition of the light, its color temperature, changes.

To carry out this experiment in optimum conditions we would have to isolate through birefringence the regions of the additive primaries from the spectrum, to mix them again with a suitable lens system, to combine them, and to vary the light intensity by the insertion of pairs of polar-izing filters. It would be essential to have light of an equal-energy spectrum available.

Color television functions on the principle of additive mixture. The picture screen consists of a system of minute filter discs in the additive primaries red, green, and blue. These are made to light up more or less strongly by rays directed at them. The different intensities at which this occurs in the various primaries result in the mixture, i.e., the appropriate hue. Naturally, the intensity intervals are not fixed here; the possibilities of variation are continuous.

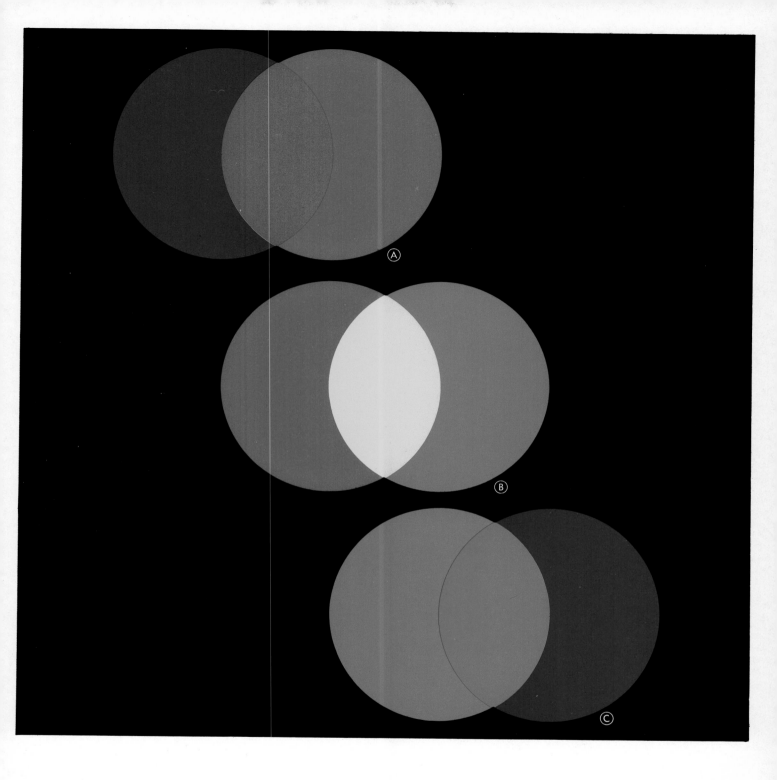

Fig. 40 Additive mixture. If the fully saturated ideal colors
blue and red are superimposed, magenta (A) is obtained.
(B) and (C) show how yellow and cyan are produced by
two additive primaries each.

The conditions of additive mixture are illustrated in a different way in fig. 42. Representation A shows diagrammatically that the maximum saturation of every additive primary has been divided into nine saturation grades each. Each saturation grade is therefore one-ninth of the total intensity of a primary color. The ten saturation grades of fig. 39 must then be interpreted so that the first grade has 0, and the tenth 9 parts, and every grade is one step higher than the preceding grade. One saturation grade therefore represents 11.11 per cent of the total saturation of a primary color.

Figs. 42B and C show accordingly how any hue is composed of a certain number of saturation grades of the primary colors. The hue in fig. 42B, for instance, a tinted yellow, consists of three saturation grades of blue, eight saturation grades of green, and nine saturation grades of red. Fig. 42C, on the other hand, is a muddy, dark green, made up of one saturation grade of blue, seven grades of green, and two grades of red.

Subtractive mixture

Subtractive color mixture begins always with white, which may be either an equal-energy spectrum white light, or a white surface that is able to reflect all visible electromagnetic vibrations evenly and at the highest possible intensity. Good-quality art-paper, for instance, meets these requirements. Its reflecting power can be higher than 90 per cent across the entire spectrum.

In subtractive mixture, conditions are exactly the opposite of those in additive mixture. Whereas the starting color of the additive system is black, that of the subtractive system is white. White indicates the presence of all visible radiations. They are all reflected by the white paper surface. Any substance introduced between the light source and the white surface of the paper causes a reduction of the visible radiation. It takes away, 'subtracts', something from the radiation, hence the term 'subtractive mixture'.

We thus have subtraction whenever color phenomena are produced by the taking away of spectral components from white light. It is immaterial whether this occurs during transmission or reflection. We speak of transmission when light rays penetrate another medium, of reflection when they are sent back, reflected by a substance. A white substance differs from a colored one in that it reflects all the incident light rays; the colored substance reflects only part of them. That part of the light which is not reflected is absorbed — swallowed — by the substance, which converts it into heat.

Everybody knows that stone or sand exposed for a prolonged time to intense sunlight in the summer becomes so hot that we cannot walk on it with bare feet. We have already explained the reason for this: the sizeable constitutents of the light that are absorbed represent such a large quantity of energy that the material becomes really hot.

Parts of the light can be absorbed not only by more or less solid substances such as colored filters or liquids, but also by fog, haze, or gases.

Let us consider the various ways in which the impression of the color red can be created:

1. By direct emission of this spectral region, e.g., by appropriate radiation of the black body, or the combustion of a certain substance.
2. By a light source encased in red glass, e.g., a darkroom safelight.
3. By a white light passed through a red filter, e.g., from a projector on which such a filter has been mounted.
4. By a substance that has the property of absorbing all other parts of the spectrum and reflecting only the red region, such as a tomato or a corresponding opaque pigment.
5. By a sheet of white paper that has been covered with a red transparent layer.

Only the first case has nothing to do with subtraction. Here we have radiation that consists of the red spectral region only. In the other four cases, however, the color has always been created by subtraction. In all four examples white light was present at the beginning from which at some stage spectral portions were taken away by subtraction so that only red was left. It makes no difference at all whether the absorption occurred in the glass of the darkroom safelight, in the filter, in the skin of the tomato, or in the color layer on the white paper. This illustrates that a layer of transparent color applied to white paper is in principle exactly the same as a color filter inserted in a beam of light. The color layer absorbs the same spectral regions as the color filter. As only a part of the white light can pass through the red filter in front of the projector, so only a part can pass through the red color layer on the paper. The residual, unabsorbed rays reach the surface of the paper where they are reflected. To emphasize it once more: reflection takes place on the white paper surface, not in the transparent color layer. It is nevertheless usual to speak of the reflectance curves of transparent colors too, although they are strictly absorption curves, because, as we have seen, this colored substance itself can reflect nothing.

Subtractive colors originate in, and subtractive color mixture begins with, white as we now know; white re-

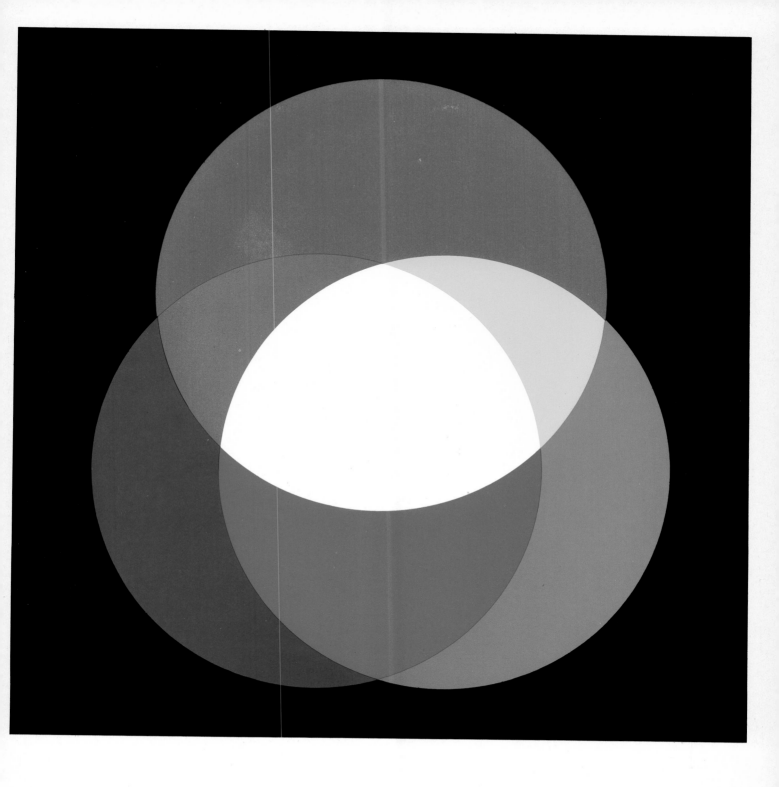

Fig. 41 The additive primaries are the one-third colors red, green, and blue. If two of each are mixed, the subtractive primaries, the two-thirds colors, are obtained. Where all three additive colors are superimposed white is the result.

presents the entire spectrum, and is therefore the 'three-thirds color' (fig. 32D). Subtractive mixture starts from here. We can now guess readily that the end point will be black, for if, beginning with white, colors are produced by subtraction, the end can only be black, i.e., the limiting point where no electromagnetic vibrations at all are left.

The subtractive primaries must logically be two-thirds colors. For if we begin with the entire spectrum, white, and produce colors by subtraction we must inevitably reach the two-thirds colors on the way from white to black before we reach the one-third ones (see fig. 33A).

The subtractive primaries are called yellow, magenta, and cyan. Each of them reflects two-thirds of the spectrum, absorbing one-third. Cyan reflects the blue and the green spectral regions and absorbs the red. Yellow reflects green and red, and absorbs blue; lastly, magenta reflects blue and red and absorbs green. We were already able to study this in detail in fig. 32.

In body colors, the absorbed part of the light always corresponds to the complementary color of the reflected hue. For the absorbed and the reflected parts together after all produce the previously present white light, i.e., an equal-energy spectrum.

In other words: yellow is produced if the blue region is subtracted from the white light by absorption; the red and green regions are left. Magenta is produced by absorption of the green region, with red and blue left. Cyan is produced by absorption of the red region, with green and blue left.

But what happens if we 'mix' two subtractive primaries 'together'? Let us begin with the simplest example: white light is beamed at a white surface with a projector. This achromatic, white, three-thirds hue contains all the colors possible. We now introduce into the beam the color filter of a subtractive primary, e.g., magenta, that removes the green region from the light; the blue and the red rays pass through the filter and reach the white wall. Naturally, the color impression is magenta. If we now introduce a second filter of another subtractive primary color, e.g., cyan, into the beam behind the magenta filter, the following occurs: the magenta light transmitted by the magenta filter, consisting of the blue and the red region of the spectrum, reaches the cyan filter. This absorbs the red region and transmits only the blue region, which is able to reach the white wall and produce the impression of 'blue' there. If we now introduce the third subtractive primary, i.e., yellow, in the beam behind the two others, the blue region of the spectrum will be absorbed, and no visible light at all will be able to reach the white wall through this combination of three filters. The color impression is black.

The situation is exactly the same if we work with layers of transparent colors on a sheet of white paper. In fig. 43 various color layers are overprinted on white paper so that they partially overlap. Fig. 43A shows that where cyan and yellow overlap, green is the result. The two two-thirds colors cyan and yellow have produced the one-third color green. In fig. 43B yellow and magenta overlap, resulting in red. Here too, a mixture of two two-thirds colors produces a one-third color. Fig. 43C illustrates accordingly the creation of blue from magenta and cyan.

Fig. 44 represents the complete scheme of subtractive mixture. The basis is the white paper. Where only one color layer covers the paper, two-thirds of the spectrum are reflected; these are the subtractive primaries cyan, yellow, and magenta. Where two overlap, the one-third colors blue, green, and red are produced. Where black appears in the center of the picture, all three subtractive primaries are superimposed.

What has been demonstrated in figs. 43 and 44 is shown once more in cross section as it were in fig. 45. The white paper (A) is capable of reflecting all the visible electromagnetic vibrations incident upon it. The reflection is reduced by the violet region if a layer of yellow color (B) is applied to the paper. In the illustration the red, green, and blue regions of the spectrum are symbolized by arrows. The blue arrow does not penetrate the yellow layer; this means that this spectral region is absorbed. The two regions red and green can pass through the yellow layer, reach the white paper surface, which reflects them; they now enter the eye of an observer. The impression of a yellow hue is created.

If we now coat the magenta layer (C) on top of the yellow layer, the green region is absorbed first as can be seen in the center of the illustration. The red and blue regions can pass through the magenta layer and reach the yellow layer. This absorbs the blue region, only transmitting the red one; this is incident on the white paper surface, from where it can be reflected into the eye of an observer.

If, lastly, the cyan color (D) is coated on these two layers as shown on the left of the picture, the red region will be absorbed by it. Cyan transmits the green and blue regions, green is absorbed by the magenta layer, so that only the blue region can pass through this. It reaches the yellow layer, where it is absorbed in turn. No other visible rays are left that could fall on the paper surface and be reflected by it. The color impression is black. Here we must return once more to fig. 33, where the additive mixture was already explained by the combination scheme on the left. It can now also be used to illustrate subtractive mixture. Whereas the additive mixture begins with black at the bottom apex, the subtractive mixture begins with white at

Fig. 42 If the intensity of an additive primary color is divided into nine equal values, 'color values' are obtained; they are diagrammatically represented in (A).

(B) and (C) show how mixed colors are produced by the numerical variation of color values. (B) is a tinted value, (C) a dark, impure green.

Fig. 43 The examples (A), (B), and (C) show the system of subtractive mixture with overprinted color layers. Where two subtractive primaries are overprinted at maximum saturation the colors green, red, and blue are produced.

Fig. 44 The basis of subtractive mixture is white, i.e., a background that reflects all the incident light. Each subtractive primary takes one-third of the spectrum away from the reflection. A one-third color is produced by two two-thirds colors each. If all three subtractive primaries are superimposed in layers of maximum saturation, black results.

Fig. 45 The spectral regions of white light — red, green, and blue — are diagrammatically represented as arrows. A yellow layer of color (B) is applied to the white paper surface (A). The blue spectral region is taken away from the white light (on the right of the illustration). (C) and (D) show how the green and red regions are taken away.

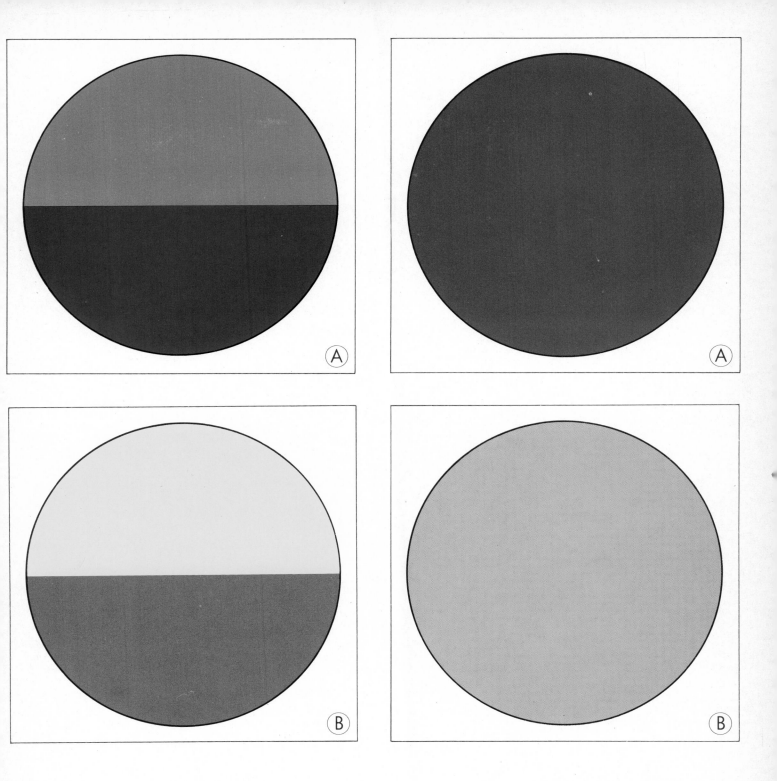

Fig. 46 On a disc revolving at sufficient speed body colors are mixed additively. Red and blue produce a shaded magenta (A). Logically, two subtractive primaries, e.g., magenta and yellow, mix to give a tinted color (B).

the top. From there we obtain the two-thirds colors magenta, cyan, and yellow. The subtractive mixture of two of these always produces a one-third color, which is located on the next-lower plane. For when two two-thirds colors are mixed, that third is left that in each of the two original colors was present as potential reflection or transmission. This is how the colors blue, red, and green are produced. From there we obtain black, which results when all three primary colors become fully effective in subtraction.

Color photography (transparencies and cine film) is based on the principle of subtractive mixture. So is printing technology if transparent inks are used. With screen printing, however, additive mixture is involved in addition to the subtractive method as we shall see presently.

In this chapter we explained only the principle of subtractive mixture. As we progress farther, we shall deal in great detail with the production of the various hues with this method.

Simultaneous additive and subtractive mixture

Body colors, whose color impression is always caused by the subtraction of spectral regions from white light, can also be mixed additively. More precisely, it is not the body colors themselves that are additively mixed, but their reflections. This can be illustrated most lucidly with a revolving disc. Fig. 46A, left, shows the area of such a disc, half of which is covered with blue, the other half with red. At a high enough speed of rotation, i.e., faster than 24 r.p.m., the separate colors can no longer be distinguished on the disc, their reflections blend.

Naturally the resultant magenta on the right cannot be a two-thirds color that looks exactly like the subtractive primary magenta. For each portion of the revolving disc reflects only one third of the spectrum, the red on the red half, the blue on the blue half. The product of the additive mixture of red and blue must therefore be located on a straight line connecting magenta and black in the same plane as the one-third colors in the diagram of fig. 33A.

The situation is analogous when two subtractive primaries are mixed additively. The product is inevitably much lighter because every portion of the disc reflects two thirds of the spectrum. Fig. 46B shows this. On the left the colors yellow and magenta are applied to the two halves of the disc, on the right a tinted red is obtained, which in the diagram of fig. 33A must be located exactly halfway on the line connecting red and white. In this experiment, naturally no fully saturated red can be produced, because the optimum red is a one-third color, but two thirds of the spectrum are reflected throughout by the disc.

The following simple calculation applies to fig. 46B: yellow = one-third color red + one-third color green. Magenta = one-third color red + one-third color blue. The three one-third regions blue, green, and red mix additively to produce an achromatic radiation energy that tints the non-compensated red region.

Additive mixture of subtractive colors can be brought about not only by rapid movement, but also by the break-up of the colored areas into tiny elements or dots so small that the eye can no longer see them discretely. This is the method adopted in high-quality multicolor printing. In a 155-screen in four-color printing, 14,400 screen dots occupy a single sq.cm. The resolving power of the retina of the eye is not high enough to make them separately visible.

This effect of additive mixture when colored areas are broken up into tiny elements is shown in fig. 47. Here we have a coarse screen, whose structures complement each other so that the blue at about 45 per cent precisely matches the red at about 55 per cent. In a perfect print, the white of the paper base must not appear anywhere in the picture.

Here only 100 blue and 100 red, i.e., altogether 200 screen dots occupy 1 sq.cm. The further away the observer moves from the print the more difficult he will find it to recognize the individual screen dots. Already at a distance of only a few steps he will see only a single hue in the entire area. Whereas he will at first have seen the different colors red and blue clearly (if necessary through a magnifier), they now merge into a dark, shaded magenta. The result looks quite similar to that of fig. 46A, because the original colors and the system of mixture are the same. Only the quantitative distribution of the two colors is, for technical reasons, slightly different. Whereas each color occupied exactly half of the revolving disc, the screen picture contains about 10 per cent more red than blue. Naturally, a deviation of the hue from the theoretically expected result can occur both in the experiment described in fig. 46 and in that of fig. 47. This is explained on the one hand by inadequate absorption and reflection of the inks used, and on the other by the variation in the saturation at which they were laid on.

In printing techniques subtractive colors are produced whenever any pigments or pastes are used. In multicolor screen printing subtractive mixture occurs when at least two transparent inks are superimposed.

Fig. 48 shows a highly magnified three-color screen print of a gray tone value consisting of 20 per cent cyan, 15 per cent yellow, and 12 per cent magenta. In the box at bottom right this tone value is printed with a 155-screen. The rest of the picture shows the same tone value highly magnified. The magnified screen structures contain no

Fig. 47 On this illustration the additive mixture of red and blue can be studied. The two additive primaries in the box are printed together as integrated screen formations, with red at a higher percentage than blue. The screen dots should preferably be looked at through a magnifier.

additive mixture because all the picture elements are large enough to be discretely perceived by the retina. In the box, however, additive mixture joins the subtractive method. Here the multicolored picture of the screen dots disappears and all that can be seen is a uniform blue-gray hue. This color impression is caused by the additive mixture of the color stimuli of all the individual colored screen dots.

All the components of the screen picture have additively merged into a uniform tone value. The cyan, yellow, magenta, red, green, blue and black values have mixed together with the blank white paper surface according to the same principle as shown in fig. 47.

Possibilities of modifying a color

In the chapter on the subtractive mixture the scheme of the laws governing the mixture of body colors has been explained in outline. It represents, as it were, a functional framework, the limiting cases of subtractive mixture.

Let us now look for a system that demonstrates the relations between the colors in detail. It should cover all the hues that can possibly be created by the mixture of the three subtractive primaries. The arrangement of the mixed hues in this system should be designed to illustrate the quantitative relation between each hue and the various primary colors and the relation between each hue and the entire system.

We must begin with the consideration how a given subtractive primary color can be changed at all. Imagine a paintpot, a brush, and a sheet of white paper. How can we demonstrate with these tools the possibilities of change of the primary color to be examined? This is obviously not very difficult. Let us begin with the two extremes. Either we apply no color at all to the paper, when we shall have white. Or we apply as much of it as possible, and shall achieve maximum color saturation. This 'as much as possible' merely means 'enough for maximum saturation'; to apply more paint is quite pointless as we have already learned.

The question we have just asked is really already answered. All the hues possible with this one available body color are situated between these two extremes, the white of the paper and maximum saturation. The number of hues is infinite, because the color intensity increases continuously as the point moves from white to saturation, as fig. 49A shows. This representation is also called continuous graduation. The reason why it is also called 'color wedge' is shown in fig. 49B. If we enter the color proportions on a graph, we find no saturation at all on the right at 0 per cent, and full saturation on the left at 100 per cent. Such a graphical representation of the quantity of color applied to the paper has the shape of a wedge.

It is of course pointless to operate with an infinite number of saturation grades of a subtractive primary color. The human eye is quite incapable of perceiving a very large number of differences in saturation in such a color graduation. Depending on how much optically darker or lighter a color is a larger or smaller number of saturation grades can be distinguished. With black, optically the darkest color, this number is obviously highest. But it is futile to divide a tone range into more than thirty or at most forty steps.

Fig. 49C illustrates the development of a step wedge from the continuous color wedge B. Ten steps can be seen. Step 0 in the right indicates the total absence of any saturation ratio of this color. Step 9 indicates full, maximum saturation. The total number of ten steps makes the use of a decadic system possible.

Step 1 of course does not denote 10 per cent, but 11.11 per cent saturation. Accordingly, step 2 = 22.22 per cent, step 3 = 33.33 per cent, and so on. Step 9 represents 99.99 per cent, which is near enough 100 per cent.

Fig. 49D shows such a graduated saturation, divided into ten steps, for each of the three subtractive primaries.

The possibility of change in a single subtractive primary color is therefore unidimensional. This, naturally, also applies to any other color irrespective whether it is a body color or a colored light. A single color can be changed from full saturation to complete disappearance. All the possible grades of saturation are located on a straight line connecting these extreme points.

Possibilities of mixing two colors

The mixture possibilities of two colors cannot be represented in one dimension. A plane is required for a meaningful schematic arrangement. The second color calls for a second dimension.

If all the results of mixture possible between two random original colors are to be made visible in a plane the four corner points of this representation will be as follows: firstly and secondly the two original colors themselves, thirdly their complete mixture, and fourthly white. If we now look for a suitable area to represent the relation on which this mixture is based, the square offers itself.

Each of the two colors is arranged so that it continuously graduates from one side of the square to the opposite side. At the side where the graduation begins the color must be at maximum saturation. The saturation progressively decreases towards the opposite side, which must be completely without color. Fig. 50 shows such a graduation in cyan. In practice it is a continuous color wedge broad enough to cover the entire area.

Fig. 48 Normal color printing is carried out with the subtractive primaries yellow, magenta, and cyan. The gray area in the little square is composed of fine screen dots of these three primaries. The large area shows these screen formations at high magnification. The mixture here is both subtractive and additive.

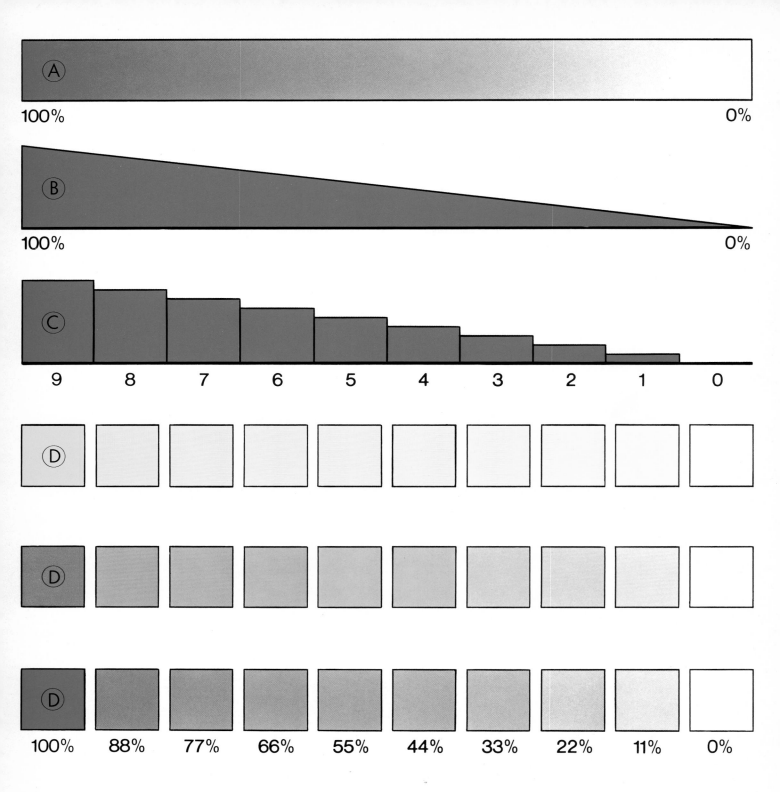

Fig. 49 (A) illustrates the continuous graduation of a color from maximum saturation to complete absence. (B) is the diagrammatic representation of the quantitative relations. (C) shows the conversion into ten saturation grades, and (D) the grades of the three primary colors.

Fig. 51 shows the same graduation in magenta. The only difference is that it runs from bottom to top instead of from left to right.

These two graduations of the subtractive primaries cyan and magenta are superimposed in fig. 52. The abundance of all the possible mixture proportions and changes in these original colors has now become visible. The two graduations proceed at an angle of 90°. In this arrangement the four corners of this square have the originally required colors cyan, magenta, blue, and white.

In theory, this area consists of an infinite number of colored dots, of which each has a different mixture proportion of the two original colors. There is a fixed mathematical relation between the distance of the colored dot from the sides of the square and the ratio of the mixture of which it consists. This can be clearly seen on the two scales of the percentage values for each graduation direction. From the location of the dot in the area both the composition of the hue of its original colors and its appearance can thus be clearly defined. If a vertical line is drawn from any point of the area to the bottom scale the percentage of the original color cyan can be read off. A horizontal line to the scale along the left side of the square indicates the percentage of magenta.

All mixtures of the same proportions of cyan are on a vertical line above one another, all those of the same proportion of magenta on a horizontal line next to one another. These are lines of equal saturation for each of the original colors. If, for instance, a mixture consists of 70 per cent cyan and 30 per cent magenta, this dot must be located on the saturation line of 70 per cent of the cyan and on that of 30 per cent of the magenta graduation. This also determines the distance of this colored dot to the 0 per cent saturation lines of both cyan and magenta. For the distance of this colored dot from the 0 per cent saturation line of cyan is 70 per cent of the total distance between the two sides of the square.

By means of the two distance values to the 0 per cent saturation lines of cyan and magenta respectively the location of each colored dot in the area can be precisely calculated. These two values give a clear indication of the mixture ratio of the colors applied to the paper on any point of the area.

As we have already observed, it is pointless in practice to work with an infinite number of colored dots. This area graduation must therefore also be converted into steps as has already been explained in fig. 49. Thus each graduation is divided into 10 grades of saturation, so that the square is divided into 100 little squares. Only now is it possible to see quite clearly how the adjacent squares differ from one another. From the infinite number of

colored dots of fig. 52, 100 equidistant color hues are thus chosen in fig. 53. A logical scheme of mathematically precise relations has been established.

The color cube

The abundance of color variations that can be mixed with three colors can be no more represented on a plane than the possibility of mixtures of two colors on a straight line, i.e., in one dimension. The third dimension is required for the representation of the possibilities of three-color mixture.

The relations between the three colors and the laws of color mixture can be demonstrated only in a color space. Since this has concrete boundaries it is always a geometrical body. It is called a color solid, because the colors are arranged in it according to a certain system.

The previous chapter showed the square as the optimum area for the demonstration of the possibilities of two-color mixture. Logically, the solid doing the same for three colors should be a cube.

We all know that a cube is bounded by six squares. Each opposite pair of squares determines the penetration direction of a primary color. Each of the three primary colors traverses the solid so that it is present at full saturation in one face and that its saturation progressively decreases, until, on the opposite face, the proportion of this color is nil.

Analogously the same happens as has been shown in figs. 50 and 51. But unlike these illustrations of graduations across an area, the graduations now occur in a solid space. The three different penetration directions of the subtractive primaries are demonstrated in figs. 54A, B, and C. In A it is cyan which traverses the solid from the front to the rear face, in B magenta traverses from right to left, and in C yellow from top to bottom.

Lastly, fig. 54D shows the cube from the same perspective with all three primary colors arranged simultaneously.

Which colors must we expect to find in the eight corners of the cube? Fig. 59 gives us the answer. White is where the color proportion of all three primaries is nil. Diagonally opposite all three primaries are fully saturated, producing black. The remaining six corners are occupied by the six primaries, i.e., the three one-third colors and the three two-thirds colors.

Naturally, the color space, too, contains an infinite number of colored dots. It is necessary for the sake of clarity to proceed in much the same way as we have done in fig. 53 when we divided the area into saturation grades. According to the suggestion by Alfred Hickethier the cube is divided so that 1000 points of intersection are produced.

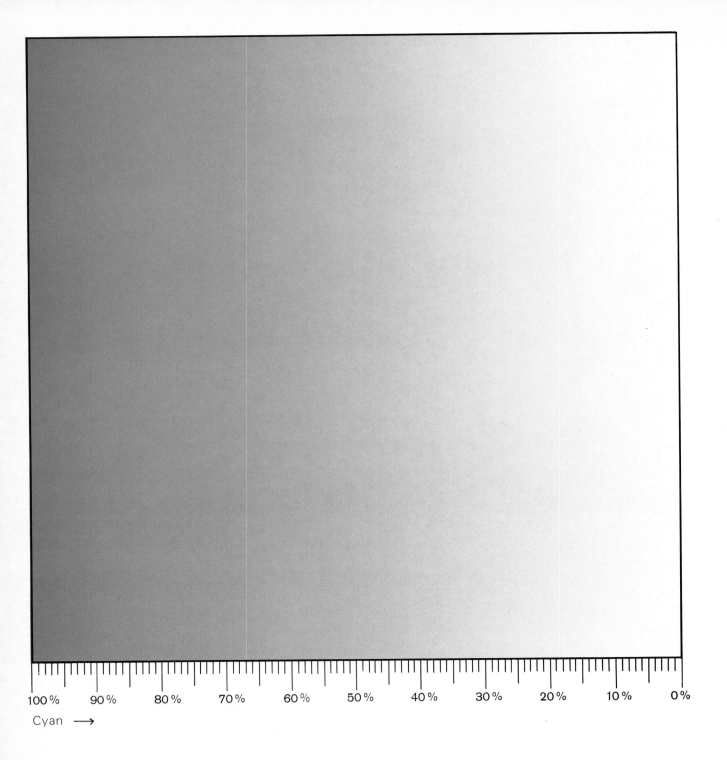

100 % 90 % 80 % 70 % 60 % 50 % 40 % 30 % 20 % 10 % 0 %

Cyan ⟶

Fig. 50 Graduation of cyan. Parallels to the vertical sides
are lines of equal saturation. The saturation value can be
read off the scale along the bottom.

92

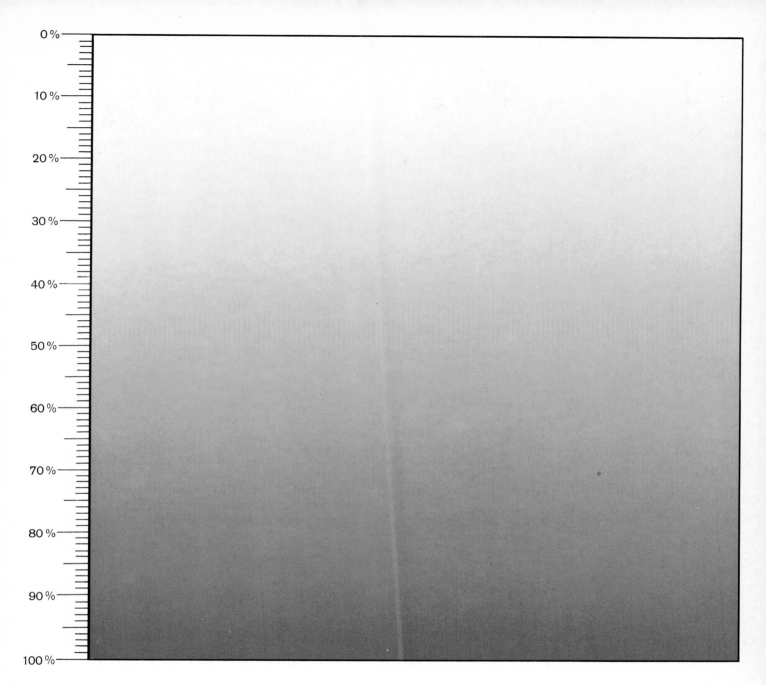

Magenta

Fig. 51 Graduation of magenta. Parallels to the horizontal sides are lines of equal magenta saturation. The saturation value can be read off the scale on the left.

Magenta

Cyan ⟶

Fig. 52 The graduations of cyan (fig. 50) and of magenta (fig. 51) are overprinted. This produces all the mixture variants possible. By drawing a vertical line one can determine the mixture ratio of cyan, and by drawing a horizontal line that of magenta, of any desired point in the square. The percentages are read off the points of intersection with the respective scales.

94

It is cut parallel to its faces at eight equidistant intervals between two pairs each of opposite faces. Including these two faces there are now ten planes in each direction. Since there are three cutting directions, they result in 1000 points of intersection.

Fig. 55 shows the vertical faces of the cube of fig. 55D (but divided into saturation grades). In fig. 56 we see the base on the left, and the top on the right.

It is already known that the penetration direction of yellow in this geometrical body is vertical. This means that in the top face yellow is present at full saturation in every color hue. In the base yellow is absent from all hues. Horizontal sections through his cube produce planes of equal yellow saturation. The closer a horizontal section is to the base, the smaller is the proportion of yellow of every hue. Figs. 57 and 58 show the eight sections between the base (fig. 56A) and the top (fig. 56B).

The ten planes of figs. 56, 57, and 58 are the sections of the subtractive primary yellow. The arrangement is analogous to the ten sections of the subtractive primaries cyan and magenta respectively.

The distances of any colored dot from the three cube faces, which in this system are the reference planes, precisely define not only its position in the continuous color solid but also the proportions of its mixture, for these distances to the associated reference planes correspond to the degree of saturation of the primary color concerned.

The three reference planes for the subtractive primary colors used all meet in the white corner.

A colored dot, for instance, which is at a distance of 33 per cent (of the total distance between the relevant two opposite faces) from the reference plane, has a saturation value of 33 per cent in the primary color concerned.

A certain colored dot that is at a distance of 33 per cent from all three reference planes thus has a proportion of 33 per cent saturation in each of these colors.

Obviously we must not overlook the fact that we cannot conduct practical experiments mixing some paste paints according to these rules and expect to be successful. We cannot simply mix these paints in a pot and apply the product to the paper. The laws of subtractive mixture are valid only when transparent color layers are superimposed. The direct mixture of paste paints or pigments is subject to the laws of integrated mixture.

The color cube in fig. 59 stands on its black corner. The white corner points upwards. Careful study of this representation reveals that we have already seen a closely similar one in fig. 33A. Basically the colors are arranged according to the same system in both instances.

Hickethier's color code

It was Alfred Hickethier's idea to give color hues code numbers. He suggested the division of the saturation progression of a primary color into ten steps, numbering them 0–9. We have already done this in fig. 49.

The 1000 intersection points produced when the penetration direction of each primary color is divided into ten saturation planes can now be very neatly defined by three-digit figures. 1000 numbers are available between 000 and 999.

Hickethier has called this system 'numerical order'. For the individual digits of a number indicate the proportion of one of the three original colors in the relevant mixture. We must emphasize that this numerical system is subjective, because it refers to the three closely defined existing original colors used in a special case. Since these original colors may have quite different reflecting properties, given mixture proportions but other original colors can produce different mixture results.

The system is nevertheless eminently suited to familiarize the novice with these relations.

The color cube shows all the possibilities of mixture imaginable of three primary colors. Since three components are concerned in the technical application of subtractive mixture (color photography, multicolor printing), it is possible to indicate the proportion of each primary color with a three-digit number.

In the top of fig. 60, we see the step wedges for the three subtractive primaries with the corresponding code numbers. The first digit denotes the yellow, the second the magenta, and the third the cyan component. As we already know, the yellow saturation grade 5, code number 500 (i.e., 0 parts magenta, 0 parts cyan) indicates a saturation of 55.55 per cent, not 50 per cent. The same of course applies to all the other grades. Saturation grade 090 means 99.99 per cent (which we can treat as 100 per cent) magenta saturation.

The composition can be easily found in every color code number. Three hues have been chosen at random in the bottom part of fig. 60, with their code number below. On the right of each hue its composition of the individual saturation grades of yellow, magenta, and cyan is shown. For better understanding the associated code number is printed below each of the three circles. The saturation grades can be added up arithmetically:

$$
\begin{array}{r}
700 \\
+\ 060 \\
+\ 002 \\
\hline
=\ 762
\end{array}
$$

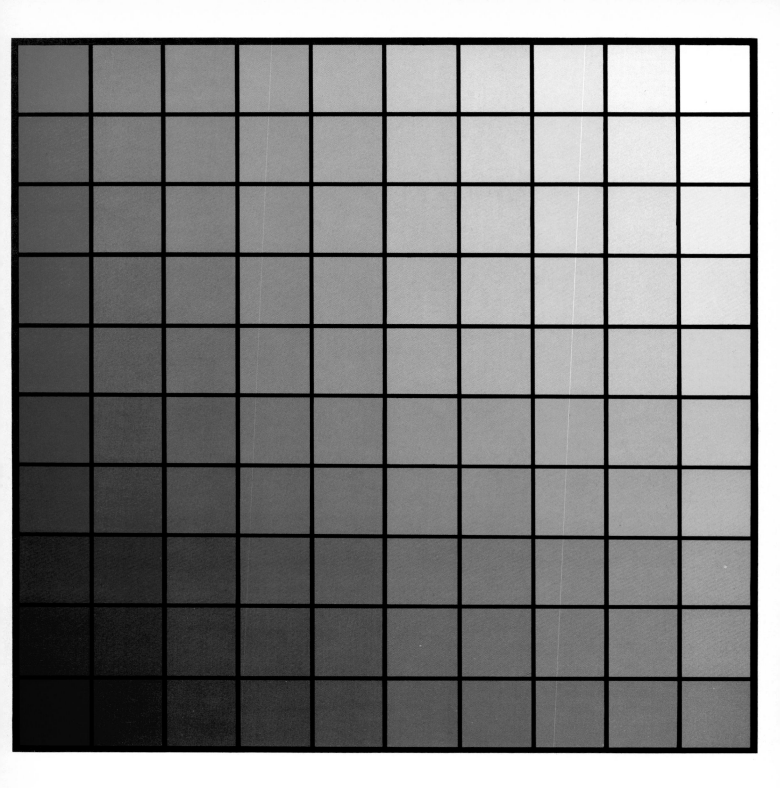

Fig. 53 The order of the hues is basically the same as in
fig. 52, but the graduations have been divided into 10
steps. This produces 100 mixed hues of cyan and magenta.

96

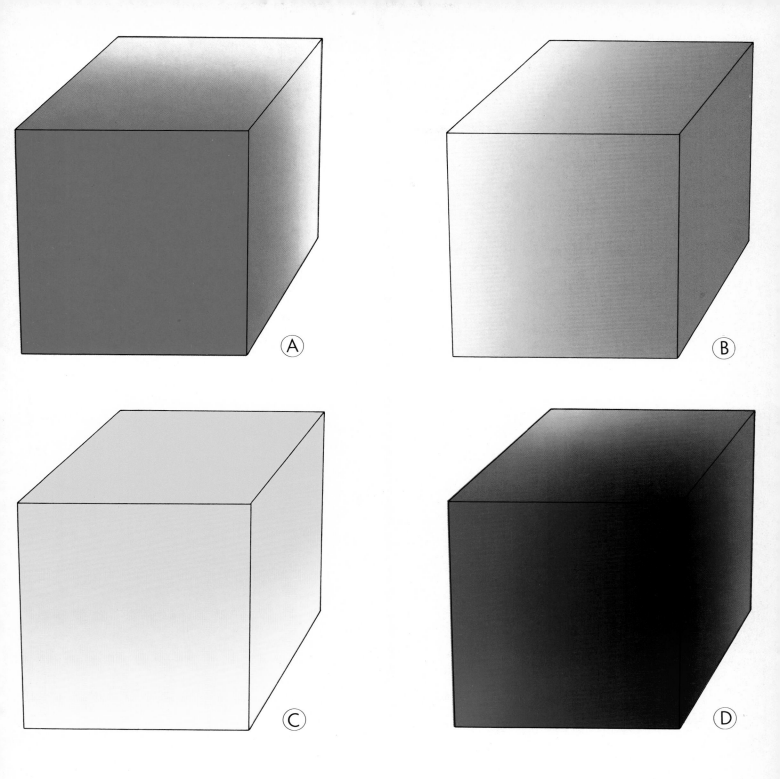

Fig. 54 As we require a plane for the representation of the possible mixtures of two subtractive primaries, we require a geometrical body for the representation of the possible mixtures of three subtractive primaries. Starting from the square of fig. 53, we develop the cube. In (A), (B), and (C) the three traversing directions of the subtractive primaries are shown individually, and in (D) together.

◁ Fig. 55 If the cube stands on the base of fig. 53 where
yellow values are completely absent, the saturation value
continually rises from the base to the top. This can be seen
on the four vertical faces shown here, in which the gradu-
ation of yellow from the bottom to the top is demon-
strated. The narrow strips at top and bottom and between
the fields provide information on the graduation.

△ Fig. 56 Yellow graduation progresses between the base
(A) of the cube and its top (B). No mixture of (A) con-
tains any part of yellow. The closer a point in the geo-
metrical space of the cube lies to the surface, the greater
its saturation value of yellow. In the surface itself yellow
is a component of every mixture at maximum saturation.

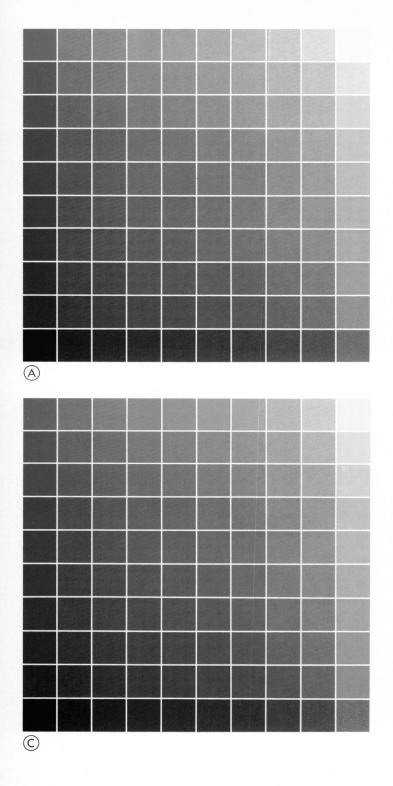

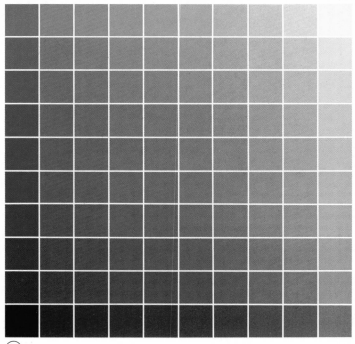

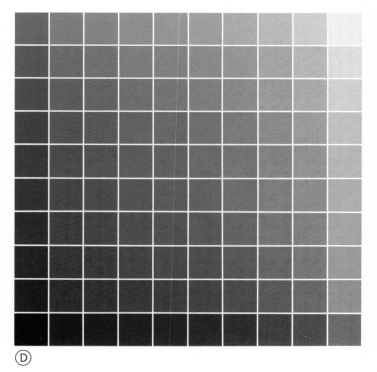

Fig. 57 If eight saturation sections for the primary color
yellow are cut between the base and the top of the cube
shown in fig. 56, the planes (A), (B), (C), and (D) are
obtained. Their yellow saturation values are: A = 11.11%,
B = 22.22%, C = 33.33%, D = 44.44%.

100

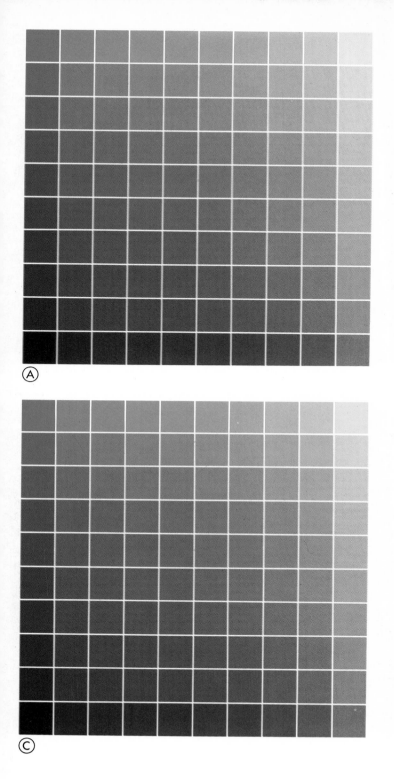

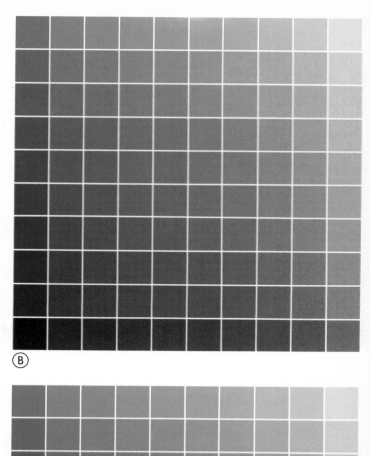

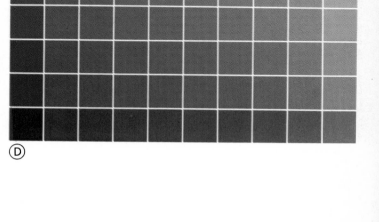

Fig. 58 These are the four further saturation sections for yellow in the cube; their values are: A = 55.55%, B = 66.66%, C = 77.77%, and D = 88.88%.

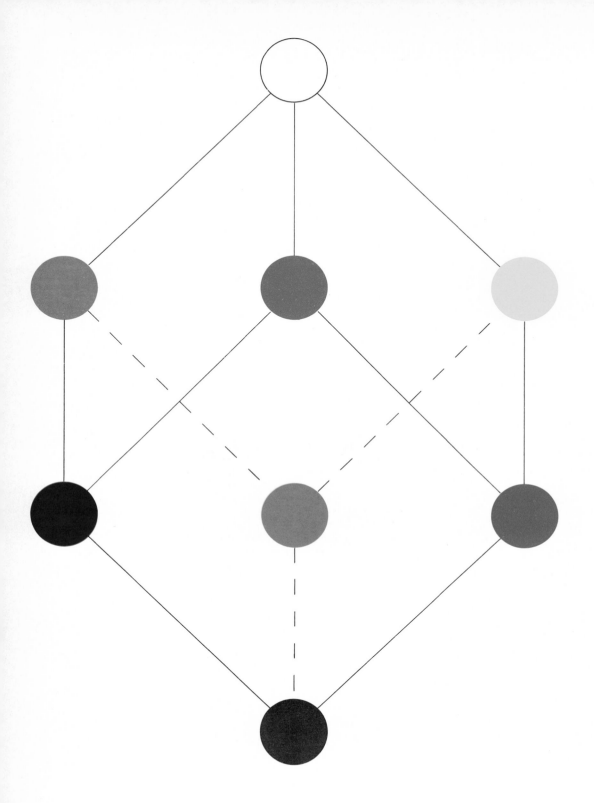

Fig. 59 If the color cube is stood on its black corner, the gray axis runs vertically upwards to the white point. The closer a point in this color space to white, the brighter it must be. The one-third colors blue, red, and green lie closer to black, the two-thirds colors magenta, cyan, and yellow lie closer to white.

In this system 000 denotes the absence of all saturation from each of the three subtractive primary colors. No color at all was applied to the white paper in this area. 999 denotes the presence of all three primaries at full saturation, i.e., black. A number of three identical digits always indicates an achromatic hue, provided of course that the original colors are subtractive primaries meeting the gray conditions, i.e., that they always produce gray when they are mixed in equal parts. 333 for instance will be a light gray, 666 a dark gray.

A number containing a 0 always denotes a pure mixture of two primaries, one containing two 0s always indicates a certain saturation grade of only one primary color.

In the chapter 'Complementary colors' it was pointed out that the maximum complementary color of a certain hue is the difference between this hue and black. In Hickethier's system this would therefore be the difference between a given hue, e.g., 037, and 999:

$$\begin{array}{r} 999 \\ -\ 037 \\ \hline 962 \end{array}$$

The minimum complementary color, on the other hand, is represented by the number necessary to bring all the figures of a certain hue to the lowest common value. If we take our number 037 again, we obtain the following constellation:

$$\begin{array}{r} 037 \\ +\ 740 \\ \hline 777 \end{array}$$

Hence, the maximum complementary color of 037 has the number 962, the minimum the number 740. The range of complementaries for the hue 037 occupies the straight line between the dots 962 and 740 in the color space.

We must of course remember that the practical determination of the complementary color in this way is inaccurate and faulty, since it disregards inadequate absorption and inadequate reflection of the original colors. Nevertheless, this number system enables us to obtain a quite concrete idea of the theoretical basis.

It is also interesting to investigate the achromatic factor of a hue chosen at random. This could also be described as shading, subduing or breaking. In any given code number, the highest common value always represents the gray value, the achromatic portion of the mixture. The hue 428 can be split up into a gray component and a color component. The highest common value is 222. Added to this is a color component of 206. Here is the calculation:

$$\begin{array}{r} \text{Gray value } 222 \\ \text{Color value } \underline{206} \\ 428 \end{array}$$

The various figures of a code number can, according to the subjective execution of the system, mean proportion of weight, or of area in screening (screen printing), or absorbing power (color photography).

Ostwald's pyramid (double cone)

At the beginning of the century Professor Wilhelm Ostwald created a color system which was a considerable improvement on the previously known systems.[8] It is sometimes still used today.

The starting feature for Ostwald's considerations was the color circle already shown in fig. 35. This color circle, he thought, contained all the monochromatic colors. He assumed that it would represent all pure colors at maximum saturation when the two ends of the spectrum are joined through the magenta hues.

Ostwald's system is based on the fact that every hue of this color circle is modified towards white and black.

All possibilities of modification between any color and white and black can be systematically arranged in a triangle. Fig. 61 shows such a 'triangle of equal color tone', whose three corners are formed by a green tone, white and black. The straight lines connecting the corners represent the possibilities of modification of this tone to white and to black, and lastly the gray axis, i.e., the connection between white and black.

If we imagine this triangle of equal color tone to be made of card and standing vertically on its black corner as shown in fig. 61, a rotary motion around the black-white axis will produce the shape of a double cone in fig. 62. The double cone is therefore a color solid for an infinite number of triangles of equal color tone. For each single one of this infinite number of tones on the color circle has in theory its own triangle of equal tone.

Since it is, however, pointless because of the inability of the human eye to record slight differences in tone value to operate with infinite numbers of color tones, Ostwald divided his double cone into twenty-four triangles of equal tone, where the saturated color always corresponds to a hue on the twenty-four-sector color circle of fig. 35.

We can indeed imagine that a large number of tones can be mixed if in addition to a pot of a certain color a pot of black and a pot of white are available. This is how we must imagine the origin of the triangle of equal color tone. The pure saturated color is in the corner on the left of fig. 61. The next field in the direction of white is mixed

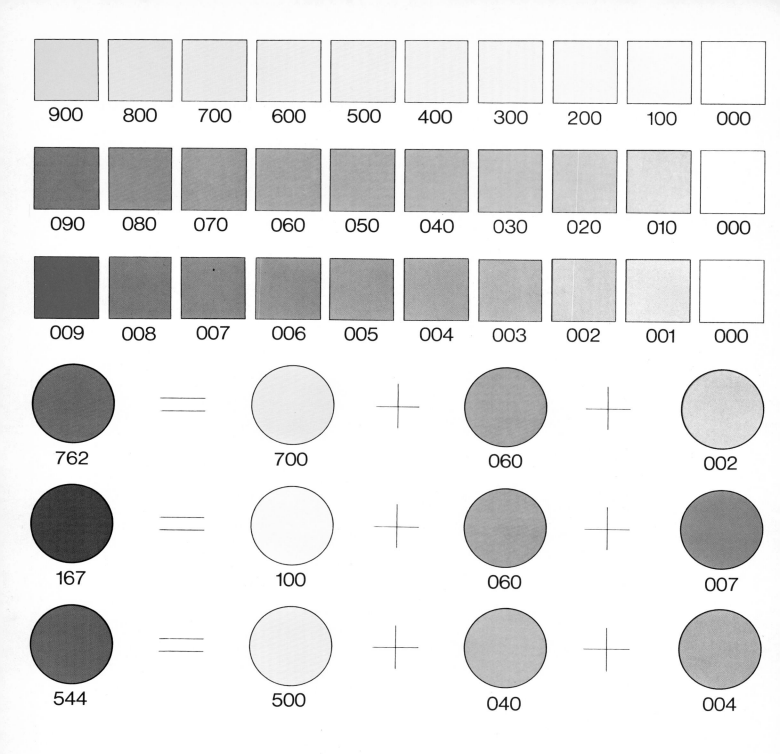

900	800	700	600	500	400	300	200	100	000
090	080	070	060	050	040	030	020	010	000
009	008	007	006	005	004	003	002	001	000

762 = 700 + 060 + 002

167 = 100 + 060 + 007

544 = 500 + 040 + 004

Fig. 60 Hickethier's color code allots three-digit num-
bers to 1000 hues. The top of the illustration shows the
code numbers given to the various saturation grades of the
primaries. Below are examples of mixtures, in which the
saturation values of the individual primaries can be recog-
nized.

Fig. 61 Ostwald's system is based on the colors of the color circle. Every single one of the infinite number of colors of the color circle can be modified towards black and towards white. A triangle in which one of these colors as well as black and white are arranged in the three corners Ostwald calls a 'triangle of equal color tone'.

with a certain proportion of white, the following with a larger proportion. The pure tone becomes lighter and lighter, until in the apex of the triangle only the white of the paper is left.

The situation is analogous along the base of the triangle. The proportion of black increases the more closely the tone approaches black.

The connection between black and white, i.e., the vertical side of the triangle, shows pure gray steps.

All the hues of this triangle are systematically arranged. Colors which have the same saturation proportion of the chromatic original color always occupy vertical lines parallel to the gray axis.

All hues containing the same white proportion are found on the lines parallel to the 'color tone — black' side, those containing the same black proportion on the lines parallel to the 'color tone — white' side.

Ostwald elaborated his system immensely and put it to practical use in his color atlas. Ostwald's color manual is published and distributed by a company in the US.[9] Fig. 63 shows it open at pages with two complementary triangles of equal color tone. This would correspond to a vertical section through the color solid along the gray axis.

This color manual contains all the hues in the shape of tablets, which can be taken out for practical comparison. They are of course also handy for color combinations and for finding out whether or not colors harmonize.

The manual is designed so that one can look at any triangles of equal color tone side by side.

Ostwald established a nomenclature for his color solid which determines each single hue. Each tablet has a number and two letters. The number denotes the hue on the twenty-four-sector color circle. The first letter indicates the white proportion (Ostwald calls it 'saturation'), the second the black proportion ('brightness'). The letter 'a' indicates the lightest variant; both saturation and the black content increase down the alphabet.

Thus, for instance hue 13 ic is found on the triangle of equal color tone 13 on the point where the 'saturation line' i intersects the 'brightness line' c.

Ostwald thought it possible to find, automatically, with the aid of a certain scheme he had established, hues that would produce optimum harmony with each other. This system has, however, been violently attacked by artists. But his ideas have been developed further. The color manual shown in fig. 63 includes a scheme that promises that color harmonies can be found systematically.

The CIE system

A system recommended by the Commission Internationale d'Eclairage in 1931 has attained great importance in science. It is known as 'Standard Valency System' or CIE system.

Scientists have to be able to rely on a system that functions with mathematical precision and permits the mathematical definition of all manifestations of color. These demands are met by the CIE system. The layman, however, will hardly be in a position to comprehend the relations, since the system is not very clear, and, in addition, mathematically very complicated.

The basis is additive color mixture; but the additive primaries are represented by monochromatic radiations instead of spectral regions; these radiations are called 'primary valencies' or 'standard valencies'. They have the following wavelengths:

Blue additive primary = 435.8nm
Green additive primary = 546.1nm
Red additive primary = 700.0nm

Fig. 64 shows a scheme of the CIE system. The black point is at the bottom. It is the zero point, the origin. From here the saturation of the primary valencies increases until it reaches its maximum at the boundary face of the system. This boundary face is also called the 'spectral color sequence'. It is shown once again in fig. 65.

The boundary line of the 'spectral color sequence' is occupied by all the monochromatic colors at full saturation. The arrangement corresponds to that of the spectrum. Blue and red, i.e., the shortest-wave and the longest-wave visible radiations are connected by the so-called 'purple boundary'. All the tones of the magenta region lie on this line.

The position of every monochromatic spectrum color in this spectral color sequence (fig. 65) is found on the basis

$$Red + Green + Blue = 1$$

Hence each color must have a value smaller than 1, since 1 is the sum of all three primary valencies. At the same time 1 = white light.

The exact position on the spectral color sequence is defined by the mathematical determination of the values X, Y, and Z for the three primary valencies. It is of course enough to enter only two of these values in the coordinate system, since the third is always the difference between the two entered values and 1.[1][1]

It is true that with the three primary valencies we can represent every hue by stating the appropriate mixture ratio of these three original colors. But it is impossible to obtain each hue at full saturation. The reason for this is that a

Fig. 62 If a triangle of equal color tone is rotated around the gray axis, Ostwald's Pyramid (double cone) is produced. All the pure colors are arranged on the surface, i.e., the connection between the colors of the color circle and the tops black and white. Ostwald called the points situated inside the body 'muddy'.

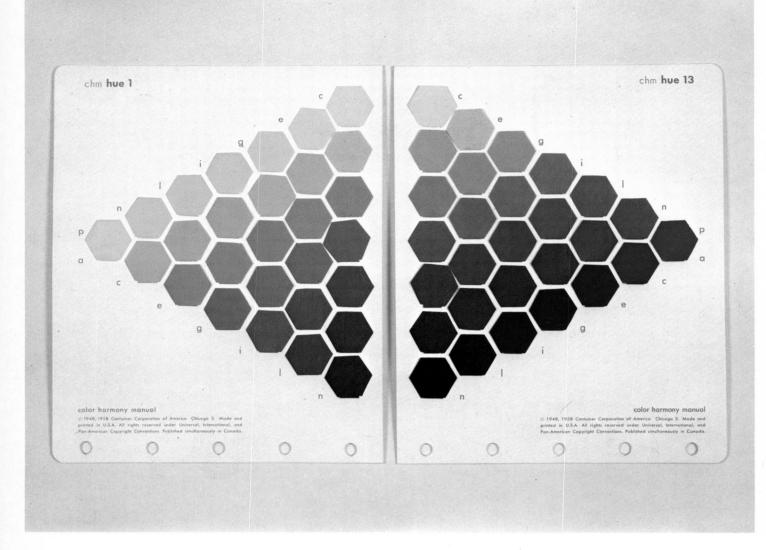

Fig. 63 Two pages from a color manual according to
Ostwald. If desired the triangles of equal color tone can
be viewed side by side. The various hues are on push-in
plastic tablets.

108

hue that can be obtained through a mixture of two primary valencies must always lie on the straight line connecting these two points. But the spectral color sequence is curved. As a result, monochromatic spectrum colors can be more saturated than the mixture of the relevant primary valencies. In addition fig. 64 demonstrates that because of the choice of the monochromatic color 546.1 for green a considerable part of the color space in the green region cannot be included at all.

A mathematical difficulty would arise because those colors outside the straight lines connecting the three points of the primary valencies that are located on the spectral color sequence would have to be allocated negative values. Parts of the cyan, green, magenta, and blue regions would be affected.

To make the mathematical aspect easier and obviate the introduction of negative values a reference system has been established in which a color space is reserved between the reference values X, Y, and Z. It is seen in fig. 64 that all the colors of the color solid proper, i.e., the irregular cone, are accommodated within this color space. X is the reference value for the saturation proportion of the primary valency 700.0 nm (red), Y that for 546.1 nm (green), and Z that for 435.8 nm (blue).

This external reference system permits the determination of every point in the irregularly-shaped color space by positive values X, Y, and Z.

Let us once more closely examine the boundary plane of the color space, the spectral color sequence of fig. 65. To begin with it is important that the point for white is situated in the central region of the plane. Depending on the type of light to which the calculations refer, the position of the white point is naturally displaced in a relevant direction, because the various types of light differ, after all, in their spectral composition. The system is therefore very well suitable for the comparison of various types of light.

The achromatic axis (gray axis) is the straight line connecting the white with the black point (fig. 64). The convex surface of the irregular cone shows all pure spectrum colors at increasing saturation. The edge of the spectral color sequence represents the monochromatic spectrum colors at maximum saturation. From the edge towards the center of the spectral color sequence the colors appear tinted until they merge into an achromatic white.

DIN 6164

The DIN 6164 System was devised by Professor Manfred Richter, Berlin. The DIN 6164 Color Chart[12] was de-

veloped through his initiative in collaboration with the Federal Institute for Materials Testing and the Industrial Standards Sub-committee on Color.

It was Professor Richter's aim to produce a color solid in which the hues are spaced at equal degrees of sensation (regular progression); his color solid is illustrated in fig. 67G.

Richter's color solid is divided by twelve vertical sections in a way quite similar to that used by Professor Ostwald's double cone. These sections along the gray axis are thus also cut in accordance with the twenty-four-sector color circle. The possible modifications of the individual tone are elaborated on twenty-four supplementary sheets. A twenty-fifth sheet shows the gray axis.

Sheet No. 3, which contains all the possible modifications of tone 3 of the twenty-four-sector color circle, is reproduced in fig. 66.

All the mixed hues of the various sheets are produced in the form of insert tablets. They can be taken out for the comparison or combination of hues. The pure tone at full saturation is always on the right in the top row of each sheet. Towards the left saturation progressively decreases until the tone of lightest saturation is reached at the extreme left. The vertical columns are headed S = 1 to S = 7, so that all hues of the same saturation are arranged in vertical columns.

The horizontal rows show the dark progression. D = 8 means darkness grade 8 or black. D = 1 is the lightest darkness grade in this system. All the hues arranged horizontally therefore have the same degree of shading or black proportion (brightness).

Each hue in this system is identified by three numbers, each separated from the others by a colon, e.g., 3:5:2. The first figure indicates the color tone and therefore the number of the tablet, the second figure the 'saturation' and the third figure the dark grade.

The DIN 6164 color chart is not only of practical use to the artist and the technologist, it also offers an exact mathematical basis to the scientist.

Critical assessment of the color systems

The physicist and mathematician Heinrich Lambert (1728–1777) was probably the first who succeeded in establishing a reference system that would cover all the manifestations of color. His color solid was a pyramid, shown in fig. 67A. The corners of the triangular base were occupied by the colors yellow, red, and blue (in those days, of course, there were no pigments of present-day standards of purity available as magenta and cyan). The black point occupied the center of this triangle. Sections through the

Fig. 64 Representation of the CIE system. One recognizes the primary valencies red, green, and blue. But since it is not possible to cover the entire color space with them, the mathematical primary valencies X, Y, and Z are used; they are represented by the black arrows. From the spectral color sequence of the surface of this system the colors become progressively darker the closer they approach the black point at the bottom corner of the system.

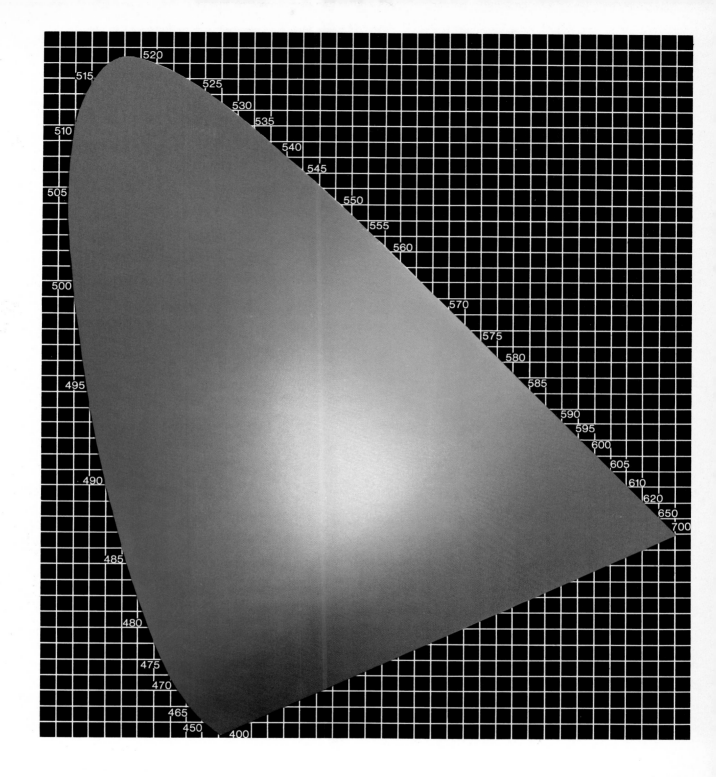

Fig. 65 This 'spectral color sequence' is the surface of the CIE systems shown in fig. 64. The monochromatic colors, whose wavelengths are given in the illustration, progress along a curve from blue to red. The straight line connection between these two points is called the 'purple boundary'. The position of the white point in this system changes with the type of light.

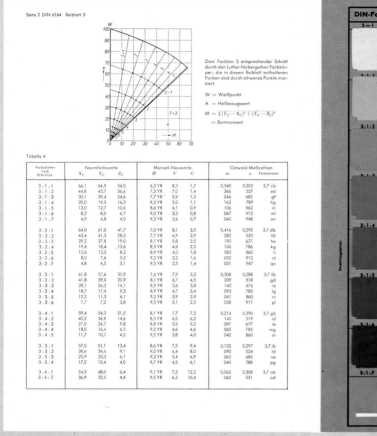

Fig. 66 The supplementary sheet No. 3 of the DIN 6164
system developed by Professor M. Richter, who has made
the attempt at an arrangement of the individual hues
according to equal degrees of sensation, while maintain-
ing the mathematical advantages of the CIE system.

pyramid parallel to the base showed colors of greater brightness the more closely the section approached the apex, which was the white point.[13]

The obvious fault of Lambert's System, the arrangement of black in the same plane as the pure chromatic colors, was already avoided by Tobias Mayer (1745), whose double pyramid shows the black and the white points equidistant from the chromatic pure colors (fig. 67B).

The painter Philipp Otto Rünge (1777–1810) arranged the colors in a sphere (fig. 67C). His continuous practical contact with colors made him think about the laws governing them. To him our earth seemed to be the right geometrical model for a color solid.[14] He therefore fashioned the 'Equator' of the circle out of the purest colors. The 'South Pole' became the black point, the 'North Pole' the white point. All the possible mixtures are located inside the sphere. The line connecting the North and South Poles is the gray axis.

It was Professor Ostwald who discovered a structural fault in Rünge's color sphere, for he noted that the colors differed less from one another the more white and the more black respectively they contained. He felt that it could not be right to accommodate the possibilities of modification of any saturated pure color towards black or white on the curved surface of a sphere, but that they should be represented by a straight line.

If according to this way of reasoning straight-line connections are established from every point on the color circle to the black point and to the white point, the form of a double cone is produced; it is shown in fig. 67D and has become known and famous as Ostwald's Pyramid.

In 1910 Prase had the idea of arranging the colors in a cylindrical form (fig. 67E). The top of the cylinder represented white; towards the bottom the colors became darker. The cylinder acquired an irregular shape ending in the black point.

Alfred Hickethier, who died a few years ago, was purely a practitioner. He came from the printing industry and knew from experience the possibilities of mixture offered by the subtractive primaries available in the printing process. He arranged his system in the form of a cube, already suggested by Charpentier in 1885 and Becke in the 1920s. Hickethier's contribution to the theory of color is therefore not the cube (fig. 67F) but his numerical system, with which it became possible to define certain hues by three-digit numbers.[15]

Whereas Lambert's, Rünge's, and Hickethier's systems were arrangements, pure and simple, of body colors, Ostwald started from the modification of monochromatic colors, i.e., colored lights whose mixtures he copied in the form of body colors. This approach, however, seems illogical because he violated the principle of monochromatic reference colors in his use of the magenta range.

The CIE system, already explained in detail (fig. 64), is, unlike the previous ones, a purely theoretical, purely scientific, purely additive system,[10] which permits the execution of exact mathematical calculations. As we have already mentioned, it is, however, rather obscure and, because of the complicated mathematical construction of the reference color sequence, can, without a thorough grounding in the subject, be understood only with difficulty. In addition it appears illogical that the optimum colors are arranged on the same plane as white.

This order resembles Lambert's, except that here the subtractive primaries are found on the same plane as black.

But the gravest disadvantage of the CIE system consists in the fact that the distances between hues in the color space are strongly distorted compared with the correct ones according to the equal degree of sensation. Nor can we easily detect a relation between the position of a color dot in the color space and its mixture proportions of the primaries. This is another reason why the CIE system proves unsuitable as a demonstration model.

In the USA in 1935 Judd was the first to attempt to eliminate the drawback of the deviation of the distances from those corresponding to equal degrees of sensation (regular progression). His system has undergone various modifications of which McAdam's (USA) is the best-known. In practice it is another version, a rectification of the CIE system with the aim of achieving approximately regular progression. In the USA McAdam's color space is often called the UCS (Uniform Chromaticity Scale) diagram.[11]

Another color system that has become widely accepted in the USA is Munsell's (see Bibliography). Munsell tried to create a system in which the equidistance between all color hues took absolute precedence. He tried to achieve this regarding not only the color tone, but also shading and saturation. The result of this is a completely asymmetrical color space.[11] Professor Manfred Richter, on the other hand, endeavoured to establish the best possible approximation of the two requirements of 'equal degree of sensation' and 'exact mathematical definability' in his DIN 6164 color chart (fig. 67G).

The empirical constructions by Lambert, Mayer, and Rünge were considerably improved by Ostwald's Pyramid. The triangles of equal color tone were able to contribute much to the understanding of the relations in the color space. Through the arrangement according to hue, 'bright-

ness', and 'saturation' each point in the color space could be exactly determined and calculated. The logical error of Ostwald's construction consists, in the author's view, in the fact that all saturated pure colors are of equal importance on the color circle and have equal distances to black and white. And if the primary colors are accorded a special position corresponding to that of white and black, their interconnections must, even according to Ostwald's logic, represent straight lines — which precludes the arrangement on the color circle.

Charpentier's cube, which Hickethier used, does not commit this error (see fig. 59). If it is placed on its black corner, the one-third colors blue, green, and red are nearer to the black point than the two-thirds colors yellow, magenta, and cyan, which are nearer to the white point. In addition the connections between the six primaries are straight, which is logical. This arrangement is certainly more lucid. The scientists refused to take the cube seriously as a color solid, probably because Hickethier, as a pure practitioner, confined his system to the establishment of all the possibilities of mixture based on the three defined subtractive primaries. This is all he wanted to do. He was unable to support his ideas with a theoretically sound basis.

What the CIE system, McAdam's color diagram, and Professor Richter's DIN color chart have in common is that they offer a good foundation for mathematical operations. In this context we can regard McAdam's system as an improvement of the CIE system, and DIN 6164 in turn as an improvement of McAdam's system. DIN 6164 has the great additional advantage that it has push-in color tablets for every established hue and can therefore be of great practical use, even to people who do not have the slightest knowledge of the theory of color.

None of the three systems is, however, very clear. They proceed only from the additive mixture and have no reference to the physiological processes of vision and to the laws of the mixture of body colors. All monochromatic colors as arranged on the curve of the spectral color sequence are assumed to be equivalent. Primary colors have no precedence over the other colors.

The construction of Munsell's system is slightly clearer, since it is based and built on practical precepts. But it does not seem to be enough to give precedence to the equal degree of sensation of all hues and to raise this demand to the status of being the sole starting point for a system to the exclusion of other references.

One feature, however, is common to all color systems described so far. A gray axis runs straight through their color space, connecting the black and the white points. It forms the backbone of each of these systems, of each

color solid. The chromatic colors are arranged around the gray axis, always in the sequence of the color circle. Basically the systems differ only in the distances of the six primaries from black and white.

It is as illogical in the CIE system and its modifications to arrange all the six primaries on the same plane as white as it was of Lambert to arrange additive and subtractive primaries on the same plane as black. With Rünge and Ostwald the six primaries are located on a plane between black and white. Only the cube has, as we have seen, the advantage that the subtractive primaries are closer to white, the additive ones closer to black. This corresponds without doubt better to their total spectral energy. But even in the cube, the distance relations do not seem to be logical. Here the distance between the one-third color green and the two-thirds color magenta is equal to that between black and white. Both distances are body diagonals. The distance between one element in the color space to another must, however, be the greater the greater the difference between the spectral energy of the color stimuli. Consequently, the maximum extent of a color space should be between the two points black and white. All other distances should be shorter.

These considerations led the author to look for a new color solid. He started from the requirements that a new color system has to meet and eliminated those that were completely unrealistic. Regarding these he came to the following conclusions:

a) the possibility of the practical realization of the system, e.g., in the form of sample charts
b) precisely equal degree of sensation of all hues in the color space (regular progression)
c) the complete representation of all visible color manifestations

were inacceptable, because

a) no color substances are yet in existence that correspond to the theoretical requirements of optimum subtractive primaries. It is therefore impossible to realize the theoretically correct system in practice. The problem would not be solved even if these color substances were found because tolerances, which would have an effect on appearance, cannot be eliminated in the production of color samples. It must, in addition, be expected that environmental influences cause changes in the individual hues in the course of months or years.

b) The equal degree of sensation (regular progression) is not demanded, because here equidistance is always a matter of personal judgment. It is true that the judgment of the 'average' observer can be defined, as Munsell has

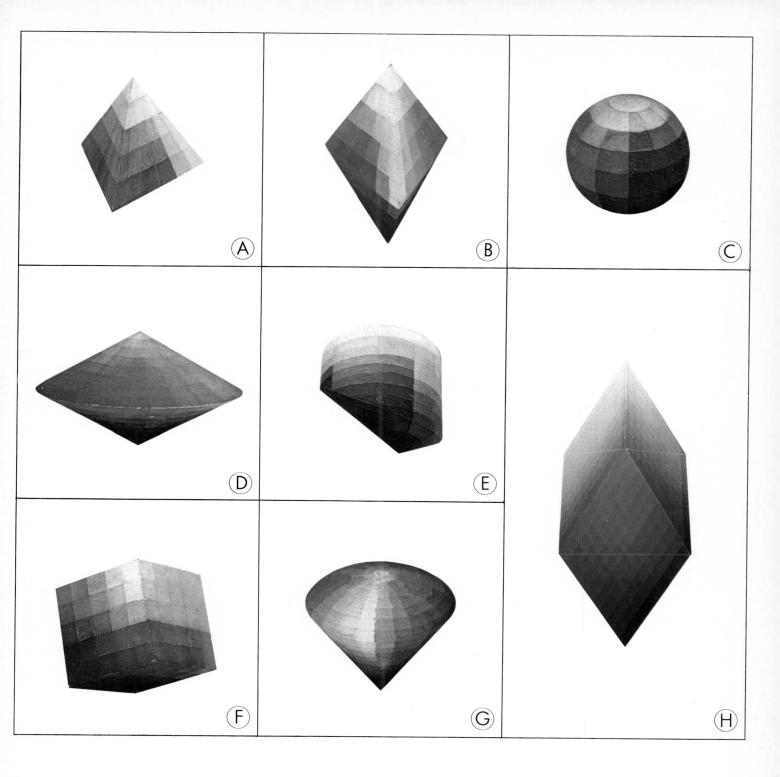

Fig. 67 Various color solids. (A): Heinrich Lambert (1728–1777), (B): Tobias Mayer (1745), (C): Philipp Otto Rünge (1777–1810), (D): Wilhelm Ostwald (1853–1932), (E): Prase (1910), (F): Charpentier (1885) and Hickethier (1952), (G): Professor Richter DIN 6164 (1962), (H): Küppers (1958).

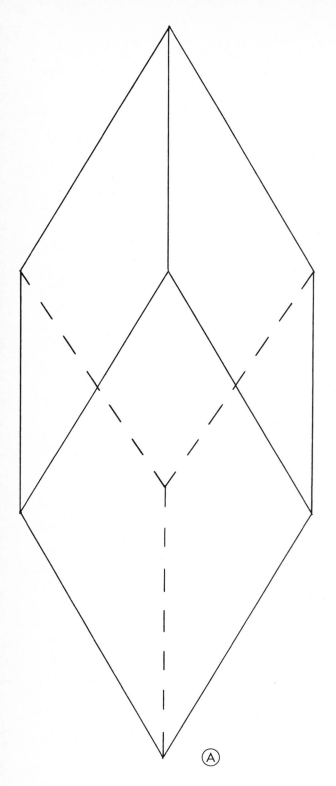

Fig. 68 The rhombohedron (A) has six rhombic faces, whose shorter diagonal equals the sides in length. Two sections divide it into three new, symmetrical, geometrical bodies — the octahedron and two tetrahedra. The faces of these three new bodies are equilateral triangles.

shown; but reliance on this judgment must to some extent be limited. It is, moreover, impossible to concede all primaries the same importance and significance simultaneously, and at the same time to raise the precisely equal degree of sensation to the governing principle. The two demands are mutually exclusive, and a choice had therefore to be made between them: equal importance of all primaries was given precedence.

Point c) raises difficulties. It is not yet possible to supply an unequivocal answer to the question whether a system built upon the ideal optimum primary colors can accommodate all the color manifestations imaginable, including, for instance, luminosity and the saturation of monochromatic colored lights. It must not be forgotten that we are thinking of a system that has no place for inadequate absorption and inadequate reflection of primary colors. We therefore depend on speculation. At present nobody is in a position to ascertain whether monochromatic colored lights can in fact look more saturated than such optimum primaries or mixtures of them. Obviously nobody has so far investigated these optimum colors carefully and compared them with monochromatic colors, in spite of the fact that it is well within the realm of possibility to isolate these optimum colors from the spectrum for comparison with monochromatic light, although it naturally calls for considerable technical layout.

We can presume that there are no differences. Everything suggests that we always have to deal with only three factors in the theory of color: the construction of the human eye with the three different types of cone; the physical conditions of the spectrum in which the absence of the magenta colors is decisive; and last but not least the fact that even in the mixture of body colors there can always be only three primaries.

The following points, therefore, still call for an answer to the question what requirements the best possible color system has to meet:

1. It must be clear. Everybody must be able to understand it readily both as a scheme and as a model.
2. It must be firmly and obviously related to the physical principles.
3. It must agree with the physiological functions of the visual organ.
4. The laws of both additive and subtractive mixture must be clearly identifiable.
5. It must be logical.
6. It must be easy to represent all relations mathematically.

When we look at the color systems and color solids of the past we note that their authors referred either empirically to the appearance of the individual hues resulting from mixtures or to the monochromatic colors of the spectrum (except Hickethier, who refers to subtractive primaries). The present author considers this wrong because he believes that the monochromatic colors can only be components, not the primary colors themselves. In his opinion the primary colors must cover spectral regions in the form already described at length in the previous chapters (see fig. 32).

In the search for a better system able to meet the conditions listed above the author developed the 'rhombohedron' as a new color solid. It will be discussed in detail in the following chapters.

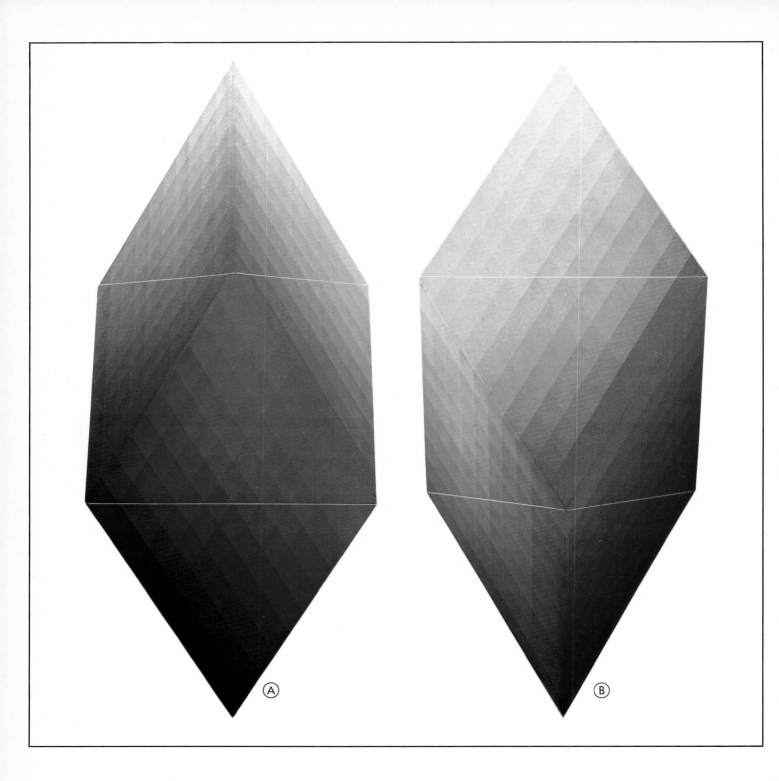

Fig. 69 Two color photographs of the rhombohedron. The gray axis passes through the body from the black point in the base corner to the white point in the top corner. Between (A) and (B) a 180° rotation around the gray axis has taken place.

118

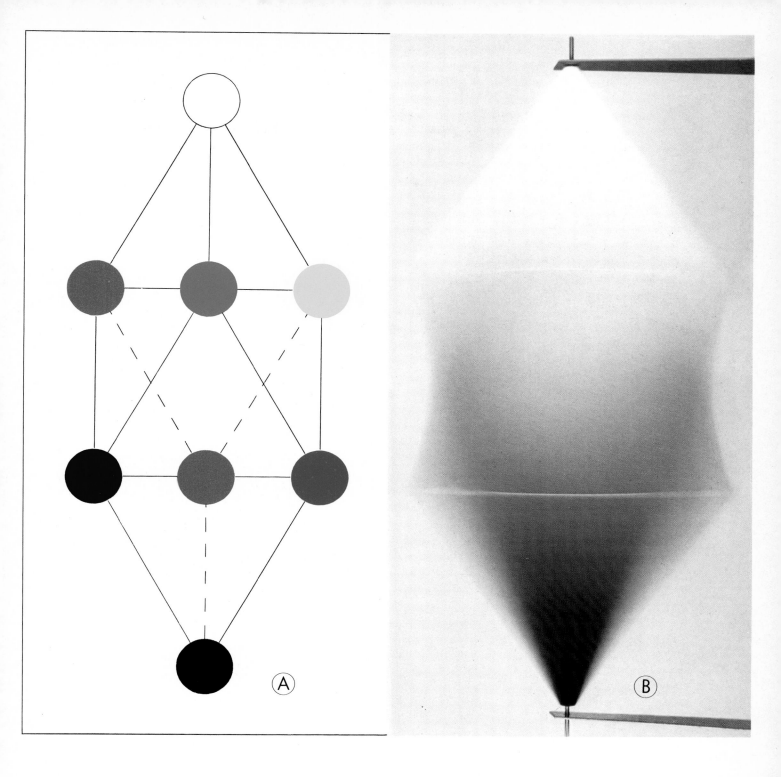

Fig. 70 (A) is a simple scheme showing the arrangement in the rhombohedron of the six primaries, black, and white. If the color solid shown in fig. 69 is rotated rapidly the colors on its faces neutralize one another by additive mixture, producing gray; this is shown in the photograph (B).

The rhombohedral system

The rhombohedron as a geometrical body

The rhombohedron (fig. 67H) is a regular geometrical body. It has six faces whose sides are of equal length, and eight corners. To this extent it resembles the cube, but differs from it in that the two diagonals of a face are not of equal length; in the rhombohedron the shorter diagonal has in fact the same length as the side of a face (fig. 68A).

Each rhombus is therefore bisected into two equilateral triangles by the shorter diagonal of the face.

If two horizontal body sections are cut through the rhombohedron standing on its apex along the shorter diagonals of the faces (see fig. 68B), the single symmetrical body will be divided into three new, again completely symmetrical, geometrical bodies.

The new bodies produced in this way are two tetrahedra and an octahedron, each with four and eight equilateral triangles respectively as faces.

The body sections divide the vertical axis of the rhombohedron into three equal lengths. The height of the two tetrahedra is therefore the same as that of the octahedron.

Arrangement of the colors in the rhombohedron

Fig. 69 shows the rhombohedron, standing on its black corner, from two sides. The white point forms its top corner. The line connecting the black and the white points is the achromatic axis (gray axis).

The scheme of fig. 70A illustrates the arrangement of the colors in the color solid, with the additive primaries, the one-third colors, situated on the plane that cuts the gray axis in the point at one third of the total distance to the black point. This plane is triangular as we have already noted in the preceding chapter. The corners of this triangle are occupied by the primaries blue, green, and red.

The subtractive primaries, the two-thirds colors, accordingly lie on that plane which cuts the gray axis at the point at two thirds of the total distance to the black point. This plane, too, is of course an equilateral triangle. Its corners represent the primaries yellow, magenta, and cyan.

The eight end points of the color solid, i.e., the three subtractive primaries, the three additive primaries, black and white, are the extreme points of the color space. All the other hues are arranged between them, regularly and continuously.

If we rotate the rhombohedron around its gray axis fast enough for the eye to be no longer able to distinguish the individual colors, these will be completely lost, and all we can see is an achromatic graduation from the black to the white point. Fig. 70B shows the rotating rhombohedron of fig. 69 stationary and from two sides. Naturally these colored representations of the rhombohedron serve only to make it easier to understand. It has been pointed out that it is impossible for technical reasons to reproduce the color solid exactly as if it were theoretically correct: firstly, we have no perfect optimum colors; secondly, other technical difficulties stand in the way.

This color system is based on the existence of optimum primary colors. We therefore must explain the role of the six primaries, i.e., the three additive and the three subtractive ones in it.

To this end we must once again look at the two color photographs of fig. 69. The subtractive primaries traverse the color solid from one face to the opposite face in such a way that they are present at full saturation in every point on one face. The color saturation decreases more and more in the direction of the opposite face, where not a trace is left of the original color.

There are thus three faces on which one subtractive primary color each is completely unrepresented. They therefore demonstrate the possibilities of mixture of two subtractive primaries each.

Each of these three faces meeting in the white point forms a reference plane for subtractive mixture. The vertical distance of a random point in the color space to each of the three reference planes indicates the saturation value of the mixture for the associated subtractive primaries. This means that the vertical distance to the reference plane corresponds to the saturation value of this primary color. If a point is situated in the reference plane itself, the distance and therefore the saturation value = 0. At the maximum distance, i.e., 100 per cent, the saturation value, too, is 100 per cent.

What has been said about subtractive mixture analogously applies to additive mixture. One of the three faces meeting in the white point each represents an additive primary at full saturation. In traversing the solid, this saturation decreases continuously until it reaches 0 per cent —

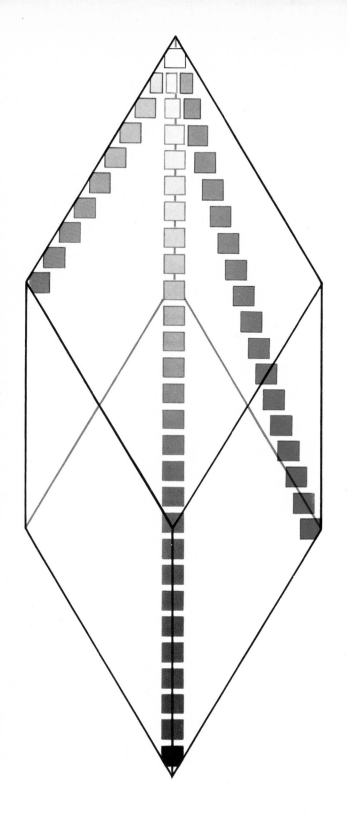

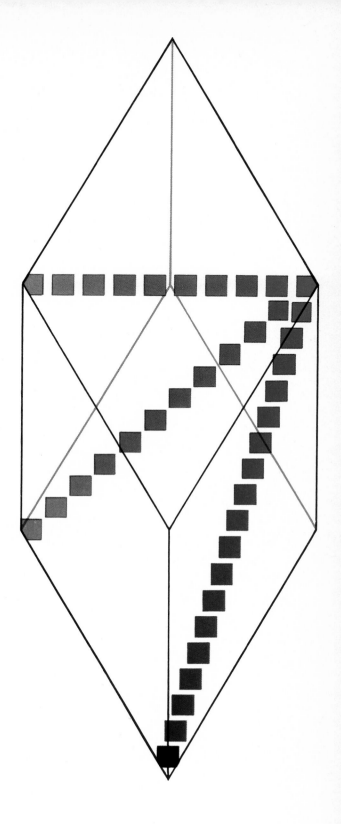

Fig. 71 The color distance relations in the rhombohedron differ basically from those in all other color solids. The maximum distance is found between the optically darkest and the optically brightest possibility of vision — black and white. The distance between a two-thirds color and white must be less than between a one-third color and white.

Fig. 72 Vertical sections along the gray axis produce color tone planes (A). Sections parallel to the faces are saturation planes. Whereas theoretically an infinite number of sections can be cut through the body, (A) refers to the twenty-four-sector color circle (twelve body sections), (B) to the ten-step color graduation (i.e., eight body sections, top surface, and base).

complete absence of the color concerned — on the opposite face.

The three faces from which an additive primary each is missing meet in the black point. They show the two mixtures of two additive primaries each. These three faces meeting in the black point form a second reference system. A random point in the color space indicates by its distance from the additive reference planes its mixture proportion of each additive primary color. Here too, its distance to the reference plane corresponds to its saturation value. If a point is situated in the reference plane itself, its saturation value = 0. If it is at maximum, i.e., 100 per cent distance from the reference plane, the saturation is also at a maximum.

It can be seen clearly that in this color system the points 'black' and 'white' have acquired an enormous importance. White is the point of intersection between the three reference planes for the subtractive, black that of the three reference planes for the additive system.

It is therefore possible to define the relations both to subtractive and to additive mixture of every point in the color space. Its distances from the three subtractive reference planes represent the mixture ratio of the three subtractive primaries. Its distances from the three additive reference planes determine its mixture ratio of the additive primaries. Naturally, the distance of a point from a given subtractive reference plane is the difference between the total distance between the two relevant faces and the distance from the additive reference plane.

Because this sounds a little difficult, we want to explain it with an example: a certain point has a distance of 60 per cent from the reference plane for the subtractive primary color magenta. Its distance to the reference plane of the additive primary color green must therefore be 40 per cent of the total distance between the two reference planes.

Since the individual points in this color space are arranged according to a mathematically logical sequence, it is not surprising that the distances between the extreme points also appear to be consistent, as fig. 71 shows. The longest distance in this color space is between the black and the white point. Only these two points have this maximum distance, because only they correspond to 'all' (equal-energy spectrum) and 'nothing' (absence of visible electromagnetic vibrations). The distance between an additive primary and a subtractive primary color is correspondingly shorter.

All distances between points in this system correspond to the total energy of the color stimuli associated with each point. The rhombohedral system is therefore energy-referred and quantitative.

To be able to study the conditions in the color space

closely, let us divide the saturation graduation of each primary color into ten steps in the same way as Hickethier suggested and realized in the cube. We proceed from the idea that the quantity of pigment or light energy required for the maximum saturation of a primary is divided into nine equal parts. Each part is a 'color value'. The saturation grade 0 thus has no color value, and the saturation grade 9 has nine color values. Altogether each color therefore has ten saturation grades. One color value can therefore be regarded as the basic unit of quantity (see also fig. 42).

We must of course not forget that the color space itself consists of an infinite number of points. By the division of the continuous graduation of saturation into steps of ten saturation grades, we obtain, as in Hickethier's color code system, 1000 regularly arranged points in the color space, which yield precise information about the relations and changes of colors.

All relations will be much easier to understand if it is possible to name the color values of the various primaries for the given points in the color space. The highest possible number of color values is twenty-seven. In subtractive mixture it denotes black, in additive white.

Since all the primary colors are considered of equal 'rank' and equivalent, this applies also to the color values. Each color value is equivalent to one of any other primary color. This has the enormous advantage that the color content of any colored picture, e.g., of a color transparency, can be found as a clearly defined geometrical body inside the rhombohedron.

Saturation planes of the rhombohedron

As already pointed out in the preceding chapter, the rhombohedron is traversed uniformly and continuously by the primary colors. The opposite faces have a certain relation to each other. If all the hues having nine saturation grades of a certain primary color occupy one face, the opposite face will have those hues from which this primary color is completely absent. This opposite face is always the reference plane for the corresponding primary color. It includes all hues of saturation grade = 0 of this primary color. Hence this reference plane is the 0 saturation plane for this primary color. If we now cut eight sections parallel to this reference plane through the solid, we obtain, together with the two faces, ten saturation planes (fig. 72B). These ten saturation planes are equidistant in the color space. Each of them is occupied by hues that have identical values of a primary color. The hues on the next saturation plane have one value more or less respectively of this primary color.

If these eight sections are cut in each of the three poss-

Fig. 73 All the mixtures of saturation value 44.44 per cent in the subtractive primary cyan, i.e., all the mixtures containing four color values of cyan, are situated on saturation plane (A). All mixtures on saturation plane (B) have a 100 per cent saturation value in the subtractive primary magenta. It is therefore saturation plane 9 of magenta.

124

Fig. 74 The shapes of the color tone planes change according to the position of the color tone section. But they are always parallelograms.

The shortest side cannot become shorter than in (A).

The shape of the parallelograms changes owing to the position of the points on the line connecting the two primaries as seen in (B).

Fig. 75　Color value planes are horizontal sections through the rhombohedron standing on the black corner. It will be seen at top right that the sections are triangular in the tetrahedron, and different in size.

The sections through the octahedron are hexagonal (top left). In (A) and (B) the base and the top face of the octahedron are shown in top view.

ible directions, i.e., parallel to each of the three reference planes, a total of thirty saturation planes is produced, i.e., ten of each primary color. The 1000 fixed points in the color space are therefore the points of intersection of these thirty planes of saturation.

We must again recall that the 1000 points were chosen from an infinite number of points in the color space. Naturally, the number of sections through the body can be increased or decreased at will. But all the hues situated in a plane parallel to the associated reference plane have always the same saturation value of the relevant primary color.

Fig. 73 shows two saturation planes in color. Fig. 73A is the saturation plane 4 of the subtractive primary cyan. This means that in subtractive mixture each hue on this plane has four values of cyan, which, as we know, corresponds to a degree of saturation of 44.44 per cent. Fig. 73B shows the saturation plane 9 of the subtractive primary magenta. In subtractive mixture it includes all the hues of nine magenta saturation values, i.e., all those hues in which magenta is present at full saturation.

Color tone planes of the rhombohedron

If vertical sections are cut through the rhombohedron, color tone planes are obtained. The direction of the cut can be rotated at will round the gray axis. By means of any number of sections we can produce any number of color tone planes as we can see on fig. 72A. Twelve sections at 30° intervals, however, are quite sufficient to make the color tone planes visible for all the tones of the twenty-four-sector color circle.

They are all parallelograms, but as Fig. 74 illustrates their form can vary widely. Black and white always occupy two of the corners of the parallelogram. The third corner is formed by a certain 'full color', the fourth represents the complementary of this 'full color'. The corner of a certain color tone plane moves the closer to white the higher the total spectral energy of this color tone. Conversely, of course, it moves the closer to the black corner the lower the total spectral energy.

The closest possible approximation of the corner of the parallelogram to white is defined by the location of the points for the subtractive primaries. The location of the points for the additive primaries defines the closest possible approximation to black.

The connection between the white and the black corner of each color tone plane is the gray axis. This bisects the parallelogram into two triangles, which have exactly the same function as the triangles of equal color tone in Ostwald's Pyramid, except that here they are not equilateral but irregular. But two triangles of equal color tone forming a color tone plane together are of course congruent and, as is already obvious from what we have said before, complementary to each other.

The arrangement on the two color tone planes of fig. 74 reveals that a hue becomes the lighter the more closely it approaches the white, and the darker the more closely it approaches the black point. Fig. 74A shows a color tone plane in which the corners have reached the greatest possible approximation to the black and to the white point, because they represent the two-thirds color yellow and the one-third color blue. In fig. 74B the corners of the parallelogram have moved more towards the center in accordance with the appearance of the full colors.

Planes of equal color values (brightness planes)

Planes of equal color values (brightness planes) are obtained if sections are cut through the rhombohedron at an angle of 90° to the gray axis.

They are occupied by those hues that have the same number of color values. It is immaterial whether these values are made up of one or of three primary colors, provided the number of values is the same. Here too, of course, we can imagine an infinite number of sections through the color space. But corresponding to the system chosen here only twenty-seven sections are cut because the maximum possible number of color values is twenty-seven. The relations can thus be traced most clearly.

Obviously one could have called the planes of equal color value simply 'brightness planes'. But this creates a problem by ignoring the different perception of brightness as explained in fig. 11.

Planes of equal color values can have the most varied shapes as fig. 75 illustrates. Fig. 75A shows sections of equal color values within the space of the octahedron (in perspective in the upper part of the illustration), and fig. 75B within the space of the tetrahedron. These sections can therefore have the shape of 'zero-gons' (i.e., points), triangles, and hexagons. Their areas, too, vary widely.

The entire color system begins in the black point, i.e., the hues of twenty-seven color values, and ends in the white point, i.e., the hues of zero color values. There is only one hue that has these values. As soon as we move the section only a little from these extreme points into the solid on the gray axis, we produce triangular sections that increase in size up to the color value planes 9 and 18. We have already met these two planes 9 and 18 when we divided the rhombohedron into two tetrahedra and an octahedron. They are the boundary faces between these bodies. Fig. 75 bottom, shows them again in top view.

Fig. 76 Color value planes can also be called brightness planes. (A) and (B) are base and top face of the octahedron (see also figs. 75A, B). On (A) will be found all color mixtures of the same brightness value as the additive primaries, and on (B) those of the same brightness value as the subtractive primaries.

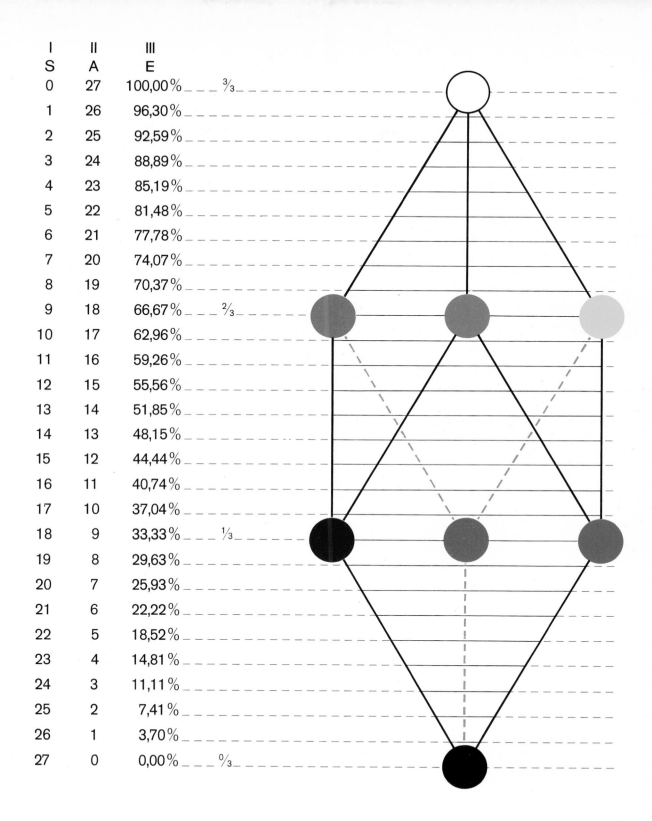

I S	II A	III E	
0	27	100,00 %	³/₃
1	26	96,30 %	
2	25	92,59 %	
3	24	88,89 %	
4	23	85,19 %	
5	22	81,48 %	
6	21	77,78 %	
7	20	74,07 %	
8	19	70,37 %	
9	18	66,67 %	²/₃
10	17	62,96 %	
11	16	59,26 %	
12	15	55,56 %	
13	14	51,85 %	
14	13	48,15 %	
15	12	44,44 %	
16	11	40,74 %	
17	10	37,04 %	
18	9	33,33 %	¹/₃
19	8	29,63 %	
20	7	25,93 %	
21	6	22,22 %	
22	5	18,52 %	
23	4	14,81 %	
24	3	11,11 %	
25	2	7,41 %	
26	1	3,70 %	
27	0	0,00 %	⁰/₃

Fig. 77 Here the already known scheme of the arrangement of the colors in the rhombohedron and the brightness values for the twenty-seven color value sections are seen side by side. Column 1 contains the digital sums of the color values in subtractive, column II that of the color values in additive mixture. Column III shows that the color stimulus is the same in subtractive as in additive mixture.

As soon as the plane of equal color values enters the octahedron, the shape of a hexagon is produced, to begin with consisting of three very long and three very short sides. The closer the section approaches the center of the octahedron, the more regular will the sides of the hexagon become; the central section is a regular hexagon.

To understand the concept of the color value planes it is advisable to make use of Hickethier's system again, for it can naturally be applied unchanged to the consideration of the previously mentioned 1000 points of intersection, except of course that we must constantly bear in mind that the color values in question are always those of theoretically correct, ideal colors.

We already know that each three-digit code number of Hickethier's system indicates the degree of saturation and therefore the color values of the three subtractive primaries. We can therefore see at first glance the color values of which a mixture consists. If we now obtain the digital sum of such a code number, we shall know at once the plane of equal color values on which a certain hue must lie. The code number 246 for instance has the digital sum 12 (2 + 4 + 6). This hue, together with all others of the same digital sum, occupies plane 12 of equal color values. This applies, for example, to a gray of 444 or yellow-orange of 930.

The sections of equal color values of planes 9 and 18 can be seen in fig. 76. It is not surprising that the plane 18 of equal color values (76A) appears considerably darker than plane 9 (76B), for the colors of digital sum 18 must be much darker in subtractive mixture, because they are much closer to the black point (twenty-seven color values) than the colors of digital sum 9.

In both triangles of equal color values, however, the fundamental arrangement is the same. The further away a hue is from the center of the triangle, the more 'colored' it is. The center is always the point of absolute neutrality. The more closely a hue is located to the center, the more subdued, broken, achromatic it must be.

In the diagrammatic representation of the rhombohedron in fig. 77 the twenty-seven sections of equal color values are shown. To the left of the diagram are three scales. The first column shows the digital sums of the color values of all hues on the corresponding plane of equal color values with subtractive mixture. The second column shows the same, but with additive mixture. The corresponding values of the first and second columns added up always total twenty-seven. The reason for this is the same as that given when the planes of saturation were explained. There the saturation value of subtractive mixture and that of additive mixture added up to 100 per cent, i.e., the total distance between two opposite faces. For the same reason the digital sums of subtractive and additive mixture must add up to twenty-seven for the same plane of equal color values.

The third column shows the percentage of the spectral energy of each single color tone referred to the equal-energy spectrum. Here the figure is identical for subtractive and for additive mixture, for all we are left to consider here is the color stimulus, irrespective of its origin. It is also immaterial whether by the application of nine color values to a sheet of white paper one third of the total spectral energy was absorbed, leaving two thirds, or these two thirds were produced in additive mixture by the superimposition of a total of eighteen color values. In each case the spectral energy of the color stimulus will be 66.66 per cent of that of the equal-energy spectrum.

We can call the representation of fig. 77 quite correctly (within the already mentioned limitation) the brightness graduation in the rhombohedron. The subtractive plane 27 represents maximum darkness. The brightness of the individual hues increases the smaller the subtractive digital sum, until it reaches its highest value in white.

The achromatic planes

If we look at a rhombohedron from above we see a hexagon whose center is white. This is shown in fig. 78A. The outermost hexagon rendered in colors represents the faces of the rhombohedron projected on to a plane in the graduation of the gray axis.

This colored body boundary is the achromatic plane 0 of the rhombohedron. All hues arranged on it have the achromatic value or achromatic grade 0. They are therefore colors of maximum chromaticity.

The achromatic planes of the rhombohedron are faces of hexahedral regular prisms that are nested and have the gray axis in common. Here too, the number of achromatic planes is infinite.

To remain within the decadic system we arranged a total of ten achromatic planes. As we already pointed out the achromatic plane 0 is the outermost body boundary. All that is left on it is a line, i.e., the connection between the color points of the subtractive primaries and of the additive primaries. This line is also shown in fig. 78C.

The reference planes for the degree of achromatism are the achromatic planes 0. The greater the distance of a point in the color solid from its achromatic plane, the higher its achromatic value or achromatic factor. The maximum possible distance to the achromatic plane 0 is reached in the center of the representation, which is the gray axis, i.e., the highest possible degree of achromatism.

We can deduce from these considerations that the

existing representation of the color circle we have met in fig. 35 is not logical. In the color circle all colors of the same chromatic factor are arranged side by side, and accorded equal importance. The color hexagon of fig. 78B seems to be the better arrangement. Here, the six primary colors are given a predominant, special position. They are situated in the six corners of the hexagon. This corresponds to their special significance within the rhombohedral system and within the laws of color mixture. The connections between these points of extreme chromaticity must be straight lines.

Fig. 78C demonstrates once more how the relations in the color space present themselves when they are seen only from the perspective of chromaticity. The zig-zag color ring denotes maximum chromaticity. It corresponds to the arrangement in the scheme illustrated in fig. 77. On this achromatic plane 0 only the line of the pointed color hexagon is left. The greater its achromatism the further inside the color solid will a point lie. The achromatic planes initially increase in area. When a certain point is passed the area decreases again, until again only a line is left, i.e., the line of maximum achromatism, the gray axis shown as a vertical line in the representation.

Chromaticity and achromatism are two concepts that complement each other like black and white. It is actually immaterial whether we speak of chromaticity or achromatism, or of a chromatic or an achromatic plane. Only in connection with the distance relationships in the rhombohedron must we refer to achromatism, because the achromatic factor in a hue corresponds to the distance of the hue from the achromatic plane 0, not to its distance from the gray axis.

As we already know one can define the degree of chromaticity with Hickethier's color code.

Chromaticity is the sum of those color values that in a mixture exceed the achromatic value. It is thus possible to 'dissect' every hue into an achromatic and a chromatic value. Let us take hue 225 as an example:

$$
\begin{array}{ll}
222 & \text{achromatic value} \\
+\ 003 & \text{chromatic value} \\
\hline
225 & \text{hue}
\end{array}
$$

If we now want to determine the degree of chromaticity, we must refer the chromatic values to the six individual primary colors (not just to the three subtractive ones).

Analogously to Hickethier's color code the highest possible chromaticity can be defined with the chromatic factor 9:

$$
\begin{array}{l}
090 = \text{chromatic factor } 9 \\
099 = \text{chromatic factor } 9
\end{array}
$$

The code number 090 is referred to magenta, the code number 099 to blue. In both cases the result is the chromatic factor 9. Mixtures of the same ratios of the subtractive primary colors have the chromatic factor 0, because no color value exceeds the achromatic value:

$$
\begin{array}{l}
000 = \text{chromatic factor } 0 \\
444 = \text{chromatic factor } 0 \\
999 = \text{chromatic factor } 0
\end{array}
$$

In a code number of a subtractive mixture in which only two subtractive primaries are present, the following calculation applies, e.g., for the hue 940:

$$
\begin{array}{lll}
440 & = \text{chromatic factor for orange} & = 4 \\
+\ 500 & = \text{chromatic factor for yellow} & = 5 \\
\hline
= 940 & = \text{chromatic factor} & = 9
\end{array}
$$

The same applies to a hue defined by the subtractive code number 358:

$$
\begin{array}{lll}
333 & = \text{achromatic value. Chromatic factor} & = 0 \\
+\ 022 & = \text{chromatic factor for blue} & = 2 \\
+\ 003 & = \text{chromatic factor for cyan} & = 3 \\
\hline
= 358 & = \text{chromatic factor} & = 5
\end{array}
$$

Division of the colors into groups

We must once again look at fig. 68B. This demonstrates how the rhombohedron is split up into three new geometrical bodies when a section each is cut along those planes that are occupied by the additive and by the subtractive primaries respectively.

This cannot be an accident, but must have a deeper significance. Quite obviously it must be an inevitable division of the infinite number of hues into three definite groups. How do these groups differ from one another, what are their mutual boundaries?

Let us begin with that tetrahedron whose corners represent white and the subtractive primaries yellow, magenta, and cyan. Fig. 77 showed that in this part of the rhombohedron all those hues are located whose subtractive digital sum lies between 0 and 9. No hue whose digital sum is larger than 9 by even only a fraction could be situated inside this tetrahedron, because the plane 9 of equal color values is the boundary face.

Fig. 79 illustrates diagrammatically the boundary effect created at the digital sums 9 and 18. Fig. 79A is a cyan area at maximum saturation on white paper. This hue has the code number 009, digital sum 9. This cyan color is therefore one of an infinite number of points on plane 9

Fig. 78 If we look at the rhombohedron from above, we see a hexagon as shown in (A). The connecting lines between the primaries printed in color are the outlines of the body. They are situated on the achromatic plane 0. The degree of achromatism increases the closer the achromatic plane approaches the gray axis. (B) shows that the representation of the pure colors in the color circle is not logical. The shape of the color hexagon is derived from (A). Lastly, (C) shows how all visible chromaticity is arranged between the achromatic line (vertical gray axis) and the zig-zag hexagon of maximum chromaticity. The representation of any hue can be reduced to a combination of the area of the color hexagon and the line of maximum achromatism.

Fig. 79 The break-up of the plane into small triangles symbolizes the division into color values. If, as in (A), nine out of nine triangles are cyan, this means maximum saturation. Tinting can take place only if the number of nine color values is not reached (B); moreover, it is im- material here whether the nine color values are of one primary or of several primaries as in (C). Full chromaticity exists in mixtures of digital sums between 9 and 18 (D + E). With only a single color value above 18, shading sets in as (F) shows.

of equal color values (fig. 76B), here a corner point because it is a primary color.

The area of fig. 79A is divided into little triangles to explain the process diagrammatically in greater detail. In fig. 79A nine out of nine little triangles are cyan. This means that the area is covered with nine color values, i.e., saturation is greatest. On fig. 79B, however, of the nine little triangles only eight are cyan; one is white. This indicates that we now have only eight color values; these are unable to cover the paper at maximum saturation. The white component, blank on the paper, will therefore influence the appearance of the cyan color; our cyan will be slightly tinted.

The plane of equal color values of digital sum 9 contains basically all those colors that have exactly two-thirds of the energy of the equal-energy spectrum. It is completely immaterial whether the colors are chromatic or achromatic. This plane accommodates the gray with the subtractive code number 333, the optimum magenta, or a green that has the subtractive code number 504.

All those hues of an energy value higher than two-thirds of the equal-energy spectrum are located in the top tetrahedron of the rhombohedron. The color tone of fig. 79C should schematically be achromatic, but have a digital sum which is smaller than 9 by only a fraction of a whole color value.

This color area, which consists of equal numbers of magenta, yellow, and cyan triangles, shows only a few white triangles. It is therefore one of the typical hues of the top tetrahedron, which we shall call 'white tetrahedron' because the white point is at its top.

We can deduce from these considerations that all the tinted colors are to be found in the white tetrahedron. When we look again at the cyan area of fig. 79A we appreciate that a color whose subtractive digital sum is 9 cannot be tinted, for the white paper can no longer have any effect on the appearance of this hue. It is again entirely immaterial whether the color is pure, chromatic as the cyan shown here, or achromatic like gray 333. Gray 333 cannot be tinted either since according to this scheme a two-thirds color is present in every area of the white paper as in fig. 79C, but without the white triangles found there.

All those hues whose subtractive digital sums are between 9 and 18 are situated in the octahedron. Fig. 79D shows the scheme of a hue of subtractive digital sum 11. Two color values of magenta have been added to nine yellow values. If another seven magenta values were added the entire area would be orange and the hue produced have a subtractive digital sum of 18. This hue would lie on the plane of equal color values that forms the boundary with the black tetrahedron.

Fig. 79E shows another hue of digital sum 18. It is the scheme of a hue of subtractive code number 927. To the nine yellow values (whole area) two magenta and seven cyan values have been added. The scheme shows that throughout the paper another one-third color, i.e., either green or red, is fully effective.

The octahedron therefore contains all those hues that have neither a white nor a black component.

We see from fig. 79F that shading will at once take place if even only a fraction of a color value is added to the subtractive digital sum of 18. Only at this point do the subtractive primaries begin to cancel each other.

Compared with hue 927 of fig. 79E, hue 937 of fig. 79F is already muddier, shaded. One of the nine little triangles is black. As soon as the limit of eighteen color values is exceeded blackening must occur. All hues of subtractive digital sums above eighteen are situated in the tetrahedron with the black corner, which we call 'black tetrahedron'.

The black tetrahedron contains all the shaded hues. We thus distinguish between three large groups of color:

a) the tinted colors of the white tetrahedron
b) the full colors of the octahedron
c) the shaded colors of the black tetrahedron.

A special position opposite the innumerable points inside the color solid is occupied by the points arranged on the surfaces. The hues situated on those surfaces that meet in the white corner represent all the pure subtractive mixtures, mixtures of only two subtractive primaries.

The other three surfaces, meeting in the black corner, accommodate all pure additive color mixtures, i.e., mixtures of only two additive primaries.

This results in a further classification of all hues: all pure hues are found on the surfaces, all the others inside the color solid. But what should they be called? Surely words such as 'broken', 'subdued', or 'shaded' are basically unsuitable? The most obvious term is 'impure colors'.

Hence the two tetrahedra as well as the octahedron contain pure, impure, and achromatic hues. All the hues of the color space can therefore be divided into nine groups based on nine characteristics:

1. pure tinted colors
2. impure tinted colors
3. achromatic tinted colors
4. pure full colors
5. impure full colors
6. achromatic full colors

S

S 7 6 2

S 2 3 7

S 7 3 1

S 1 5 6

S 8 0 3

S 2 8 2

A

A 2 3 7

A 7 6 2

A 2 6 8

A 8 4 3

A 1 9 6

A 7 1 7

S

S 0 1 4

S 5 4 4

S 9 9 0

S 4 1 6

S 0 3 8

S 8 2 0

A

A 9 8 5

A 4 5 5

A 0 0 9

A 5 8 3

A 9 6 1

A 1 7 9

Fig. 80 Hickethier's color code can be modified by the introduction of the prefix S before the number for subtractive, and A before that for additive mixture. The same color tone can thus be described in terms of its proportions in subtractive and in additive mixture. The code numbers always add up to 999.

7. pure shaded colors
8. impure shaded colors
9. achromatic shaded colors.

To begin with we explained the classification of the colors in groups exclusively in terms of subtractive mixture, simply because we did not want to complicate the subject needlessly, but make it easier to grasp.

But we must now prove that the same explanation applies also in terms of additive mixture. For this a modification of Hickethier's system as used up to now is necessary. In future we must distinguish between subtractive code numbers and additive code numbers. Fig. 80 shows two rows of random hues with their subtractive code numbers marked S on the left, their additive ones marked A on the right.

To make the representation as lucid as possible each code number is printed on a colored background whose tone corresponds to the associated primary color.

The first example is a hue of subtractive code number S762. The associated additive code number is A237. It can be seen at first glance that the two numbers add up to 999.

The subtractive code number for a certain subtractive primary therefore has a fixed relation to the additive code number for the corresponding additive primary.

To the subtractive primary yellow corresponds the additive primary blue, to the subtractive primary magenta, the additive green, and to the subtractive primary cyan, the additive red. Subtractive and additive color values together always add up to nine:

Yellow	S900 + A099	= 999
Magenta	S090 + A909	= 999
Cyan	S009 + A990	= 999
Blue	S099 + A900	= 999
Green	S909 + A090	= 999
Red	S990 + A009	= 999
White	S000 + A999	= 999
Black	S999 + A000	= 999

This tabulation shows once again what we have known for a long time: that the subtractive primaries are two-thirds, and the additive primaries one-third colors. For the color stimulus of a subtractive primary, e.g., yellow, nine values of this color are required for maximum saturation. To obtain the same yellow color in additive mixture the two corresponding additive primaries, i.e., green and red, at full saturation are necessary. On the color stimulus, the code number S900 contains the same information as the code number A099. Both indicate that the green and red

thirds of the spectrum are fully present as color stimuli.

The same applies to all the other numbers in this table, which makes any further explanation unnecessary.

Let us return to fig. 80. When we look at the vertical columns we shall see that the color stimulus of a certain hue, i.e., the spectral distribution entering the eye, can be completely defined both by a subtractive and by an additive code number. We must of course again bear in mind that these considerations can be correct only with the theoretically correct optimum colors of neither inadequate absorption nor inadequate reflection. Hence, tinted colored lights have an additive code number of a digital sum larger than 18. Shaded colored lights have an additive code number of a digital sum smaller than 9. All those hues of additive digital sums between 9 and 18 are called full colors.

This can be proved analogously to the procedure used for subtractive mixture.

The system of arrangements in the rhombohedron

Our rhombohedron is a color space containing an infinite number of points each representing a hue. These points are logically arranged with reference to the ideal (theoretically correct) subtractive and additive primaries. Simple mathematical relations are thus established.

There is a system of three subtractive reference planes for subtractive color mixture. These are the three faces of the rhombohedron that meet in the white point.

There is also a system of three reference planes for additive color mixture; these are the three faces of the rhombohedron that meet in the black point.

There is furthermore an infinite number of planes that cut the color solid parallel to these reference planes. These are the planes of equal saturation or saturation planes. They cut the color body in three different directions:

1. in the yellow/blue direction
2. in the magenta/green direction
3. in the cyan/red direction.

In addition the color space is cut by an infinite number of planes of equal color values, cutting the gray axis at an angle of 90°.

There is also an infinite number of planes that cut the gray axis along the direction of its progress, the planes of equal color tone or color tone planes.

Finally there are the achromatic planes occupying the faces of hexahedral prisms, whose common axis is the gray axis.

There are therefore six possibilities of reference for each point in the color space:

1. saturation planes in the yellow/blue direction
2. saturation planes in the magenta/green direction
3. saturation planes in the cyan/red direction
4. color value planes
5. color tone planes
6. achromatic planes.

For the definition of any point in the three-dimensional color space the indication of any three of these six possible kinds of planes is sufficient. It is immaterial whether the values supplied refer to the additive or to the subtractive system, whether color tone planes, color value planes, or achromatic planes are known. Three relevant definitions are always enough to determine all the other references of a hue, a color point, i.e.

1. the subtractive mixture ratio
2. the additive mixture ratio
3. the color tone
4. the brightness (or more accurate the number of color values or the spectral energy)
5. the degree of achromatism.

We can readily identify the large group of colors to which a hue, a color point chosen at random, belongs. It belongs to:

1. the pure tinted colors if the point is located on one of the faces of the white tetrahedron
2. the impure tinted colors if the point is inside the white tetrahedron
3. the achromatic tinted colors if the point is located on the gray axis in the white tetrahedron
4. the pure full colors if the point is on one of the faces of the octahedron
5. the impure full colors if the point is inside the octahedron
6. the achromatic full colors if the point is located on the gray axis in the octahedron
7. the pure shaded colors if the point is on one of the faces of the black tetrahedron
8. the impure shaded colors if the point is inside the black tetrahedron
9. the achromatic shaded colors if the point is on the gray axis in the black tetrahedron.

To enable the reader to understand these relations as clearly as possible, figs. 81 and 82 show models of the color solids that can be cut out and assembled.

The model of a rhombohedron can be made of fig. 81. The two tetrahedra and the octahedron can be made of fig. 82. To obviate the need for cutting the pages from the book, the two illustrations have also been reproduced on the flaps of the jacket.

Fig. 81 Cut-out pattern of the rhombohedron for making a paper model. The illustration is repeated on the flap of the book jacket for cutting out.

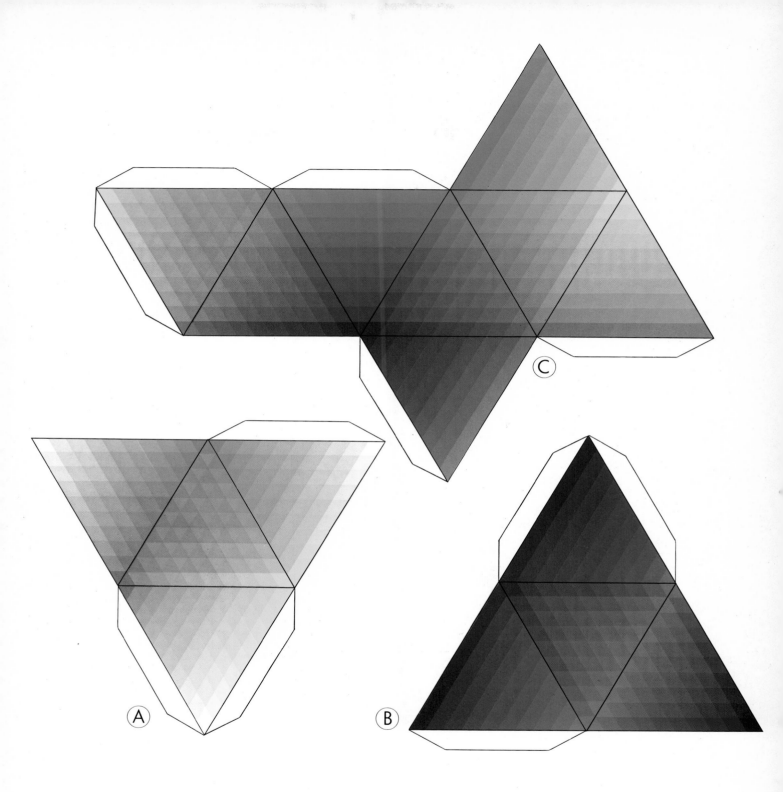

Fig. 82 Cut-out patterns of the two tetrahedra (A, B) and the octahedron (C) for making a paper model. They are repeated on the flap of the book jacket for cutting out.

139

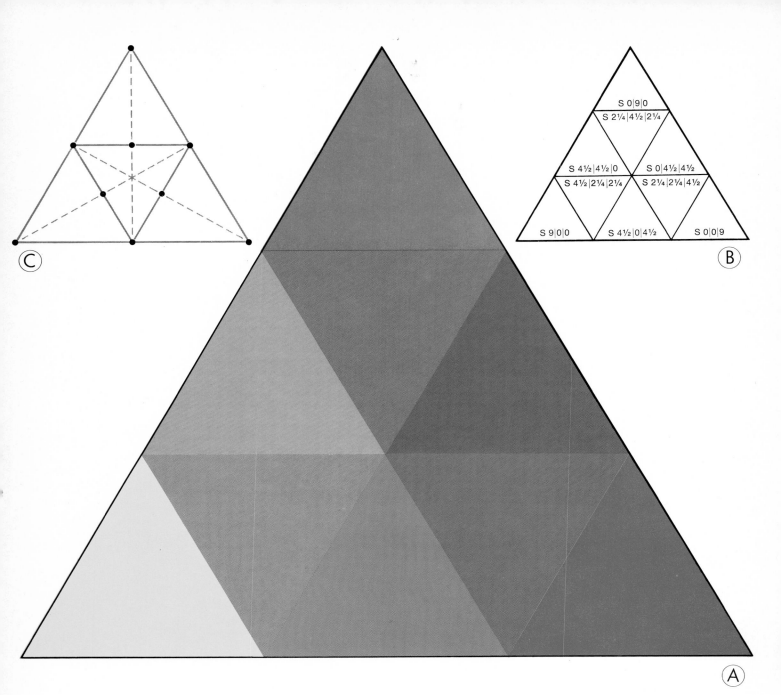

Within the large triangle (A), the following labels appear:

Triangle C (top left) and Triangle B (top right) contain the following text for B:

S 0|9|0
S 2¼|4½|2¼
S 4½|4½|0 S 0|4½|4½
S 4½|2¼|2¼ S 2¼|2¼|4½
S 9|0|0 S 4½|0|4½ S 0|0|9

Fig. 83 Goethe suggested the arrangement of the subtractive primaries in the corners of a triangle. Between two of them we find the color tone produced by a 50:50 mixture of the two original colors. If these two-color mixtures are in turn mixed 50:50 each, the hues on the inside are produced. The quantitative relations are shown in (B). In (C) we recognize the positions of these nine points on the plane of equal color values S9.

Conclusions

A new law of mixtures: the integrated mixture

We have become familiar with additive mixture and sub-tractive mixture. Cogent conclusions have proved that the laws of both mixtures obey the same basic principle. It is, after all, always the color stimulus that triggers a corresponding color perception in the observer. It is therefore always visible electromagnetic vibrations at certain mixture ratios that trigger a physiological process in the viewer's eye. Whether the color stimulus originated in addition or in subtraction is immaterial. Only the spectral composition is important.

The laws of subtractive mixture are valid only if transparent subtractive primaries are superimposed in layers as in color photography and sometimes in multicolor printing.

The subtractive laws therefore do not apply if paste paints or pigments are mixed directly. But in this case not even the laws of additive mixture can be applied.

This connection is obvious if we remember that subtractive mixture requires white as an indispensable basis. The laws of subtractive mixture cannot operate otherwise. The situation is analogous in additive mixture, where black is the essential basis. But when paste paints or pigments are mixed, neither white nor black is present as a starting basis. The directly mixed colors act only against one another irrespective whether they are transparent or opaque.

If we consider these relations we come to the conclusion that there must be a third law of mixture in addition to those of additive and subtractive mixtures, to apply whenever body colors are mixed directly.

For each tiny particle in a paste paint or a pigment absorbs a certain part of white light. This is, after all, why it appears colored. Here subtraction has become effective. Since the individual particles are microscopically small they cannot be distinguished separately; the resolving power of the retina is not high enough; but their reflections mix additively.

Thus a part of additive and a part of subtractive mixture are involved. The laws of the two mixtures are, as it were, in gear. Both the subtractive and the additive primaries must be available. But since neither white nor black are present as a basis, these two colors, too, must be added.

Because of the interaction of the subtractive and ad-ditive mixture laws the author has called this new law 'integrated mixture', and formulated it as follows:

1. The eight integrated primaries are called:
 White
 Yellow
 Magenta
 Cyan
 Blue
 Green
 Red
 Black
2. In an integrated mixture at most four of the eight integrated colors can be present, i.e.
 white
 one two-thirds color
 one one-third color
 black
3. An integrated mixture must always have nine color values (referred to the decadic color value system). This corresponds to a quantity of 100 per cent.
4. The color values required for the mixture are determined according to Hickethier's code number system in the same way as the chromatic factor.
5. The achromatic factor indicates the black values required for the mixture.
6. The chromatic factor indicates the number of values of the chromatic primaries required for the mixture, separately according to one-third and to two-thirds colors. The two chromatic primaries forming part of an integrated mixture must be adjacent on the color hexagon.
7. If the black and the chromatic primary values together do not add up to nine, the difference is made up by white values in the mixture.
8. The laws of integrated mixture apply whenever body colors, i.e., paste paints or pigments, are mixed directly.
9. The eight integrated primaries must be matched to one another in saturation and color intensity (pigmentation).
10. As long as the eight integrated primaries do not fully meet the theoretical requirements of their spectral

Fig. 84 Selected harmonies from the nine hues of the
harmonic color triangle of fig. 83. The study of the position
of the relevant points in fig. 83C is full of interest.

Fig. 85 These, too, are selected harmonies from the harmonic color triangle of fig. 83. Here it is also useful to check the position of the relevant points on the color value plane 9 in fig. 83C.

properties deviations will occur. The laws of integrated mixture can nevertheless be practically applied by reference to eight integrated primaries representing the best possible compromise.

11. The ideal integrated primary colors must have the following spectral properties:
 a) white must fully reflect the equal-energy spectrum
 b) the chromatic primaries must be optimum one-third and two-thirds colors
 c) black must not reflect at all.

Integrated mixture applies whenever the inks are mixed before inking or used for dyeing. A total of nine color values is always required, otherwise the quantitative relation of the mixture is no longer correct. For nine color values correspond to normal inking, normal thickness of the film, and integrated mixture, after all, always involves only one color layer. It is therefore not possible to start from the subtractive primaries for, as we know, a total of twenty-seven color values can be varied in three layers in the subtractive system described, of which color printing and color photography are the best examples.

Since in the mixture of paste paints or pigments the number of nine color values must not be exceeded, the subtractive primaries are not enough to produce all the results of mixture. A new starting basis is therefore required. It is established by the eight integrated primaries.

These are the eight colors already introduced in fig. 5.

Any subtractive mixture must first be analyzed for its proportions of all of these eight colors. Let us use hue S363 as an example. Here the black value is the amount of color values common to all three subtractive primaries present, producing the achromatic value S333. This corresponds to three parts black in the desired mixture. The chromaticity of this hue is the result of three magenta values (S030) that exceed the achromatic value. If in accordance with this realization three black values were mixed with three magenta ones, the quantitative relation would not be correct, because they add up to only six color values. To obtain the required nine values we must therefore add three white values. White is therefore always the supplement necessary to arrive at the figure 9. The following calculation then applies to hue S363:

3 black values	= S333
+ 3 magenta values	= S030
+ 3 white values	= S000
9 color values	= S363

In the hue S759 the chromatic factor is determined by the color values S204 added to the achromatic values S555. The calculation for the mixture is as follows:

5 black values	= S555
+ 2 green values	= S202
+ 2 cyan values	= S002
9 color values	= S759

Here no white is involved because the nine possible color values are already allocated. The realization is important that in such a mixture as S759 the green value of S202 contained in the chromatic value of S204 must not consist of yellow and cyan, because this would disturb the quantitative relation. Instead, there are two values of the green primary.

The most complicated possibility of mixture exists with hues such as, for instance, S238. This mixture must be produced as follows:

2 black values	= S222
+ 1 blue value	= S011
+ 5 cyan values	= S005
+ 1 white value	= S000
9 color values	= S238

Laws of color harmony

To establish rules for the harmonic matching of colors has been the aim of Rünge and Goethe among others. Ostwald, too, was convinced that color harmonies are based on certain inevitable relations. His model was the twenty-four-sector color circle, around whose center he rotated a triangle or a square. In any position, so he thought, the corners of the triangle or the square would point at colors that harmonized with one another. Ostwald's theory of color harmony was much ridiculed and spurned by contemporary artists. Nevertheless, a similar model, which, however, refers to the entire color space of the double cone, has been developed and executed in America.[9]

Field and Itten[3] have made interesting contributions to the definition of laws of color harmony. Most recently Albers[16] and Mante[17] have again taken up these ideas and made attempts to reformulate them.

No matter how valuable such work may be individually, it has so far not yet been possible to establish an objective basis for laws of color harmony and to adduce convincing arguments in their favor.

We may expect that color harmonies can be derived from clearly defined relations between the various hues. The basis of harmony will be found to consist of common

features, connections, supplementary factors, or of the degree of difference, distinctive features. But colors can be related on only four defined levels: their

1. tone
2. brightness
3. degree of achromatism
4. saturation conditions referred to the primary colors.

We cannot imagine any other relations.

Now the rhombohedral system includes an infinite number of color tone, brightness (or color value), achromatic, and saturation planes. The color space is systematically divided by these planes in six different directions. The author considers it fairly certain that the connections of color harmonies and disharmonies can be found on these innumerable planes.

It can be assumed that mutually harmonizing hues are arranged on these planes in certain patterns, which may be lines, triangles, polygons, circles, or parts thereof. It must also be expected that the regularity of these patterns has a certain relation to the interaction of the color harmonies concerned.

There will be harmonies in every plane — arranged at a longer or shorter distance from, and regularly or irregularly round the achromatic point or the achromatic axis. Other harmonies will probably lie only in parts or marginal zones of a certain plane.

It is also imaginable that harmonies should lie on the faces of geometrical bodies within the rhombohedron, e.g., on the surface of a sphere.

Goethe's harmonic triangle points to the justification of these expectations. For it is interesting to note that its structure is identical with the color value plane 9 of the rhombohedron (fig. 76B). If we take from the color value plane 9 the colors he suggested and arrange them as he did, we shall obtain the triangle shown in fig. 83A. Fig. 83B gives the subtractive code numbers for the nine selected hues. It was necessary to operate with fractions to show the quantitative relations of the subtractive primaries. As we know, a color value plane is made up of an infinite number of points, which according to Hickethier's system of code numbers all have the same digital sum. Only a small proportion of them can therefore be defined with the integers in the decadic system. We have overcome these difficulties with the use of fractions.

The triangles in figs 84 and 85 indicate how according to Goethe's suggestions selected harmonies can be isolated from this harmonic triangle. The hatched areas in the triangles show color harmonies.

This specific color value plane 9, covering all hues of

subtractive digital sum 9, is, however — we must emphasize it once again — only one of the innumerable planes in the rhombohedric system. The nine hues of fig. 83A are again only a tiny selection from the innumerable hues on this plane 9. The position of the nine points of fig. 83A on the color value plane is shown in fig. 83C. The large triangle includes a smaller equilateral one standing on one of its corners. The achromatic point of this color value plane is the center of both triangles.

When looking at fig. 83 we must of course always remember that with the hues shown there the harmonies can only be approximate, simply because optimum harmonies can be obtained only if the optimum, theoretically correct primaries are available. But as the example has proved, there is no difficulty in calculating the required spectral composition or the mixture ratio of the required colors.

It will be possible to explain harmonies in terms of the theory of sets. The tentative experiments by Dr Jäckel-Hartenstein are confirmed here. The theory of sets seems to provide the suitable method for determining the extent of agreement and difference between hues quantitatively and qualitatively. Laws can be derived from these elements that permit the calculation of the interaction in advance.

To open up the entire color space to practical use, to give the artist access to all harmonies, it would certainly be enough to represent a reasonable choice from the infinite number of planes according to Hickethier's decadic system of code numbers. If, to adapt ourselves to this decadic system, we adhere to the representation of the saturation of the primaries in ten grades, we obtain a total of seventy-nine planes in the color space:

```
    12 color tone planes
  + 27 brightness (color value) planes
  + 10 achromatic planes
  + 10 saturation planes in the yellow-blue direction
  + 10 saturation planes in the magenta-green direction
  + 10 saturation planes in the cyan-red direction
  ─────────────────────────────────────────────────
  = 79 planes
```

Will the basis offered here make the crystallization and formulation of objective laws of color harmony a pure labor of love?

Hardly anything is final

We may assume that man has always been fascinated by the magic of his colorful environment. Plato already pondered on the strangeness of color manifestations. But color as a phenomenon could be explained only after Newton

successfully proved that all colors are already contained in a ray of white sunlight.

Many, experts and dilettantes alike, have struggled with the problem. Some were able to advance our knowledge a little towards a solution of the riddle.

Others failed because they could not bring themselves to renounce their preconceived ideas. One of these was Goethe, the German poet, who refused to incorporate in his considerations the physical results of Newton's experiments. They did not fit into his romantic and mystical concept of the Universe.

Since about 250 years ago Sir Isaac Newton first passed a light ray through a glass prism and was thus able to split it up into its colored components, the possibility of interpreting the natural laws of color and the laws of color mixture has come close to being realized.

Many theories have been established, systems and color solids developed. The chapter 'Critical assessment of the color systems' (fig. 67) deals with the more important ones. All of them surely contain part of the right solution.

It is astonishing that nobody has yet made the attempt to study all the details of the vast field of the theory of color, to coordinate them and to build them into a comprehensive system of integrated function. Naturally this work must be based on the conviction that all individual phenomena, such as additive or subtractive mixture, the physical or the physiological conditions, can be explained in terms of one and the same law.

This was the starting point for the author's work. He postulated at the outset that there cannot be several laws, several correct solutions, and made the attempt to coordinate all details logically. From these efforts a geometrical form, the rhombohedron, suddenly crystalized.

If we pursue the history of the theory of color we shall see that knowledge has been acquired step by step. The most important, in fact also the first step, was Newton's discovery. Scientific progress rarely springs from isolated achievements, but results from knowledge previously accumulated by many others.

There nevertheless appears the occasional solution that is immediately right and is never queried later, such as the Laws of Pythagoras. The author is not rash enough to claim this for the rhombohedral system; but there is always the possibility.

It is his earnest hope that his work can be of help to those who have made it their task to reach an understanding of the relations between colors.

Harald Küppers ▷

Author's acknowledgements

My thanks are due to Dr W. Dotzel for reading part of the manuscript, and to Professor F. Lautenschlager for drawing my attention to some inaccuracies in the text. His lectures gave me considerable inspiration for my work. I am also grateful to Professor M. Richter for a number of useful suggestions, and to Dr Terstiege and the Federal Institute for Materials Testing for their active help in obtaining important illustrative material.

I also wish to thank Mr K. P. Guth for his invaluable help with the composition and production of the originals and Mr W. Goldbeck for his untiring insistence on optimum lithographic reproduction.

My special thanks are due to my partners in the printing firm of Wittemann-Küppers K.G., Messrs H. Wittemann, K. H. Pickerd and W. H. Müller. Only their active support made the large number of expensive reproductions necessary for such a book an economic proposition.

I am grateful to the publishers for the superb production of the book.

Last, but not least I must thank my wife and children for their forbearance when work on this book left me no time for them.

Points to remember

'Color' as a problem

1. The problem of color can be approached from the most varied points of view, such as
a) the natural sciences
b) the theory of color
c) technology
d) chemistry
e) biology
f) medicine
g) psychology
h) art
i) philosophy.
2. A mental scheme can be set up in which the problem of 'color' is seen from various angles. It results in a 'problem circle'. The historical development of knowledge can be added as a third dimension, transforming our logical model into a cone.

Color and language

1. The word 'color' does not have a precise meaning; it can describe the following phenomena:
a) the property of matter of reflecting or transmitting light differentially
b) the different spectral composition of light rays
c) the visible electromagnetic vibrations entering the eye, i.e., the color stimulus
d) the color perception produced in the brain
e) staining and dyeing substances.
2. Man can readily distinguish about 10,000 hues; but everyday language offers only about ten original, genuine names for colors. This makes it impossible to describe most of the hues accurately.

Which color names are 'right'?

1. The original names of colors do not indicate well-defined hues, but broad ranges of colors.
2. During the study of sources it is necessary to have a clear idea what the author precisely means by the color names he uses.

Everything is really gray

1. Matter is achromatic. Color perception is produced only as a result of a physiological process within a person.
2. Matter has the property of absorbing part and reflecting or transmitting the other part of the incident white light. This produces its colored appearance.
3. Color perception in the brain is caused by different color stimuli, i.e., by electromagnetic vibrations of different wavelengths.
4. Body colors are a relative property of a substance. Their appearance depends on the ambient light. If the spectral composition of the light changes, the appearance of body colors may also change.
5. Plants absorb part of the energy of the light. They need it to carry out the process of photosynthesis.

The process of vision

1. The visual organ consists of the eye and the optic nerve. Its task is to collect visual information and to pass it on to the brain.
2. The eye consists of a lens system, the iris, and the retina. The lens system is capable of forming a sharp image of objects at different distances successively on the retina. The iris regulates the quantity of the incident light. The retina has the task of converting the physical stimulus into a physiological one.
3. Cones and rods are embedded in the retina. The cones register qualitative and quantitative differences in visual radiation; the existence of three different types of cone is assumed, which are sensitive to the three spectral regions blue, green, and red respectively. The rods can perceive quantitative, i.e., brightness, differences only.
4. The optic nerve conducts the physiological stimulus to the brain, where both the color perception and vision itself originate.

Visual defects

1. The blind spot is the area of the retina from where the nerve bundle leaves for the brain. In this spot the individual eye is blind.
2. In night-blind persons the rods do not function.
3. The cause of color blindness or defective color vision is the inability or reduced ability of the cones to react to certain spectral regions.

Optical illusions

1. Our eyes can deceive us. We must not always believe what we see.

2. The process of vision is normally coupled with an unconscious mental process of memory.

3. We do not always see objects as they really are. We often see them as we are accustomed to see them.

4. An object surrounded by many larger ones can appear smaller to us than when it is surrounded by many smaller ones.

Adaptation and simultaneous contrast

1. The eye can adapt itself to different brightnesses of illumination (adaptation).

2. Only brightness differences in the field of view are perceived consciously. The eye unconsciously adapts itself to changes in the general illumination.

3. The question whether an object is perceived as white or not does not depend on the absolute quantity of the light it reflects but on the ratio of its own reflection to that of its surroundings.

4. Enhancement of contrast by the eye is called simultaneous contrast.

5. Achromatic simultaneous contrast makes a given gray appear lighter against a black than against a white background.

6. Colors, when adjacent, can mutually influence their appearance. This phenomenon is called simultaneous color contrast.

7. Simultaneous color contrast can have the effect of a given color tone appearing more colored against a neutral, more neutral against a colored background. It may appear brighter against a dark, darker against a bright background. The color tone may shift owing to simultaneous color contrast.

8. The fact that the eye requires a certain time to see a color tone constantly uniformly is called color assimilation. The color perception changes when the tone is viewed for a prolonged period.

9. The process of color assimilation can be easily observed if one eye is closed, and a color tone viewed with the other eye for a prolonged period, and then alternately with one eye and the other.

The family of electromagnetic vibrations

1. Electromagnetic vibrations have wavelengths from 1000km to fractions of $\frac{1}{1000000000}$mm.

2. Wavelength is the distance between consecutive wave crests.

3. Light is electromagnetic radiation, i.e., energy.

4. Electromagnetic vibrations of wavelengths between about 380 and 720 nanometers are visible to the eye.

5. A nanometer is the $\frac{1}{1000000000}$th part of 1m ($\frac{1}{1000000}$mm).

6. Besides light, the family of electromagnetic vibrations includes electric current, radio and television waves, heat and X rays, alpha rays and cosmic rays.

The light spectrum

1. White light consists of electromagnetic vibrations of various wavelengths.

2. Radiations of different wavelengths are perceived by the eye as different colors.

3. All visible colors are contained in white. A color is always part of white light.

4. A spectrum is produced by the dispersion of a light ray in a glass prism.

5. The spectrum is the fanning-out of the rays contained in the light and their systematic arrangement according to their wavelengths.

6. The colors of the spectrum are blue, cyan, green, yellow, red.

7. Colors of a single wavelength are called monochromatic or spectrum colors.

8. Magenta is not part of the spectrum, since it is not a monochromatic color. It is composed of other monochromatic colors.

9. Magenta is obtained by the superimposition of the two ends of the spectrum, i.e., the blue and the red region.

Emission and reflectance curves

1. Light is not always neutral-white. It can be colored owing to its spectral composition.

2. The spectral distribution of types of light, i.e., the 'light colors' can be clearly represented by means of emission curves.

3. Reflectance curves indicate the reflecting power of body colors.

4. Not even daylight is constant. Its spectral composition changes according to the position of the sun and the weather.

5. 'White' is the sum of all visible electromagnetic vibrations of equal intensity.

6. 'Black' is the absence of visible electromagnetic vibrations.

7. Body colors appear gray if all electromagnetic vibrations of white light are reflected equally, but at lower intensity.

8. 'Gray-light' can be made visible only if white light is included in the field of view as a reference.

Metameric colors

1. The same color tone can be produced by widely different spectral compositions.

2. Colors of identical appearance but of different spectral

or reflectance curves are called metameric ('conditionally identical') colors.

3. Metameric colors may appear identical in a certain type of light, but may be very different in another.

4. Quantitatively identical mixtures of metameric colors can produce results of different appearance.

Spectrum analysis and color temperature

1. The visible rays of glowing or burning substances can be dispersed in a spectrum. A characteristic emission curve is obtained for every substance. This process is called spectrum analysis.

2. A 'black radiator' is a hollow body that when heated emits visible electromagnetic vibrations through an aperture.

3. The color of a certain light can be defined by the temperature of the black radiator at which light of this color is emitted. The light colors agree only optically, their emission curves can be different.

4. °Kelvin is a scale unit corresponding to the °Centigrade but beginning at absolute zero, i.e., -273°C.

5. At a color temperature between 5000 and 5500°K the spectrum is fairly well balanced in all regions. If the color temperature rises above this value the proportion of the short-wave radiation increases. If it sinks below this value the proportion of the short-wave radiation decreases, leaving the long-wave rays predominant.

6. Simple measuring instruments have been designed that directly indicate the color temperature of the light.

Polarization and interference

1. The movement of light waves can be compared with rotating spirals. It is three-dimensional.

2. Polarized light vibrates in only one plane and is therefore two-dimensional.

3. Polarizing filters transmit light rays coming from only one direction.

4. Undesirable reflections and flare can be eliminated with polarizing filters (uses: in color photography, for sunglasses, in microscopy).

5. If two polarizing filters in tandem are appropriately rotated, they transmit less and less light. At an angle of 90° only very little, if any, light can pass through the filter arrangement.

6. Interference is the superimposition of different vibrations. The energy of the vibrations is added up when two wave crests coincide, and mutually extinguished when wave crest meets wave trough. Interference phenomena occur between very closely spaced surfaces (soap bubbles, oil patches, Newton's Rings).

7. Luminous colors can be produced with the aid of polarization and interference; they change when one of the two polarizing filters is rotated. Artists make use of this phenomenon when they want to produce 'objects of light'.

Properties of body colors

1. Properties of body colors are:
 - a) chromaticity
 - b) transparence
 - c) light fastness
 - d) varnish fastness.

2. Body colors are divided into opaque and transparent colors.

3. The properties of the primary inks used in the printing industry are standardized.

4. Certain green, red, and blue colors cannot be obtained in color reproduction by the mixture of primary inks because of inadequate absorption and inadequate reflection of the original colors.

5. Hues that cannot be produced for screen printing by the mixture of primaries can be obtained by the addition of other inks.

6. In four-color printing, additional inks mean additional runs and therefore higher costs.

Color saturation and measurement of color density

1. Maximum saturation of a color has been reached when the colored substance absorbs the maximum amount of incident vibrations within its absorption range and reflects the maximum amount of vibration within its reflection range.

2. If a transparent color is not fully saturated it appears tinted. If the point of saturation has been exceeded it appears shaded.

3. Fluctuations in color holding during printing affect the luminosity of the colors. Changes in the saturation of the individual constituent printing colors cause deviations in the color mixtures. This results in 'color casts'.

4. Color saturation and inking strength can be checked with the aid of densitometers.

5. It is recommended in printing to include color guides with top-quality reproductions to be able to control evenness of inking by measurement.

Primary colors and the color circle

1. Additive mixture is the mixture of colored lights.
2. The additive primaries are blue, green, and red.
3. Subtractive mixture is the mixture of body colors.
4. The subtractive primaries are yellow, magenta, cyan.
5. White represents the totality of the visible light rays.

6. Black is the absence of visible light.

7. The additive primaries are also called one-third colors.

8. The subtractive primaries are also called two-thirds colors.

9. Gray is produced when all the visible light rays are reflected at reduced intensity.

10. A spectrum represented in the form of a circle, with magenta inserted between the two ends of the spectrum, is called a color circle.

11. The difference between the reflectance curve of a primary color and the theoretically correct ideal color is called inadequate absorption or inadequate reflection.

12. Inadequate absorption and inadequate reflection can cause unsatisfactory mixture results.

Complementary colors

1. Colored lights are called complementary when they add up to produce an achromatic hue or white.

2. Body colors are called complementary when they add up to produce an achromatic hue or black.

3. In additive mixture complementary colors can within certain limits be more tinted than the hue that, added to a given one, produces an achromatic hue.

4. In subtractive mixture complementary colors can within certain limits be more shaded than the hue that, added to a given one, produces an achromatic hue.

5. Colors that complement emission or reflectance curves to an equal-energy spectrum or to equal-energy intensities within the spectrum are complementary, so are all body colors and colored lights appearing identical with these.

Additive mixture

1. The starting point of additive mixture is black. It corresponds to the absence of visible electromagnetic vibrations.

2. The end point of additive mixture is white. It corresponds to the equal-energy spectrum and therefore to the sum of all colors.

3. If two additive primaries are superimposed the hue of a subtractive primary is produced. Two one-third colors add up to one two-thirds color.

4. The additive mixture of red and green produces yellow, of green and blue, cyan, and of blue and red, magenta.

5. The additive mixture of all three additive primaries produces white.

6. White consists of the three thirds of the spectrum.

7. If the additive primaries are each scaled into 10 intensity steps, 1000 different hues can be obtained by mixture. In additive mixtures these can be fully distinguished only if a white reference light is present in the field of view to prevent adaptation of the eye.

8. Color television is based on the principle of additive mixture. The additive primaries red, green, and blue are used.

Subtractive mixture

1. The starting point of subtractive mixture is white. It represents all the visible electromagnetic vibrations.

2. The end point of subtractive mixture is black. Black is produced when all light rays are absorbed by body colors or layers of colors.

3. When the absorption of two subtractive primaries each becomes effective, red, blue, and green are produced, the same hues we have already met as additive primaries. The result of a subtractive mixture of two two-thirds colors is the color stimulus of a one-third color. The residual visible third is that spectral region that is not absorbed by either of the two subtractive primaries.

4. The subtractive mixture of yellow and magenta produces red, of magenta and cyan, blue, and of cyan and yellow, green.

5. If the three transparent subtractive primaries are superimposed as fully saturated color layers, the result will be black.

6. Colors are produced by subtraction whenever light strikes absorbing objects.

Simultaneous additive and subtractive mixture

1. Reflections of body colors can be mixed additively.

2. The reflections of color samples on a revolving disc are additively mixed as soon as the speed of revolution exceeds the limit of inertia of the eye.

3. Reflections are also additively mixed when areas are broken up into minute screen elements that can no longer be resolved by the eye.

4. Multicolor screen printing is based on both additive and subtractive color mixture.

Possibilities of modifying a color

1. The possibilities of modifying a color are one-dimensional.

2. The possibilities of variation of any color are located on the line between its maximum saturation and the point where it is totally absent. Any body color can be modified towards white, any colored light towards black along a straight line.

3. A single color can be varied only in its saturation.

4. The continuous uniform saturation graduation between 0 per cent and 100 per cent is called the continuous wedge of a color, and, with black, the continuous gray wedge.

5. Color or gray wedges graduated into saturation steps (tone graduation) are called step wedges.

Possibilities of mixing two colors

1. Two dimensions are necessary for the systematic representation of the possible mixtures of two colors.
2. The square is particularly suitable for the demonstration of the possibilities of mixing two colors.
3. The colors are arranged in the square so that they progress from one side to the opposite from maximum to zero saturation (complete absence). The progression directions of the two original colors form an angle of 90°. The four corners of the square are occupied by the two original colors, their complete mixture, and white.
4. The distance of a color point from the sides representing the 0 per cent saturation lines define the appearance and the mixture ratio of the color with mathematical accuracy.

The color cube

1. Three dimensions are necessary for the representation of the possibilities of mixing three colors.
2. The possibilities of mixture of the subtractive primaries yellow, magenta, and cyan can be neatly arranged in a cube.
3. Every primary color traverses the cube from one face to the opposite face, decreasing in intensity from maximum to zero saturation (complete absence).
4. The distances from the three reference planes completely define the position of a point in the color space and therefore its mixture ratio.
5. The distance of a color point from its reference plane corresponds to the proportion of the relevant primary color in the mixture.

Hickethier's color code

1. Each color wedge of a subtractive primary is divided into ten steps numbered 0–9.
2. In this system 9 = full saturation (99.99 per cent), 0 = the absence of color, i.e., no body color at all was applied to the paper.
3. The 1000 hues of the cube are given three-digit numbers, 000–999.
4. The first digit of a code number indicates the saturation grade of yellow, the second that of magenta, the third that of cyan.
5. Hence the code number 000 = white, 999 = black, 555 = gray, 900 = yellow, 090 = magenta, 009 = cyan.
6. Code numbers containing one 0 are pure mixtures of two primaries.
7. Code numbers containing two 0s are saturation grades of a single primary.
8. The minimum complementary color has the smallest possible code number that complements an existing color to produce an achromatic hue (code number of identical digits). The maximum complementary color has the code number that added to that of the given hue = 999.

Ostwald's pyramid (double cone)

1. Ostwald started from the idea that all saturated pure tones must be contained in a color circle, which is developed from a spectrum, and where the ends of the spectrum are joined by the magenta hues.
2. He thought he would be able to produce all the possible mixtures of a pure tone by mixing it with white and black.
3. He represented all the possible mixtures of a pure tone in an equilateral triangle, whose corners were taken up by the pure color, white, and black respectively.
4. Each hue was defined by a number and two letters. The number indicated the pure tone on the color circle and thereby the associated triangle of equal color tone. The first letter represented the white, the second letter the black content.
5. If all triangles of equal color tone are arranged in the sequence of the color circle so that the white points and the black points are together, the shape of a double cone is produced.

The CIE system

1. The CIE system is built up on the basis of additive mixture.
2. It is particularly well suited for the comparison of different types of light.
3. The references are the straight lines X, Y, Z, situated outside the color solid itself and intersecting in the black point.
4. Because the reference system lies outside the color solid, mathematically exact calculations are possible with all visible spectral color manifestations.
5. Spectrum colors lying outside the straight lines connecting two primary valencies can be obtained in hue, but not in saturation, by a mixture of these two primary valencies.

DIN 6164

1. The DIN 6164 color chart has the purpose of clearly defining body colors.
2. In the DIN 6164 system the colors are arranged largely at equal degrees of sensation.
3. The twenty-four supplementary sheets of the DIN color chart correspond to the tones of the twenty-four-

sector color circle. Each sheet shows the possibilities of modification of its color tone.

4. Hues of equal saturation are arranged vertically, those of equal darkness horizontally.

5. Each hue is defined by a combination of three figures separated by colons. The first figure is the number of the tone on the twenty-four-sector color circle, the second figure the saturation grade, and the third figure the darkness grade.

6. The DIN color chart has been designed with a push-in tablet for each hue; the tablet can be removed from the chart for practical use.

The rhombohedron as a geometrical body

1. The rhombohedron is a regular geometrical body; it has eight corners and six rhombic faces, whose shorter diagonal is equal in length to a side.

2. Three new symmetrical geometrical bodies are produced by two sections along the shorter diagonals of the faces: two tetrahedra and one octahedron. All the faces of these new bodies are equilateral triangles.

Arrangement of the colors in the rhombohedron

1. In the rhombohedron the colors are arranged so that black forms the bottom and white the top corner. The primaries occupy the corners of the planes of the sections dividing the body into two tetrahedra and an octahedron.

2. The additive primaries occupy the plane that intersects the gray axis at an angle of 90° at one third of its length.

3. The subtractive primaries occupy the plane that intersects the gray axis at an angle of 90° at two thirds of its length.

4. With theoretically correct arrangement the colors on the faces of the rhombohedron mix to form an achromatic hue if the body is revolved rapidly enough around its gray axis.

5. The six theoretically correct ideal primaries, together with white and black, form the basis of this system.

6. The reference planes for subtractive mixture are those faces that meet in the white point.

7. The reference planes for additive mixture are those faces that meet in the black point.

8. For a better assessment of the infinite number of points in the color space, the maximum saturation of a primary color is divided into nine equal color values. The result is a step wedge, in which each ascending step represents the next higher color value. Together with grade 0, there are ten saturation grades.

9. In this system the primaries and their color values are of equal importance.

10. In a total of twenty-seven possible color values there are 1000 points arranged in the color space according to a fixed system.

Saturation planes of the rhombohedron

1. Sections through the body parallel to the reference planes are called saturation planes.

2. All points on a saturation plane have the same degree of saturation as the corresponding primary color.

3. The distance between a saturation plane and its 0 reference plane clearly indicates the color value of the corresponding primary in each mixture on this plane.

4. Saturation planes always have the same shape as the faces of the rhombohedron.

5. Each point in the color space is also the point in which three relevant saturation planes intersect. The position of the point in the space is therefore clearly defined by the position of the saturation planes.

Color tone planes of the rhombohedron

1. Color tone planes are produced by vertical body section along the gray axis.

2. Color tone planes are always parallelograms divided by the gray axis into triangles of equal tone of complementary colors. The shape of the parallelogram changes according to the direction of the section.

3. Each triangle of equal color tone shows the possibilities of variation of a certain full color (optimum color) towards black, the various shades of gray, and white.

Planes of equal color values

1. Sections cut through the gray axis at an angle of 90° accommodate hues of the same sum of color values.

2. The digital sum of a Hickethier code number indicates the total number of subtractive color values in the mixture. The maximum digital sum is 27, the minimum 0.

3. The digital sum of a hue indicates the plane of equal color values on which it lies.

4. The digital sum of a code number also indicates (within the already known limits) the brightness of a mixture. In additive mixture a color is the brighter the larger the digital sum, in subtractive mixture it is the brighter the smaller the digital sum.

5. A given color stimulus produced by subtraction will logically have the same brightness as if it had been produced by addition. To this extent the color stimulus can be expressed as a percentage value of the equal-energy spectrum irrespective whether it is produced by subtractive or by additive mixture.

The achromatic planes

1. The achromatic planes are the faces of hexahedral prisms that have the gray axis in common.
2. The achromatic plane 0 is that face of the prism on which only the connecting lines of the six primaries, i.e., blue, cyan, green, yellow, red and magenta are left.
3. The degree of achromatism of a point is indicated by the distance between the point and the achromatic plane 0.
4. Each hue consists of an achromatic and a chromatic value.
5. The chromatic factor of a hue is determined by reference to its six chromatic primaries.

Division of the colors into groups

1. By the dissection of the rhombohedron into two tetrahedra and one octahedron the three groups of tinted, full, and shaded colors are produced.
2. The tinted colors occupy the white tetrahedron.
3. The full colors occupy the octahedron.
4. The shaded colors occupy the black tetrahedron.
5. Full colors have percentages between 33.33 per cent and 66.66 per cent of the equal-energy spectrum.
6. Full colors have digital sums between 9 and 18.
7. With subtractive mixture colors of a digital sum smaller than 9 are tinted, and those of a digital sum larger than 18 shaded. With additive mixture the situation is reversed.
8. The colors occupying the faces are pure colors. They are the result of mixtures of only two subtractive or two additive primaries respectively.
9. The colors inside the color solid are impure. Their mixtures always consist of the three corresponding primaries.
10. There are thus nine groups of colors:
a) Pure tinted colors
b) impure tinted colors
c) achromatic tinted colors
d) pure full colors
e) impure full colors
f) achromatic full colors
g) pure shaded colors
h) impure shaded colors
i) achromatic shaded colors.
11. The color stimulus of a given hue can be expressed by either a subtractive or an additive code number. The subtractive code number has the prefix S, the additive code number A. Corresponding subtractive and additive code numbers always total 999.

The system of arrangements in the rhombohedron

1. The rhombohedron is a color space with an infinite number of points, each representing a hue.

2. Each point in this color space is the point of intersection of six different planes, i.e.
a) a saturation plane in the yellow/blue direction
b) a saturation plane in the magenta/green direction
c) a saturation plane in the cyan/red direction
d) a color tone plane
e) a color value plane (brightness plane)
f) an achromatic plane.
3. The identification of any three of these six planes is enough to define clearly the position of a point in the space and thereby its appearance, the components of its mixture, and all its other properties. It is immaterial whether this information refers to the additive or to the subtractive system.

A new law of mixtures: the integrated mixture

1. The integrated primaries are white, yellow, magenta, cyan, blue, green, red, black.
2. Only four of the eight integrated primaries can be part of an integrated mixture.
3. The following colors can constitute an integrated mixture:
 white
 a two-thirds color
 a one-third color
 black
4. The result of an integrated mixture always refers to nine color values.
5. The color values required are determined in the same way as the chromatic factor of a hue.
6. The achromatic factor indicates the number of the black values.
7. The chromatic factor indicates the number of the chromatic values, separately in one-third and in two-thirds colors.
8. If black values and chromatic values add up to less than 9, they must be made up to 9 by the addition of the required number of white values.
9. The law of integrated color mixture applies whenever body colors are mixed directly with each other (stirred or poured together).
10. The integrated primaries must be matched in their color intensity and spectral behavior.
11. The practical results can agree with theory only as far as the original colors meet the theoretical conditions.

Laws of color harmony

1. Color harmonies can be quantitatively and qualitatively determined regarding the matching and difference in saturation, color tone, brightness, and degree of achromatism.

2. Color harmonies and disharmonies can be described with the aid of the theory of sets.

3. Color harmonies are geometrical shapes within the color space. They may lie on one or several of the four different kinds of plane, i.e. on

saturation planes
color tone planes
color value (brightness) planes or
achromatic planes

or on faces of geometrical bodies inside the rhombohedron.

Bibliography

[1] Lutz, Artur: *Geschmack ist erlernbar* (Verlag für Fachschrifttum, Munich 1956).

[2] Lüscher, Max: *Lüscher-Test* (Testverlag, Basle 1963); *Lüscher Colour Test* (Cape, London).

[3] Itten, Johannes: *Kunst der Farbe* (Otto Maier Verlag, Ravensburg 1962); *Art of Color* (Van Nostrand Reinhold, New York and London, 1961; *The Elements of Color*: A Treatise on the Color System of Johannes Itten. Ed. Faber Birren (Van Nostrand Reinhold, New York and London, 1970).

[4] Werthmüller, Hans: *Der Weltprozess und die Farben* (Ernst Klett Verlag, Stuttgart 1950).

[5] Stilling-Hertelsche Tafeln: *Tafeln zur Prüfung des Farbensinnes* (Georg Thinne Verlag, Stuttgart 1952).

[6] Klappauf, Gerhard: *Einführung in die Farbenlehre* (Teubner-Verlag, Leipzig 1949).

[7] *Licht und Sehen*, in the Series 'Wunder der Wissenschaft', (Time-Life International, Amsterdam 1967).

[8] Ostwald, Wilhelm: *Physikalische Farbenlehre*, Bd. 1 (Unesma, Leipzig 1919); *Die Farbenfibel* (1921). *Color Primer: A Basic Treatise on the Color System of Wilhelm Ostwald* Ed. Faber Birren (Van Nostrand Reinhold, New York and London 1969).

[9] *Color harmony manual* (Container Corporation of America, Chicago 1958).

[10] Bouma, P. J.: *Farbe und Farbwahrnehmung* (Philips Technische Bibliothek, Hamburg 1951).

[11] Wyszecki, Günter: *Farbsysteme* (Musterschmidt-Verlag, Göttingen 1960).

[12] Wyszecki G. W. and Stiles W. S.: *Colour Science: Concepts and Methods, Quantative Data and Formulas* (Wiley, London 1967).

[13] Judd, D. B. and Wyszecki, G.: *Colour in Business, Science and Industry* (Wiley, 1963).

[14] *DIN-Farbenkarte DIN 6164* (Beuth-Vertrieb, Berlin 1962).

[15] Müller, Aemilius: *Praktische Farbenlehre* (Chromos-Verlag, Winterthur 1961).

[16] Rünge, Philipp Otto: *Die Farbenkugel* (Verlag Freies Geistesleben 1959).

[17] Hickethier, Alfred: *Farbenordnung Hickethier* (Verlag H. Osterwald, Hanover 1952): *Colour Matching and Mixing* (Batsford, London).

[18] Albers, Josef: *Interaction of color* (Verlag Du Mont Schauberg, Cologne 1970).

[19] Mante, Harald: *Farb-Design* (Otto Maier Verlag, Ravensburg 1970).

[20] Birren, Faber: *Principles of Color: A Review of Past Traditions and Modern Theories of Color Harmony* (Van Nostrand Reinhold, New York and London, 1969)

[21] Munsell, Albert H: *A Grammar of Color: A Basic Treatise on the Color System of Albert H. Munsell* Ed. Faber Birren (Van Nostrand Reinhold, New York and London, 1969).

[22] Chevreul, M. E.: *The Principles of Harmony and Contrast of Colors* (Van Nostrand Reinhold, New York and London, 1967).

[23] Marx, Ellen: *The Contrast of Colors* (Van Nostrand Reinhold, New York and London, 1973).